Josette Baer

Seven Slovak Women

Portraits of Courage, Humanism, and Enlightenment

Josette Baer

SEVEN SLOVAK WOMEN

Portraits of Courage, Humanism, and Enlightenment

ibidem-Verlag
Stuttgart

Bibliografische Information der Deutschen Nationalbibliothek
Die Deutsche Nationalbibliothek verzeichnet diese Publikation in der
Deutschen Nationalbibliografie; detaillierte bibliografische Daten sind im
Internet über http://dnb.d-nb.de abrufbar.

Bibliographic information published by the Deutsche Nationalbibliothek
Die Deutsche Nationalbibliothek lists this publication in the Deutsche Nationalbibliografie;
detailed bibliographic data are available in the Internet at http://dnb.d-nb.de.

Coverabbildung: © SNG - Slovak National Gallery, Bratislava.
Abdruck mit freundlicher Genehmigung.

∞

Gedruckt auf alterungsbeständigem, säurefreien Papier
Printed on acid-free paper

ISBN-13: 978-3-8382-0638-7

© *ibidem*-Verlag
Stuttgart 2015

Alle Rechte vorbehalten

Das Werk einschließlich aller seiner Teile ist urheberrechtlich geschützt. Jede Verwertung
außerhalb der engen Grenzen des Urheberrechtsgesetzes ist ohne Zustimmung des Verlages
unzulässig und strafbar. Dies gilt insbesondere für Vervielfältigungen,
Übersetzungen, Mikroverfilmungen und elektronische Speicherformen sowie die
Einspeicherung und Verarbeitung in elektronischen Systemen.

All rights reserved. No part of this publication may be reproduced, stored in or introduced into a retrieval
system, or transmitted, in any form, or by any means (electronic, mechanical, photocopying, recording or
otherwise) without the prior written permission of the publisher. Any person who does any unauthorized act
in relation to this publication may be liable to criminal prosecution and civil claims for damages.

Printed in Germany

This study is dedicated to Slovak women in particular and women in general, wherever they live.

Table of Contents

Foreword ... XI

Acknowledgements .. XV

X. Introduction ... 1
 X. 1 Criteria of selection .. 2
 X. 2 The portraits .. 9
 X. 3 The method .. 10
 X. 4 A brief word on gender studies in Central Europe 13

I. Elena Maróthy-Šoltésová (1855–1939) – the first feminist? ... 17
 I. 1 The historical context .. 17
 I. 2 The feminization of the nation 20
 I. 3 *Živena* – the Slovak women's association 21
 I. 4 Elena – chairwoman and writer 25
 I. 5 The education of girls .. 28
 I. 6 *Živena* – conservative or feminist? 29
 I. 7 New times and old issues ... 37
 I. 8 Conclusion ... 40

II. Mária Bellová (1885–1973) – the first female physician 43
 II. 1 The historical context ... 43
 II. 2 "Medicine is not for you. Find yourself an occupation suitable for a woman!" .. 47
 II. 3 Medicine, not politics – Mária's life-long dedication 52
 II. 4 Conclusion ... 56

III. Chaviva Reiková (1914–1944) – a Jewish resistance fighter .. 61
 III. 1 The historical context ... 61
 III. 2 A Slovak Jew and a patriot ... 72
 III. 3 Women in the Slovak National Uprising (SNP) 75
 III. 4 Chaviva's last days .. 80
 III. 5 Conclusion ... 82

IV. Anna Štvrtecká (1924–1995) – a courageous historian 85
 IV. 1 The historical context .. 85
 IV. 2 Anna Štvrtecká, a Party historian critical of the Party ... 95
 IV. 3 *Normalizácia* – the politics of normalization
 in Slovakia ... 97
 IV. 4 Anna's critique of the normalization 106
 IV. 5 Conclusion .. 112

V. Magdaléna Vášáryová (*1948) – actress, diplomat and politician ... 135

VI. Iveta Radičová (*1957) – the first female Prime Minister 145

VII. Adela Banášová (*1980) – the face of young Slovakia 157

Conclusion .. 163

Appendix ... 171
 Chronology .. 171
 Bibliography .. 181
 Index .. 196

Abbreviations

CC	Central Committee of the Communist Party
DS	Demokratická Strana – Democratic Party
HG	Hlinkova Garda – Hlinka Guards
HSĽS	Hlinkova Slovenská Ľudová Strana – Hlinka's Slovak People's Party
HZDS	Hnutie Za Demokratické Slovensko – Movement For a Democratic Slovakia
KSČ	Kommunistická Strana Československá – Czechoslovak Communist Party
KSS	Kommunistická Strana Slovenska – Slovak Communist Party
ODS	Občanská Demokratická Strana – Civic Democratic Party
OF	Občanské Forum – Civic Forum
OSS	Office of Strategic Services
RAF	Royal Air Force
SAV	Slovenská Akademie Vied – Slovak Academy of Sciences
SDKÚ-DS	Slovenská Demokratická Kresťanská Únia-Demokratická Strana – Slovak Democratic Christian Union-Democratic Party
SNK	Slovenská Národná Knižnica, Martin – The Slovak National Library, Martin, Slovak Republic

SNR	Slovenská Národná Ráda – Slovak National Council
SNP	Slovenské Národné Povstanie – Slovak National Uprising
SNS	Slovenská Národná Strana – Slovak National Party
SOE	Special Operations Executive
SSl	Strana Slobody – Party of Freedom
ŠtB	Štátní Bezpečnosť – State Security Service
WAAF	Women's Auxiliary Air Force
VPN	Verejnosť Proti Násilie – Society Against Violence

Foreword

Dear Readers

The book you have before you is Professor Josette Baer's study of seven Slovak women, significant figures in the history and contemporary life of the country.

I was aware of Mrs Baer's work from the Slovak media before my arrival in Switzerland in 2010. On the Internet I had found her interview with the popular station FUN Radio. As ambassador I was naturally interested since it is quite rare to find a native Swiss who focuses on Slovakia. That is why I met up with her and followed her work. I reacted spontaneously when she asked me to write the foreword to her latest study.

In four years as Slovak ambassador to Switzerland, I often had to deal with a lack of both knowledge and interest on the part of ordinary citizens concerning the Central European region, not only Slovakia. In this regard, Switzerland is different from Austria or Germany, for example, which have historical links and current interests in our region. In the past, Switzerland was concerned primarily with her larger neighbours Germany, France and also Italy. But what was happening behind the Iron Curtain was of little interest to the common citizen. It is a pity that, as a consequence of these circumstances, we see hundreds or thousands of Austrian and German investors in Slovakia, while Swiss investors can be counted on the fingers of two hands. That's why I greatly appreciate Mrs Baer's latest book. In her description of the lives of seven Slovak women, she not only presents their often complicated and tragic fates, but also the difficult journey of the Slovak nation from the mid 19th century to the present day.

Professor Baer chose four historical and three contemporary personalities who have exerted a significant influence on Slovak public life. Naturally, one can discuss whether other important personages should have been chosen. For example, the following distinguished women would not be out of place among the group of contemporary Slovak personalities: the economist and former Minister of Finance Brigita Schmönerová, the Deputy Governor of the National Bank Elena Kohútiková, who rendered great service with the smooth introduction of the euro, or the successful entrepreneur Mária Reháková. Also, the famous opera singer Edita Gruberová, already a legend, or the Olympic champion Anastázia Kuzminová, who won the gold medal for biathlon in successive Olympics.

However, the author's main aim was to describe the situation of Slovak women in different historical eras; from her viewpoint it was thus not a priority to choose specific life stories. For example, in her chapter about Elena Maróthy-Šoltésová she precisely describes the struggle of the Slovak nation for self-determination, particularly in the critical years following the Austro-Hungarian Compromise of 1867. In those years, the Slovaks were threatened with oblivion: the fate of many European nations we know today only from historical studies. But the Slovaks survived, also – or perhaps mainly – thanks to their women, and today Slovakia is an equal member of the family of European and world nations.

The author's thoughts about the emancipation of Slovak women in specific epochs guide the reader through the book. As a man, I am probably not the most suitable person to make a judgement about this issue. I allow myself only to state that, with regard to female emancipation, Slovak women were not and are not worse or better off than Swiss women, or women in other countries of Central and Western Europe. One can muse on the significance for

women's rights of Empress Maria Theresa, who ruled Austria-Hungary for forty years in the 18th century, or the decree on equality for men and women in Socialist Czechoslovakia. It is a fact – also mentioned by the author – that many female emigrants from the former Czechoslovakia were astonished to learn, when they arrived in Switzerland in 1968, that women didn't have the vote.

I would like to take issue in particular with the author's opinion that the dissolution of Czechoslovakia was unconstitutional. I remind readers that both chambers of the Federal Parliament voted in favour of the separation. From the viewpoint of the Swiss political system, I can see that it is difficult to understand why Slovak and Czech voters did not get a chance to decide about such an important issue. However, the reality that Slovaks and Czechs understand each other better today than in the times of the common state vindicates the former leaders who decided not to organize a plebiscite. An election campaign on the issue of separation could have provoked nationalist agitation and done severe damage to the relations of the two brotherly nations for many years to come.

I fully understand the author's aim to describe the Slovak National Uprising as a decisive episode of Slovak history, introducing the life and fate of Chaviva Reiková. In Slovakia, however, she is practically unknown, and the question arises, since the author also mentioned others active in the SNP in those years, whether a different woman representing that generation would not have been a better choice.

One task of a diplomat and, in particular, an ambassador is to present his country in a positive light. From this viewpoint, I was somewhat taken aback by what I consider an overly pessimistic view of Slovakia's post-89 development, as discussed in the interviews with Magda Vášáryová and Iveta Radičová. They certainly have a right to their own opinion and the legitimate critique of spe-

cific aspects of our development. However, after twenty years of independence, and in comparison with other countries of our region, Slovakia's development should undoubtedly be referred to as a 'success story', all the more so as the young state's starting point after the dissolution of Czechoslovakia was significantly less propitious than that of the neighbouring countries.

With my critical views I certainly don't want to diminish the significance of the author's work or cast doubts on her objectivity or knowledge of Slovak history. On the contrary, I believe that this study will help to fill specific gaps of knowledge about the young country that still prevail in Switzerland and, in view of the fact that the author wrote her study in English, also in other European countries. It is of no importance whether the majority of readers are women or men. I think that some of the information the author gathered in foreign archives and publications could also awaken the interest of specialist circles in Slovakia.

Jan Foltín, Ambassador of the Slovak Republic
to Switzerland from 2010 to 2014,
Bratislava, Slovakia, August 2014

Acknowledgements

At first glance, every historical study by a single author might seem to be just that. Yet, the author is never working alone, since every scholar who takes their profession seriously is in steady contact with their peers, with experts who can teach them about the particularities of a region's history and the subject under investigation. As a careful student of the difficult Czech, Slovak and common Czechoslovak histories I am honoured that my colleagues and friends in Slovak and Czech academe support me in my endeavours to present my views of their political history to the English-reading public.

The idea for this study was born in Bratislava and Martin. In the summer of 2012, my friend and colleague Gabriela Dudeková, a historian at the Slovak Academy of Sciences, gave me a copy of her book about family relations in Central Europe. Gabriela's book opened up a new world to me, the history of women and family relations in Central Europe through three centuries. Her analysis and that of her fellow authors answered many questions and addressed many issues I had been wondering about – suddenly things fell into place. Their scientific contributions raised the interest of the international community of historians: the *Journal of Interdisciplinary History* at the Massachusetts Institute of Technology (MIT) Press in Boston, USA, published my review of Gabriela and her co-authors' volume.

That same summer, I visited the Slovak National Library SNK in Martin for my annual research in the archives. I was looking for source material about *Živena*, the Slovak women's association in the 19th century. My friend, the librarian Ľudmila Šimková, who is knowledgeable about Slovak history and historiography to the

point that I would like to call her the Slovak lexicon, a praise I am quite certain she would modestly and firmly reject, told me that it would be a good idea to write a book in English about Slovak women, since no such study yet exists. Ľudmila, here it is.

My thanks. I am greatly indebted to my colleagues and friends for their interest in my research and willingness to discuss specific issues with me. My thanks, in alphabetical order, go to Valerián Bystrický, Gabriela Dudeková, Karen Henderson, Karol Hollý, Adam Hudek, Vlasta Jakšicsová, Ivan Kamenec, Daniela Kodajová, Dušan Kováč, Slavomír Michálek, Jan Pešek, Jaroslava Roguľová, Stanislav Sykora, and Jozef Žatkuliak. Thomas Hardmeier is always available when I have a question about medicine; he is a retired professor of pathology and a meticulous researcher and scientist. Dan Holcer, born in Komárno and now living in Israel, helped with the translations from Hebrew and the details of Israeli history. Jan Foltín, the former ambassador of the Slovak Republic to Switzerland, supported this project from the start and I am honoured that he agreed to write the foreword.

My special thanks go to the ladies at the Slovak National Library SNK in Martin for their tireless and outstanding services. Diana Manevich from the Yad Vashem library in Jerusalem sent me archive material in a swift and uncomplicated manner. Mária Bohumelová and Anton Kajan of the Slovak National Gallery SNG in Bratislava provided me with the cover picture of Juraj Jurkovič, which I had first seen in the exhibition *Nové Slovensko/New Slovakia* in 2012. The ladies at the housing office of the Slovak Academy of Sciences SAV have made my annual research stays since 2008 such a joyful and uncomplicated matter: Mária and Lenka Vallová, Božena and Ľubica Konečná, thank you. Valerie Lange at ibidem publishers in Stuttgart is an exceptionally patient, effective and supportive editor. Peter Thomas Hill proofread the manuscript,

patiently soldiering on with the demanding task of teaching me English that is up to his own high standards.

I would like to express my gratitude and respect to the ladies who agreed to participate in my oral history interviews: Magdaléna Vášáryová, Iveta Radičová and Adela Banášová, your ésprit, commitment, modesty, beauty, honesty and intellect are inspiring – you are in a league of your own.

The errors and shortcomings in this volume are my own.

<div style="text-align: right;">Josette Baer
Zurich, Switzerland, and Bratislava, Slovakia, September 2014</div>

X. Introduction

This book[1] has been on my mind for two years. I was inspired to write about the political and social endeavours of Slovak women by a study that my friend Gabriela Dudeková published in 2011.[2]

As a political scientist focussing on the history of political thought in Central Europe and a careful student of Czech, Czechoslovak and Slovak history, I admired Gabriela's study; in an impressive *tour de force* reaching from the 19th to the 21st centuries, she and her fellow authors analysed the situation of women in the Czech lands, Slovakia in the Hungarian Kingdom, Hungary, Austria and Czechoslovakia, providing copious historical analysis based on archive material in four languages. Most valid is the fine fabric of social history: I had a precise and vivid picture of what it meant being a woman in those days, the range of freedoms and limitations Central European women faced under the various political regimes.

My study cannot compare with Gabriela's seminal volume, which is both the reference book par excellence on family relations in the Central European region and an important contribution to gender studies.[3] My intention is rather modest: I would like to present to the Western reader the history of Slovakia seen through the

[1] All translations into English from Czech, French, German and Slovak are mine, if not referred to otherwise.
[2] Gabriela Dudeková, *Na ceste k modernej žene. Kapitoly z dejín rodových vzťahov na Slovensku* (Bratislava: Veda, 2011).
[3] Two noteworthy studies are: Johanna Gehmacher and Natascha Vittorelli (eds.), *Wie Frauenbewegung geschrieben wird. Historiographie, Dokumentation, Stellungnahmen, Bibliographien* (Wien: Erhart Locker, 2009); Edith Saurer, Margareth Lanzinger and Elisabeth Frysak (eds.), *Women's Movements. Networks and Debates in Post-communist Countries in the 19th and 20th Centuries* (Köln: Böhlau, 2006).

eyes of seven women who rendered outstanding service to their nation. All seven have three things in common: they have a *Slovak cultural and political identity*, they were or are *in the public eye* and they have engaged in education, science, the arts, politics, the humanities and the media, that is, in *crucial areas of Slovak society*.

The portraits range from the late 19th century to contemporary Slovakia, presenting the activities of these women on behalf of their co-citizens. In their endeavours, all of them attempted or are attempting to make life better – for all Slovak citizens, not just women. In a wider framework, they represent the ethical values of modern Europe – 'Europeanness'. They are committed to values that the young generation of today considers normal, standard, guaranteed. Yet, in their times, these values were far from being standard, let alone constitutionally granted. They were but ideas that had to be fought for, ideas of a better and more just world that had to be put into practice. The women portrayed here campaigned for these values, and those alive today are still fighting for them on a daily basis.

X. 1 Criteria of selection

I selected the seven women on *subjective grounds* since they represent the spirit and reality of seven distinct historical eras of Slovak and Czechoslovak history. My *three criteria* for selection are: first, the seven women's *visibility* in the Slovak, Czechoslovak and European public eye; second, their *activities* not only for their nation, but also for the promotion of universal ethical values; and third, their *physical presence in Slovakia*, the fact that they stayed in their country and did not – for example – emigrate in 1945, 1948 or

1968.[4] After WWII, former officers and soldiers went to great lengths to flee with their families: most of them had fought in the Czechoslovak exile army shoulder to shoulder with the British, returned home in 1945 and then decided to flee as soon as the Communists took over in February 1948, in some cases using skills acquired in the war to take spectacular leave by stealing a Dakota and in another even driving a train across the border.[5]

In the years of the Cold War, the irrational refusal of some Western intellectuals to believe what witnesses and refugees reported about the Communist regimes in Eastern Europe can be explained by what the French liberal thinker Raymond Aron (1905–1983) called *The Opium of the Intellectuals*,[6] an almost esoteric adherence to Marxism-Leninism. Tony Judt (1948–2010), a renowned expert on French political thought, described the atmosphere among French leftist intellectuals in the 1960s:

"There was thus an aura of romance surrounding the Communist adventure that gave to its failings and mistakes a truly heroic quality. This can be sensed even in the memoirs of the victims them-

[4] An excellent account of the Slovak exile's activities is Václav Vondrášek and Jan Pešek, *Slovenský poválečný exil a jeho aktivity, 1945–1970. Mýty a realita* (Bratislava: Veda, 2011).

[5] Slavomír Michálek, *Za hranicou sloboda 1948–1953. Dakoty 'slobody' a vlak do Selbu* (Bratislava: Veda, 2013).

[6] Raymond Aron, *The Opium of the Intellectuals* (New Brunswick, London: Transaction Publishers, 2005); in his famous study, Aron hinted at Marx's saying that religion is the opium of the people, referring to Soviet Marxism-Leninism as the opium of the French intellectuals, mainly Jean-Paul Sartre (1905–1980), Simone de Beauvoir (1908–1986) and Maurice Merlau-Ponty (1908–1961). The best biography of Aron is Nicolas Baverez, *Raymond Aron. Un moraliste au temps des ideologies* (Paris: Perrin, 2006).

selves, who shared with their French sympathizers and apologists a common feeling of tragic destiny."[7]

Artur London (1915–1986), born in Moravia into a Communist family, had fought in the Spanish Civil War, survived the Nazi concentration camp of Mauthausen, the Stalinist show trials of the 1950s and was rehabilitated in 1963. He could never fully distance himself from Marxism-Leninism and the Party.[8] He emigrated to Paris and joined the leftist French radicals, who were supportive of his conviction that his terrible experience had a deeper "metahistorical level of meaning".[9] Marxism-Leninism and the Party never ceased to be his intellectual home. London, a witness to the trial of the former general secretary of the Czechoslovak Communist Party KSČ Rudolf Slánský (1901–1952), about his loyalty:

> "I never lost faith in the strength and purity of the communist ideal ..."[10]

By contrast, the wives of convicted Party members had quite different views about the regime. Heda Margolius Kovály (1919–2010)[11] and Josefa Slánská's (1913–1995)[12] memoirs provide lively descriptions of the frightening atmosphere in Prague in the 1950s. Jo Langer's (1912–1990) memoirs of Simone Signoret (1921–1985), the famous French actress and her distant cousin, illustrate

[7] Tony Judt, *Past Imperfect. French Intellectuals, 1944–1956* (New York, London: New York University Press, 2011), 137.
[8] Judt, 137.
[9] Judt, 137.
[10] Artur London, *On trial* (London: Macdonald, 1970), 389-390.
[11] Heda Margolius Kovály, *Under a Cruel Star. A Life in Prague from 1941 to 1968* (London: Granta, 2010).
[12] Josefa Slánská, *Report on my Husband* (London: Hutchinson, 1969). A summary of Josefa Slánská's memoirs on http://www.ceskatelevize.cz/ct24/domaci/167408-nelehky-zivot-po-boku-rudolfa-slanskeho/; accessed 21 April 2014.

the ignorance of Western intellectuals about life under Communism.

In 1934, Jo, born Žofia Bein, a Hungarian Jew from Budapest, had married the economist Oscar Langer, a Slovak Jew and Communist; they lived in Bratislava and she had Czechoslovak citizenship. They emigrated to the USA in 1938 and returned to Bratislava after WWII. Oscar had a high position in the Central Committee, and they enjoyed the economic privileges of the nomenklatura.

With Oscar's arrest in 1951, Jo and her two young daughters were catapulted into economic hardship and social apartheid. In 1953, the authorities sent her to the countryside in the so-called *Akcia B* (Action B), a kind of Communist 'kin liability', extended to the families of Party members accused in the show trials. One rationale of *Akcia B* was to isolate the wives and children of the convicted Party members; they were politically unreliable, infested with the virus of treason. In the countryside, they would learn how to work with the peasants and workers. The second and more important reason for *Akcia B* was the transformation of the capital's social structure: the Party's intention was to give the apartments of doctors, lawyers, university professors and entrepreneurs, that is, the urban intellectual elite, to workers; yet, mostly Party members, policemen and personnel of the ŠtB, the domestic State Security Service, moved into the approximately 1500 apartments and houses of 672 evicted and deported families.[13]

In 1955, Jo returned illegally to Bratislava and supported her daughters by doing translations. In the more liberal atmosphere of 1967, the months preceding the Prague Spring, she managed to arrange a meeting with Simone Signoret in London. Simo-

[13] For a detailed account of *Akcia B* (*Akcia Byty*, Action Housing, the deportation of 'unreliable subjects' from the cities) see Jan Pešek, "'Očista' veľkých miest", in *Štátna moc a spoločnosť na Slovensku 1945–1948–1989* (Bratislava: HÚ SAV, Prodama, 2013), 225-234; 230.

ne's appeal to the Czechoslovak authorities would certainly help to free Oscar, or so Jo must have thought. Her intention was to ask Simone for support, explaining to her famous cousin that her husband had been arrested in 1951 and accused of conspiracy against the state. The false testimony the authorities had made him give by way of torture and appeals to party discipline was used to legitimate the trial and execution of Rudolf Slánský and former Foreign Minister Vladimír Clementis (1902–1952) in 1952. Oscar's role was that of a witness to Slánský and Clementis' 'crimes'. Jo on the meeting with Simone:

> "I was anxious to explain, why I had appeared so eager ten years earlier, and I was also longing to take this unique opportunity of talking with a representative of that (to me) incomprehensible species, the French intellectual left, and seeing for myself if they really did not know, or just preferred to ignore, the truth about the régimes still so staunchly supported by *l'Humanité*. ... I had hardly started when she cut me short by saying 'But if you had stayed in New York your husband, as a communist, would have met with very much the same fate.' I fell silent. When she asked me to go on with my story I said it was useless. I excused myself ... and left."[14]

[14] Jo Langer, *Convictions. My Life with a Good Communist* (London: Granta, 2011), 168. Langer's memoirs have been translated into Slovak: Jo Langerová, *Môj život s Oscarom L.* (Bratislava: Marenčin PT, 2007). The party members, all of them in high executive functions, were accused of Titoism, terrorism, treason, Trotzkyism and Zionism. The ultimate expression of loyalty, tortured out of them, was that their admission of having committed the crimes they were accused of would serve the Communist Party's broader interests, strengthening the Communist movement in Central Europe. For a detailed analysis of the trial of Slánský and Clementis see Jan Pešek, "Nepriateľ so stráníckou legitimáciou. Proces s tzv. slovenskými buržoáznymi nacionalistami", in *Storočie procesov. Súdy, politika a spoločnosť v moderných dejinách Slovenska* (Bratislava: Veda, 2013), 210-226. For an analysis in English see Karel Kaplan, *Report on the Murder of the General Secretary* (Columbus: Ohio State University Press, 1990).

I find it hard to understand such an attitude, but Simone had the decency to admit to her mistakes later. Pained by a bad conscience, she would translate Jo's memoirs into French in co-operation with the historian Eric Vigne, displaying gracious honesty:

> "In 1957, in my hotel room in Prague, I committed a sin out of ignorance. When I received a phone call announcing my cousin, I told myself: 'Oh là là, what a drag. The family on my back while touring, what a drag!' I did not know that I had a cousin there and completely ignored that phone call, which actually was a cry for help, an SOS ... Montand and I were on the fourth stop of this tour in 1957. In the USSR, Poland and East Germany, we had seen quite a few questionable things, but we were absolutely certain that three and a half years after Stalin's death there were no more prisoners ... It is crazy that we lived eight days in the city of Prague and ignored this. I was guilty a second time in London in 1967. She wanted to talk to me, I did not let her. I had other worries."[15]

In 1970, Signoret and her husband Yves Montand (1921–1991) would star as Lise and Artur London in the movie *L'aveu* (*The Confession*), which was based on London's memoirs. The movie shows how the Czechoslovak authorities, instructed by Soviet NKVD officers, prepared the victims for the show trials by depriving them of sleep, subjecting them to beatings and long and exhausting discussions about the principles of Marxism-Leninism and the duties of a party member.[16]

[15] Interview of Jean-Claude Guillebaud with Simone Signoret, "Autour du livre de ma cousine de Bratislava", in *Une saison à Bratislava. Présenté par Simone Signoret* (Paris: Éditions du Seuil, 1981), 7-19; 7.

[16] In his depositions, which he voluntarily wrote in 1955 and 1956, the principal Czechoslovak interrogator Bohumil Doubek wrote: "I declare that in some instances I might have resisted suggestions of our own responsible officials; but I did without objection whatever the comrade advisors told me to do. ... I believed them blindly, and they knew it. They were really the first Soviet people I had met (other than in 1945), and we were in daily contact for several years;" Kaplan, *Report on the Murder* ..., 247.

This study does not deal with emigrants; that is the reason why I did not dedicate a chapter to Jo Langer in spite of the fact that her testimony is an excellent illustration of daily life under early Communism. I focus instead on how seven women committed themselves to enlightenment, education, critical thinking, knowledge, medicine, military resistance, human rights, the arts and politics in their native Slovakia. Each woman can be seen as a symbol of her times representing *the spirit and reality of the historical era* in which she lives and acts. They share the ethical values of liberty, equality and fraternity: liberty as political freedom from any rule that is not legitimate in terms of the popular vote; equality before the law, predicated on upholding the rule-of-law state; and the idea that caring for others in the sense of *res publica*, that which is common to all, is the social glue that keeps state, nation and government together.

My selection is *not representative* – and I don't claim that it is. Furthermore, it is far from my intention to belittle or ignore the efforts millions of Slovak women made in the Kingdom of Hungary, during the two world wars and under Communism to bring up their families. On top of scarce resources, they had to deal with an immense bureaucracy and a patronizing state apparatus that treated the citizens as children, depriving them of minimal civil rights. It is also far from my intention to make a moral judgement about those who emigrated; nobody who has not experienced daily life in a non-democratic regime has the right to condemn those who flee in the hope of finding a better life for themselves and their families. My focus is on the seven women, all of whom can teach us a lot about courage and commitment; they voice, through their activities, what millions of unknown Slovak women were and are concerned with, sharing with them the often brutal experience of Slovak and Czechoslovak politics.

Before I present the portraits, a brief note: I plan a second volume on seven Czech women, applying the same criteria of selection and method. I shall present women of different historical epochs to reflect the different political history of the Czech lands. To avoid unnecessary repetition, the periods of Slovak history chosen differ from the Czech ones. For example: in this volume, I am not dealing with the persecution under early Communism or the show trials of the 1950s because they are a chapter in the Czech volume. Naturally, the seven Czech women I shall choose will be of the same singular importance for the Czech lands as their Slovak counterparts were for their country. The two volumes will be separate entities in their own right; the two together will provide the reader with a more comprehensive picture of women's lives in the Czech lands and Slovakia, stressing the distinct political circumstances Czech and Slovak women had to cope with.

X. 2 The portraits

In the last decades of the 19th century, Elena Maróthy-Šoltésová (1855–1939)[17] was a writer and poet, committing herself to the Slovak women's association *Živena*, which was educating women and girls in hygiene, household issues and literature.

Mária Bellová (1885–1973) studied medicine in Budapest prior to WWI, returned to Czechoslovakia as the first female Slovak physician and specialized in the treatment of tuberculosis in children.

When Czechoslovakia was divided into the protectorate of Bohemia and Moravia and the Slovak state in March 1939, the Zion-

[17] If not referred to otherwise the biographical details of Maróthy-Šoltésová, Bellová, Reiková and Štvrtecká are from *Lexikón Slovenských žien* (Martin: Slovenská Národná Knižnica, Národný Biografický Ústav, 2003).

ist Chaviva Reiková (1914–1944) emigrated to Palestine, underwent military training with the Jewish underground army *Palmah* and returned to fight in the Slovak National Uprising (SNP) of 1944.

The historian Anna Štvrtecká (1924–1995) was a victim of the normalization period: she lost her position at the Slovak Academy of Sciences (SAV) because she refused to acknowledge the rightfulness of the invasion of the Warsaw Pact troops that had put an end to the Prague Spring in 1968.

Magdaléna Vášáryová (*1948), a popular actress in the 1970s, was the first female Czechoslovak diplomat after the regime change in 1989 and has since had various political functions and positions. Her engagement for social and cultural issues has made her an internationally known figure.

Iveta Radičová (*1956), the first female professor of sociology at Comenius University was elected in 2010 the first female Prime Minister of Slovakia. She is on the centre-right wing politics. In March 2014 she announced her resignation from politics.

Adela Banášová (*1980) is a very popular TV and radio host and a brand in her own right: in Slovakia she is better known than Coca-Cola.

X. 3 The method

In methodological terms this volume is *eclectic*. The first four chapters are in the form of essay; I describe the four women's lives based on source material I found in Slovak libraries, using *traditional historical analysis*. In the last three chapters, I portray the women using the method of the *oral history interview*. This method has a considerable advantage for the author and the reader alike – it is history rendered vibrant through the individual expression, description of events and memory of a person involved in the context subject to investigation.

A short introduction at the beginning of each of the first four chapters introduces the reader to the historical and political context. The research interest of this volume is thus to present *Slovak history from a female perspective*: how did and do women deal with political, social and economic issues? How did the rights of Slovak women change from the 19th to the 21st centuries and what are they concerned with today?

This study should be understood as a contribution to historical research on Central Europe in a wider context, with particular attention to Slovakia. It is *not* a theoretical contribution to gender or nationalism studies, but focusses on the distinct historical circumstances women were subject to. I hope I can convey how the politics of the past have affected Slovak women and how they dealt with the often complicated and cruel history of their region.

From the last decades of the 19th century to the first decade of the 21st, Slovak women lived through seven political regimes: the Austro-Hungarian monarchy (1867–1918), Czechoslovakia (ČSR, the First Republic, 1918–1938), the Slovak state (1939–1945), post-war Czechoslovakia (ČSR, the Second Republic, 1945–1948), Communist Czechoslovakia (ČSR, 1948–1970, after the federation of 1970 referred to as ČSSR), the democratic Czechoslovak Federation (ČSFR, 1990–1992) and the independent Slovak Republic (1993–).[18] Of these political regimes, only interwar Czechoslovakia, post-war Czechoslovakia from 1945 to 1948 and the short years after 1989 were legitimate in democratic terms.

After long negotiations, Czech Prime Minister Václav Klaus (*1941) and Slovak Premier Vladimír Mečiar (*1942) could not find common ground to set a course for economic privatization. In the

[18] For a documentation of Slovak sovereignty from 1993 to 2013 see Miroslav Londák, Slavomír Michálek a kol., *20 rokov samostatnej Slovenskej republiky. Jedinečnosť a diskontinuita historického vývoja* (Bratislava: Veda, 2013).

summer of 1992, they agreed to divide the state, popularly referred to as the *Velvet Divorce* (*Sametový rozchod*) analogous to the *Velvet Revolution* (*Sametová revolúcia*) of November 1989.[19] This agreement was a violation of the Czechoslovak Federal Constitution since only a plebiscite could have rendered the separation legitimate.[20] In October 1992, some twenty Slovak and Czech citizens submitted a letter to the General Secretary of the United Nations Mr Boutros Boutros-Ghali:

> "The representatives of the political parties who won the latest parliamentary elections failed to enter into a political dialogue with each other, which resulted in the decision to break up our state, without letting the citizens have a say in this matter. According to constitutional law no. 327/1991, the citizens have the right to a referendum on fundamental issues concerning the form of state and government. The political parties, however, consider the referendum redundant, since, in their way of thinking, the citizens have

[19] For a chronology of the revolutionary events in November 1989 in the international context of the Soviet bloc see Jozef Žatkuliak a kol., *November '89. Medzník vo vývoji Slovenskej spoločnosti a jeho medzinárodný kontext* (Bratislava: HÚ SAV a Prodama, 2009).

[20] Karel Vodička, "Wie der Koalitionsbeschluss zur Auflösung der ČSFR zustande kam" in *Osteuropa 45*, no. 2 (1994): 175-186, 182. In a survey done in 1990, only 9.6% of Slovaks and 5.3% of Czechs were in favour of the separation; in 1991, 11% of Slovaks and 6% of Czechs supported the dissolution of the federation. The separation prompted President Václav Havel to resign in protest; Vodička, 181. Because of the different structures of the Slovak and Czech economies, the transformation hit the Slovaks much harder than the Czechs: the unemployment rate in the first half of 1992 was 2.7% in the Czech lands and 11.3% in Slovakia; Jiří Kosta, "Systemwandel in der Tschechoslowakei. Ökonomische und politische Aspekte", in *Osteuropa 41*, no. 9 (1990): 802-818, 993. The most detailed analysis of the political and economic aspects of the separation is Jan Rychlík, *Rozdělení Česko-Slovenska, 1989–1992* (Praha: Vyšehrad, 2012).

already decided about the separation in the latest parliamentary elections, which is a blatant lie."[21]

On 1 January 1993, the Czech and Slovak Republics came into being; the international community was preoccupied with the war in former Yugoslavia and the distressing events in the former Soviet Union. The Czech and Slovak republics were internationally recognized as sovereign states. Slovakia achieved membership in NATO and the EU in 2004. The citizens of the small state in Central Europe, which hosted the 2011 Ice Hockey World Championships, experienced two world wars, interwar democracy, Fascism, Communism, the post-1989 harshness of the economic transformation and, eventually, had to face the hitherto unknown tasks of building a sovereign and democratic state.

X. 4 A brief word on gender studies in Central Europe

Western historians have been working on gender issues for decades; little is known, however, about the history of women in Central Europe. In the 19th century, Slovak women found themselves in a difficult situation. On the one hand, they were eager to engage in what we call gender issues today, for example, to found educational institutions for girls. On the other, they shared men's views that the Magyar assimilation required the nation's united resistance.

Female emancipation in the Western understanding of the freedom to choose how to spend one's life would have meant

[21] Dokument no. 37, "Bratislava, 1992, 22 října. Protest iniciativy 'Za spoločný štát' proti dohodě o rozdělení Československa zaslaný generálnímu tajemníkovi OSN Butrusovi Butrusovi Ghálímu", in *Češi a Slováci ve 20. století. Česko-slovenské vztahy 1945–1992* (Bratislava, Praha: AEP, ústav T. G. Masaryka, 1998), 533-534; 533, further referred to as *Češi a Slováci II*.

fighting a battle on two fronts: first, against the domination of men, and second, against political oppression.[22] Slovak women had neither the financial means nor the political experience to redress either affront. Moreover, the desire to promote feminist issues was further complicated by their particular understanding of *feminism* and *emancipation*:

> "The fact that the Slovak women's movement was weak and lacked decisiveness, indeed, that it was too modest, tells us more about the general conservatism ruling in Slovak society than the conservative orientation of Slovak women. ... The representatives of the Slovak women's movement were also convinced that, in the long run, a policy of small steps would be more successful than immediate radical actions."[23]

Of crucial importance to women in the Habsburg monarchy in the 19th century was the *opening up of the public sphere*, contextualizing women's public appearance in the national and cultural *spolky*[24] (associations, clubs) such as choirs, reading circles and the first Slovak women's association, known as *Živena*. The main activities of women were social care, welfare, literature, and the teaching of cooking and sewing. The education of girls was not a burning issue since a labour market for women did not yet exist.[25] Few engaged

[22] Minor parts of this introduction and the first chapter have appeared in my "*Živena* – die helfende weibliche Hand? Zur Lage der Frauen in der Slowakei vor dem I. Weltkrieg", in *Körper* (Basel: Schwabe, 2012), 147-171. For an analysis of the national movement's debates about female emancipation in the late 19th and early 20th centuries see Karol Hollý, *Ženská Emancipácia. Diskurz slovenského národného hnutia na prelome 19. a 20. storočia* (Bratislava: HÚ SAV, 2011).

[23] Gabriela Dudeková, "Konzervatívne feministky?", in *Na ceste ...*, 232-256; 51.

[24] Elena Mannová, "Mužské a ženské svety v spolkoch", in *Na ceste ...*,175-195.

[25] Daniela Kodajová, "Odborné vzdelávanie ako predpoklad a prostriedok emancipácie," in *Na ceste ...*, 149-175; 151.

in the international women's movement; the majority still adhered to the conservative view that women represented the values of faith, modesty, industriousness and passivity.

Under Communism, Czechoslovak women enjoyed constitutionally granted equality with men and the right and duty to work. Yet, society still conceived of their role as the traditional one of mother and wife; occupied with family matters during their entire lives, women took care of their grandchildren after retirement. Feminism was not popular. Václav Havel (1936–2011), the most prominent dissident of *Charter 77*, explained in 1985 that Czechoslovak women considered feminism as "dada, the fear of becoming unintentionally ridiculous when publicly addressing women's oppression by men".[26] To a society in which the civil and political rights of all were oppressed, women's issues were neither interesting nor of vital importance.

The Western analysts Einhorn and Waylen described how the political change of 1989 affected women who were being marginalized by the new democratic and economic spirit.[27] Women were the first to lose their jobs when the privatization of the large state-owned enterprises began in the 1990s. Another new development was the hitherto unknown phenomenon of sexism. The Western concept of liberty certainly introduced Sir Isaiah Berlin's two freedoms – *freedom from* state oppression and *freedom to* en-

[26] Václav Havel, "Anatomie jedné zdrženlivosti (duben 1985), in *Do různých stran* (Praha: Lidové Noviny, 1989), 65-91; 78-79. See also Veronika Wöhrer, "Som feministka, no a čo? Versuche mit einem Schimpfwort politische Arbeit zu machen?" in *Women's Movements ...*, 179-196.

[27] Barbara Einhorn, "Where Have All the Women Gone? Women and the Women's Movement in East Central Europe," *Feminist Review XXXIX* (1991): 16-36; Georgina Waylen, "Women and Democratization: Conceptualizing Gender Relations in Transition Politics," *World Politics XLVI* (1994): 327-354.

gage in matters common to all, for example, building the polity with the democratic vote.[28] But negative phenomena also wormed their way into the post-Communist societies: criminality, pornography, greed, ruthless selfishness, and asocial behaviour. A sad consequence of the regime change is the trafficking of young women who apply for a job in the rich states of the West and often land in brothels where they are forced into prostitution.[29]

A new historiography free of ideological constraints but also the aforementioned fear of embarrassment might explain the scepticism about a feminist approach to historiography: Central European scholars started only in the mid-1990s to investigate women's roles and functions in society.[30] I hope that my little study can convey an impression of Slovak women's lives through history. Let us begin with the portrait of Elena Maróthy-Šoltésová, the chairwoman of the association *Živena*.

[28] Isaiah Berlin, "Two Concepts of Liberty," in *Four Essays on Liberty* (Oxford, New York: Oxford University Press, 1969), 118-172.

[29] See Kara Siddharth, *Sex Trafficking: Inside the Business of Modern Slavery* (New York: Columbia University Press, 2010).

[30] A good account of gender studies in Central European academe is Gabriela Dudeková, "Learning to Crawl before We Can Walk: Gender in Historical Research (Not Only) in Slovakia", in *Historiography in Motion: Slovak Contributions to the 21st International Congress of Historians* (Bratislava: Veda, 2010), 146-167.

I. Elena Maróthy-Šoltésová (1855–1939) – the first feminist?

"We shall publish books of an entertaining and educational nature, but, first and foremost, Slovak women do need an 'educational institution of their own'."[31]

I. 1 The historical context

In the last three decades of the 19th century, the Slovaks in the Hungarian Kingdom found themselves in a difficult situation because of the Magyar assimilation. To maintain their cultural and linguistic identity, Slovak women started to educate their children in a patriotic spirit. Women were assigned the traditional role of mothers at the service of their families, obedient to men. This role did not change, but it was extended to the public sphere: now, *the nation was the family*. In terms of visibility in the public sphere, women began to enjoy a certain amount of social equality with men. The activities on behalf of the nation required everybody to be involved, as the Slovaks in the Hungarian Kingdom numbered only 2,002,000.[32]

[31] Ivan Kusý, *Význam Eleny Maróthy-Šoltésovej v slovenskej literature a v slovenskom ženskom hnutí* (Bratislava: Osvetový ústav, 1968), 5. Kusy quoted from the article "Dozvuky", published in the collected works of Maróthy-Šoltésová, without reference.

[32] Paul Robert Magocsi, *Historical Atlas of Central Europe. Revised and expanded version* (Seattle: University of Washington Press, 2002) 97-98. In comparison the figures of the nationalities in the Hungarian Kingdom, Croatia-Slavonia and Transylvania included: Armenians 3,000; Croats 1,682,000; Germans 2,135,000; Jews 846,000; Magyars 8,243,000; Roma 275,000; Romanians 2,802,000; Ruthenians 440,000; Serbs 1,049,000.

The Austro-Hungarian Compromise (*Ausgleich*) of 1867 divided the Empire into Cis- and Transleithania, granting the Magyars the highest degree of autonomy short of a sovereign state. Franz Joseph I (1830–1916) was the Emperor of Austria and King of Hungary in personal union. Both parts of the Empire shared a common foreign policy and the ministries of defence and finances. The constitution of the Compromise granted Vienna's non-involvement in Hungary's domestic affairs, providing the Magyar ruling elite with a free hand in the political organization of their state and, with that, the legal power to define Hungarian citizenship, which they understood as a Magyar identity. The discrepancy between constitutional theory and reality affected the non-Magyar citizens. The autonomy extended to them was not understood as a collective right, but an individual one[33] which propagated the viewpoint that they were merely Hungarian citizens, ignoring their cultural identity. From the perspective of Hungarian state law, the non-Magyar citizens' claims to language rights and cultural autonomy were simply irrelevant. The decades up to WWI would expose the non-Magyars to increasingly harsh assimilation. For the Slovaks, 1868 and 1907 were each an *annus horribilis*, cutting back the right to use Slovak in the middle schools[34] and by 1907 also in primary schools.

[33] Ľudovít Holotík, "Der österreichisch-ungarische Ausgleich und die Slowaken", in *Der österreichisch-ungarische Ausgleich 1867. Materialien (Referate und Diskussion) der internationalen Konferenz in Bratislava 28. 8 – 1.9 1967* (Bratislava: Verlag der Slowakischen Akademie der Wissenschaften, 1971), 727-745; 742.

[34] The first of the four *gymnasiums* (high schools) that taught in Slovak was opened in 1861, the last closed down in 1874. After 1874, Slovak pupils could accomplish the matura only at German and Hungarian high schools. On the universities as centres of exchange and their role for the development of the national movements in 18th and 19th century Central Europe, see Richard G. Plaschka and Karlheinz Mack (eds.), *Wegenetz europäischen Geistes. Wissenschaftszentren und geis-*

As a reaction to the May 1906 elections to the Hungarian assembly,[35] in which representatives of the nationalities, given

tige Wechselbeziehungen zwischen Mittel- und Südosteuropa vom Ende des 18. Jahrhunderts bis zum ersten Weltkrieg (Wien: Verlag für Geschichte und Politik, 1983); *Wegenetz europäischen Geistes II. Universitäten und Studenten. Die Bedeutung studentischer Migrationen in Mittel- und Südosteuropa vom 18. bis zum 20. Jahrhundert* (München: Oldenbourg, 1987).
Gale Stokes has demonstrated the importance of high-school education for national movements: children develop the ability to think in abstract terms at the age of approximately eleven, an abstraction being, for example, the term 'nation'. To develop an 'operational personality' that is capable of understanding, working with and being involved in matters of political and social interest, high-school education (*gymnasium*, *Mittelschule*) in one's mother tongue is fundamental; Gale Stokes, "Cognitive Style and Nationalism", *Canadian Review of Studies of Nationalism 9*, no. 1 (1982): 1-14, quoted from Miroslav Hroch, *Das Europa der Nationen. Die moderne Nationsbildung im europäischen Vergleich* (Göttingen: Vandenhoeck & Ruprecht, 2005), 102.

[35] Vavro Šrobár (1867–1950), a physician who run for the Slovak National Party (SNS) and would be elected Czechoslovak Minister Plenipotentiary for the rule of Slovakia in 1918, described the conduct of the elections. According to the law, the citizens had the right to be transported to the polling station and provided with meals, which the parties had to finance on their own. The political and clerical representatives campaigned for the Magyar candidate. With election day approaching, the inn-owners threw themselves at the citizens, "flooding entire villages with alcoholic drinks", because the authorities threatened to take away their licences if they failed to obey. On election day, the polls were open from 4am; Slovak citizens gathered in the district capital, guarded by gendarmes who had to keep order and prevent any violence arising between the Slovak and Magyar camps. At 7pm, the Slovak Party had a majority, with 350 votes against the Magyar Party's 220. At the end of the day, however, the Magyar candidate was declared as the winner, but it is unclear how this was achieved; Dr. Vavro Šrobár, "Voľby do Maďarského snemu r. 1906", *Slovenská Otčina 2*, no. 4 (1925-1926): 60. The aftermath of the elections did not bode

their dire financial situation, did surprisingly well, the government issued the Education Act or *Lex Apponyi*, named after the Minister of Religion and Education Count Albert Apponyi de Nagyapponyi (1846–1933). The act advanced the assimilation through suppression of the non-Magyar national groups, making Hungarian the language of instruction at the lowest level of schooling, i.e. in the primary schools. The teachers were bound to instil into the pupils a patriotic spirit in the sense of Magyar national identity, not just Hungarian citizenship.[36] By the end of the fourth class, roughly at the age of eleven, all pupils should be fluent in Hungarian in speech and writing; thorough scrutiny of the teachers by school inspectors ensured that the laws were followed – as a result, illiteracy among the non-Magyar children rose.[37] How did Slovak women cope with this difficult situation?

I. 2 The feminization of the nation

In the 19th century, all national movements, not only the Slovak, used the female body as an allegory for the national group and its values.[38] Women symbolized the good and the beautiful; the female

well for the future: on 25 June 1906, the authorities arrested Šrobár, the Catholic priest Andrej Hlinka (1864–1938) and some thirteen fellow Slovaks. They were convicted of anti-Hungarian activities in a trial that was a mockery of a rule-of-law state and sentenced to prison; "Ružomberská Golgotha", *Slovenský Týždenník IV*, no. 26, 29 June 1906, 1-2; 1.

[36] Dušan Kováč, *Dejiny Slovenska* (Praha: Lidové Noviny, 2007), 156. The best overview in English is Mikuláš Teich, Dušan Kováč and Martin D. Brown (eds.), *Slovakia in History* (Cambridge: Cambridge University Press, 2011).

[37] Kováč, *Dejiny Slovenska*, 156.

[38] Floya Anthias and Nira Yuval-Davies, "Women – Nation – State", in *Nationalism. Critical Concepts in Political Science, IV* (London, New York: Routledge, 2002), quoted from Mannová, "Mužské a ženské svety ...", 180.

body was emotionally appealing and physically attractive, connoting home, family, warmth and the morality of one's culture. Names such as *Britannia, Germania, Helvetia, Hungaria* and *Slavia* were allegories of the nation, and no national movement, led and controlled by men, could renounce on women as guardians of cultural codes and moral values. The feminization of the nation was also used as a rhetorical instrument to mobilize the men, appealing to the male honour of defending mothers, sisters and wives.

> "The feminine was closely connected with the national folklore or the nation as a theme. It suffices to look at Eugène Delacroix's painting *Liberty Leading the People* to conclude that the breasts of the naked Marianne are much more than eroticism: they symbolize motherhood, the breastfeeder, the love of Mother France leading the French revolution." [39]

The Slovak women's association *Živena* could be described as an active and helpful instrument of the national movement, a kind of executive. It was not the brains of the movement, let alone the political elite responsible for formulating the national goals, activities and efforts. These were exclusively the tasks of the male protagonists, referred to as *národovci* (national awakeners, patriots).

I. 3 *Živena* – the Slovak women's association

In 1860, Marína Hodžová (1842–1921)[40] had founded a *beseda*, a regional debating circle for girls; the members had studied Slovak

[39] Nenad Marković, "Nationalism and Mentality", in *From Postcommunism Toward the Third Millenium. Aspects of Political and Economic Development in Eastern and South-Eastern Europe from 2000–2005* (Bern: Peter Lang, 2011), 95-124; 121.

[40] Marína Hodžová was the daughter of Michal Miloslav Hodža (1811–1870), a Protestant clergyman and associate of Ľudovít Štúr (1815–1856) and Jozef Miloslav Hurban (1817–1888). The three patriots had codified Slovak as a written language in 1843.

poetry and literature and attended lectures on Slovak history.[41] The club had fifty to sixty members and collaborated with the cultural-national association *Matica Slovenska* und the Slovak *gymnasium* (high school) in Veľká Revúca. When the authorities closed the *gymnasium* in 1874 and *Matica* in 1875, the fate of *beseda* was sealed. *Živena* would prove to last longer; the association would integrate women into the national movement,

Živena became well known in Slovakia thanks to the efforts of the writer and poet Elena Maróthy-Šoltésová (1855–1939), who chaired the association for many years and would launch a journal with the same name.[42] The members organized social and cultural activities and concentrated their efforts on education in Slovak. *Živena* understood itself as an apolitical association, but it was a part of the national movement, sharing its efforts to defend Slovak cultural and linguistic identity. Patriots living in the USA[43] and Czechs who sympathized with the Slovak cause helped to finance the association. The name originated in *Živa*, the mythological Slavic goddess of the Earth.

The members of *Živena* were able to overcome the association's dire financial situation with remarkable organizational talent: they successfully advertised the journal and collected money without drawing the attention of the authorities to their activities. The self-concept of *Živena's* leading members explains their success: women's efforts were closely connected to the nation's life, but they focussed on cultural and social issues the authorities con-

[41] Jarmila Tkadlečková-Vantuchová, *Živena – spolok slovenských žien* (Bratislava: Epocha, 1969), 17-18.
[42] Kováč, *Dejiny Slovenska*, 150.
[43] In the last decades of the 19th century, some 300,000 Slovaks, mainly from the poorer regions in northern and eastern Slovakia, emigrated to the USA and Canada. They worked in the mines and the steel industry in Pittsburgh, Pennsylvania, in the Canadian timber industry and on farms; Kováč, *Dejiny Slovenska*, 143, 144.

sidered to be harmless in political terms. The women engaging in the association shared with the men the "higher goal of the unity of all Slovaks", the defence of their cultural and linguistic identity.[44]

Živena's efforts for the nation's education were practically identical to the *small works* (*drobná práce*), an idea and way of life put forward by Thomas G. Masaryk (1850–1937), professor of philosophy in Prague and the future founder of the Czechoslovak Republic. The *small works* were a basic principle of Masaryk's theory of liberation, published as *The Czech Question* in 1895.[45] To prepare the nation for independence, Masaryk suggested the *small works* as a means of *de-Austrianization*: the Czechs should rid themselves of the Austrian social norms that held high the undemocratic values of aristocracy and clericalism. They should become active and educate themselves in all areas of life, learn to be tolerant of different opinions and strive for pluralism, develop a critical mind and be responsible for their lives. The *small works* should be realized daily and in an unspectacular manner; only a nation that was well educated, critical of the political regime and willing to engage in individual responsibility would be capable of self-government in an independent state. To Masaryk, morality and the love of truth were civic virtues that would enhance the projected democratic Republic. Citizenship that deserved the name, so Masaryk thought, was based on the daily, unspectacular, pragmatic and enlightened commitment to education, rational and critical thought and love of one's fellow man.

[44] Dudeková, "Konzervatívne …", 251.
[45] Tomáš G. Masaryk, *Česká otázka. Naše nynější krize* (Praha: Academia, 1990), 171. Recommendable are Roland J. Hoffmann, *T. G. Masaryk und die tschechische Frage* (München: Oldenbourg, 1988); Radan Hain, *Staatstheorie und Staatsrecht in T. G. Masaryks Ideenwelt* (Zürich: Schulthess, 1999) and my *Politik als praktizierte Sittlichkeit. Zum Demokratiebegriff von Thomas G. Masaryk und Václav Havel* (Sinzheim: Pro Universitate, 1998).

The members of *Živena* proved capable of realizing the Masarykian *small works* – without even being aware of them. The principle of the *small works* was unknown among the masses in the Czech lands and Slovakia alike. Slovak women were far from attempting to de-Magyarize,[46] since the assimilation was too harsh; the least they could do, or so they must have thought, was to defend Slovak identity by using their language in education and instruction and by pragmatic and unfaltering commitment to their cause.

In Slovakia, Masaryk's political views would become known to a wider public only in 1898, when a group of young Slovaks who had graduated from Charles-Ferdinand University in Prague returned home. The physicians, economists and engineers, referred to as Hlasists after the journal *Hlas* (*the Voice*) they published, were eager to spread Masaryk's thought, to educate their fellow Slovaks in the sense of the professor's social and educational views of modernisation. Their success was, however, rather marginal; they had to cease publication in 1904, owing to political and financial pressure, while the conservative circles, mostly the Catholics in the national movement, were attacking them fiercely for their egalitarianism and alleged atheism.

[46] In the last half of the 19th century, Czech politicians presented an oppositional factor in Austrian politics; the so-called *Sprachenstreit* (language dispute) was a dominant issue in the relations of Czechs and Germans, who spoke the same language as the ruling Austrians. While aspirations of Germanization and growing German nationalism were afoot in the Austrian part of the Empire, it would be misleading to speak of linguistic oppression, since the Austrian government had not touched the Czechs' language rights in educational institutions. The right to speak Czech *de facto* enabled the Czech national movement to develop into a political factor, so much so that from 1882 on the Charles-Ferdinand University in Prague offered university education in Czech.

Elena knew Masaryk and his daughter Alice (1879–1966),[47] since the Masaryks used to spend the summer holidays in the Slovak countryside, close to Martin. From 1918 on, both women would concentrate their efforts on educating Czechoslovak women in the new democratic spirit of the common state. It is possible that Elena might have learnt about the *small works* prior to 1895 and 1898 in a personal conversation with Masaryk or Alice, but I deem it more likely that the principal motive of Elena and her fellow members of *Živena* was their commitment to pragmatism and equality: to improve women's lives, hence the nation's. They went about it in a pragmatic way, exercising the classic modesty and restraint society expected from women in those years. Who was this woman whom Masaryk would praise in *Čas* in 1895 with admiring words for her literary talent and organizational acumen?[48]

I. 4 Elena – chairwoman and writer

Elena was born on 6 January 1855 in Krupina and attended the German school for girls in Lučenec near Banská Bystrica from 1866 to 1867.[49] Jozef Škultéty (1853–1948), a famous Slovak author and

[47] For a biography of the president's daughter see Radovan Lovčí, *Alice Garrigue Masaryková. Život ve stínu slavného otca* (Praha: Filozofická fakulta Univerzity Karlovy, 2007); with a focus on Alice's efforts for Slovakia see Natália Krajčovičová, "Veľká dcéra veľkého otca Alice Masaryková", in *Slovensko na ceste k demokracii* (Bratislava: HÚ SAV, 2009), 189-194. About Alice's imprisonment by the Austrian authorities see Betty M. Unterberger, "The Arrest of Alice Masaryk", in *Slavic Review 33*, no. 1 (1974): 91-106.

[48] Jozef Škultéty, "Elena Šoltésová", in *Živena XV*, no. 1 (1925): 2-5; 4. Masaryk wrote to Elena on 17 October 1895, asking her to contribute an article about Slovak literature to the Czech journal *Naše doba* (*Our Times*); *Korespondence T. G. Masaryk – slovenští veřejní činitelé (do r. 1918)* (Praha: Masarykův ústav a Archiv AV ČR, 2007), 51-52.

[49] *Lexikon ...*, 237.

poet, described how the fourteen-year-old girl had first come to his attention:

> "I remember, it was either 1869 or 1870, the fourteen- to fifteen-year-old girl's speech at the *majales* [traditional student festivities in May, add. JB] of the *gymnasium* in Revúca. She attended the festivities with her father and her cousin, the famous Ema Goldpergerová, who did so much for our museum. The speech of Daniel Maróthy's daughter is lovingly remembered by many."[50]

In 1869, Elena attended the opening meeting of *Živena* in Martin, which was the cradle of the national movement, finding itself in dire straits after the closure of the last Slovak *gymnasium* in 1874. In Martin, she made the acquaintance of the wealthy patriot Ľudovít Michal Šoltés, a businessman; they married on 12 January 1875.[51] Elena soon became a member of *Živena's* board and dedicated all her energy to the association. In an article, she remembered a meeting of *Živena* she attended in 1882, describing internal problems:

> "They [the Slovak women, add. JB] don't understand 'why those, who are dedicated to our welfare and in power, but do not have the right to put obstacles in our way, would not allow us to have such an institution, which we want to build with our own means. Our men are shaking their heads in resignation. So, what to do?"[52]

She did not give up and accepted the conservatism of the Martin citizens "as a natural development of society that was similar everywhere".[53] In 1885, she organized a collection of funds to support Slovak students in need; in 1894, she contacted the Czech women's

[50] Škultéty, "Elena Šoltésová", 3. Ema Goldpergerová (1853–1917) was an ethnologist and for many years the custodian of the museum of the Slovak Museology Society in Martin.
[51] Michal Kocák, "Elena Maróthy-Šoltésová, 6. 1. 1855 – 11. 3. 1939", *Séria: Fotosúbory* (Martin: Matica Slovenská, 1985), 2.
[52] Kusý, *Význam* ..., 5.
[53] Kusý, *Význam* ..., 6.

movement and promoted the Czech journal *Ženský svět* (*Women's World*) in Slovakia. Under her guidance, *Živena* organized courses and workshops to educate girls. Thanks to her efforts, the building to honour Milan Rastislav Štefánik (1880–1919),[54] the Slovak astronomer, general of the French army and close associate of President Masaryk and Edvard Beneš (1884–1948), became a reality in 1922.

As a writer and poet, Elena was the principal figure in the foundation of the *National Almanac Živena* in 1885. Besides the anthology, she co-authored and co-edited three issues of the yearbook *Letopis Živeny* in 1896, 1898 and 1902. In 1910, she founded the journal *Živena*, which she edited largely on her own. Among her most famous novels and texts are *Na dedine* (*In the Countryside*) (1881), the novel *Proti prúdu* (*Against the Current*) (1894) and *Popolka* (*Cinderella*) (1898). She overcame her grief after her son's death with the novel *Môj syn* (*My Son*) (1913–1917), published in *Živena*. In 1923 and 1924, the novel *Moje deti* (*My Children*), based on her diary, appeared; it was translated into Croatian, French, Slovenian, Czech and Hungarian. Elena was a regular contributor to Czech and Slovak journals and newspapers, namely *Čas*, *Národnie Noviny*, *Nový Človĕk*, *Slovenská Politika*, *Slovenská Žena* and *Slovenské Pohľady*, the oldest literary journal in Slovakia.

She chaired the association from 1894 to 1927 and became an honorary member in 1927. The American branch of *Živena* acknowledged her service with the *Zlaté pero* (Golden Pen) prize in 1921, and the Republic's capital rewarded her with the Badge of Honour of the City of Prague in 1925. She was made an honorary member of the Czechoslovak Red Cross in 1935 and an honorary citizen of Martin.

[54] The best biography of Štefánik known to me is Peter Macho, *Milan Rastislav Štefánik v hlavách a srdciach. Fenomén národného hrdinu v historickej pamäti* (Bratislava: HÚ SAV, 2011).

I. 5 The education of girls

How did the education of girls look in the second half of the 19th century, and what influence did *Živena* have? In the times of the monarchy, only aristocratic and wealthy middle-class families could afford the education of girls; private tutors, mostly poor students, instructed the girls, who also had the possibility to go to a private or convent school.[55]

In the wake of the Compromise of 1867, the Hungarian government undertook reforms of the educational system; law no. 38 issued in 1868 established compulsory primary education for all children, starting at the age of six and lasting to the age of twelve. These reforms proved especially favourable for girls since they granted access to schools that had hitherto been closed to them.[56] An additional paragraph to law no. 38 issued in 1874 projected the foundation of state colleges for girls; the first college for girls opened in Budapest in 1875. Cities in Upper Hungary followed; colleges teaching in Hungarian and German opened in Trenčín in 1877, Levoča in 1879, Banská Bystrica, Pressburg/Poszony (the future Slovak capital Bratislava) in 1883 und Kassa (Košice) in 1883.[57]

Education lasted six years and the curriculum consisted of Hungarian, German, French, Literature, History, Mathematics, Geography, Biology and Chemistry, but also traditional female subjects such as Art, Handicrafts and Music.[58] In 1896, the first *gymnasium* (high school) for girls was founded in Budapest; it offered higher education similar to the boys' *gymnasiums* but was not allowed to conduct examinations. Girls had to take the *matura* exams,

[55] Kodajová, "Odborné ...", 150.
[56] Kodajová, "Odborné ...", 153.
[57] Kodajová, "Odborné ...", 154.
[58] Kodajová, "Odborné ...", 154.

the general qualification for university entrance, only at a *gymnasium* for boys; because of the different curricula, girls had to prepare with private and complementary lessons, paid for by their families.[59]

The education of girls developed in the Hungarian kingdom parallel to the development in Austrian schools; in terms of the right to higher education, Austrian, Croat, Czech, Magyar, Rumanian, Ruthenian, Serbian and Slovak girls were equally discriminated prior to the school reforms of the 1870s. But the non-Magyar girls in the Hungarian kingdom had the additional disadvantage that Hungarian was the language of instruction; they could make the *matura* only in a language that was foreign to them.

I. 6 *Živena* – conservative or feminist?

Following its foundation in 1869, men dominated *Živena* and determined its activities, goals and contents until 1918. In 1869, the journalist and editor Ambro Pietor (1843–1906) observed the activities of the Czech Women's movement in Prague: apart from the city's school for girls and a handicraft school, there were several women's clubs and an American ladies' club.[60] Up to 1500 persons used to attend the lectures and activities of these clubs.

Pietor advertised his idea of a Slovak women's association in several articles in the *Budapest News* (*Pešťbudínské vedomosti*) and the *National Herald* (*Národny hlasník*). To us, his arguments sound patronizing, but we should consider them as illustrating how men conceived of women and their role in society in the 19th century:

> "My goal is to draw the attention of my dear nation to a most important topic, a topic which has not even been publicly mentioned

[59] Kodajová, "Odborné …", 154.
[60] Tkadlečková-Vantuchová, 18.

yet. It is the question 'How to help the intellectually retarded female gender?' The female sex lacks education, which is the fundament of our nation's moral life ... And had I undertaken an investigation into this matter, I would not blame the female gender for its lack of education, but the male. Men as the ruling elite of the world bear the biggest responsibility for *the second half* of the nations being so behind in matters of enlightenment and the *life of the family* developing in such a sad way."[61]

Pietor wrote down the statutes of the association and gave it the name *Živena*; on the occasion of the annual national festivities in Turčiansky Sv. Martin, the first meeting of the council took place on 4 August 1869, with the election of the board members and delegates. *Živena* was conceptualized as a supra-confessional association, committed to democratisation and integration: the equality of the members was not considered as equality of the sexes, but as equality of social status.[62]

A total of 63 women, the famous poet and patriot Viliam Paulíny-Tóth (1826–1877) and the board members of the Sunday school of Petrovec attended the foundation. The declared goals of *Živena's* activities were the training and education of girls, the foundation of further branches on the entire territory of Slovak-speaking Upper Hungary and the support of women in need. Particular emphasis was put on the influence of mothers: they should educate their children in a "Christian, national and enlightened spirit."[63] The conservative attitude the majority of the women shared is best described in Elena's own words that reveal a particular understanding of the concept of 'emancipation':

[61] *Pešťbudínske Vedomosti*, 1869, no. 4, quoted from Tkadlečková-Vantuchová, 18, emphasis by me. Note how Pietor refers to women as "the second half of the nations" and to the Slovak nation as "family".

[62] Daniela Kodajová, "Živena – spolok slovenských žien", in *Na ceste ...*, 215-232; 219.

[63] Kodajová, "Živena ...", 220.

"If a woman, pursuing a mistaken education, intends to emancipate herself from good mores or from morality itself, if she wants to free herself and become unattached, she will, through her own fault, fall into slavery ... But if she, pursuing the proper way of education, wants to develop and move toward the rightful and noble freedom, support her, because she will contribute to the moral perfection of mankind."[64]

As conservative as Elena was in feminist terms, considering a woman's task to be at the service of the family-nation, she was certainly no "dear auntie"; she was active, energetic and "gifted with a sense of responsibility, rarely found in the Slovaks, whose behaviour is close to *oblomovčina*" as her biographer Ivan Kusý put it.[65] Elena was convinced that her activities helped to improve women's lives, that it was preferable to muster strength on a daily basis to pursue one's plans than remain idle and complaining; her dedication and pragmatism earned her the respect of her fellow activists. The female *literati* Terézia Vansová (1857–1942), Ľudmila Riznerová-Podjavorinská (1872–1951) and Božena Slančiková-Timrava (1867–1951) acknowledged her leadership and literary talent.

From the very beginning, *Živena* was in a difficult financial situation. After the closure of *Matica* and the confiscation of its property,[66] the members had serious doubts about their further

[64] Elena Marôthy Šoltésová, "Dennica", quoted from Andrej Mraz, "O dlhom živote", in *Živena XXV* (Martin: Živena, 1935), 10-11; 11.
[65] Kusý, *Význam ...*, 7. The concept 'Oblomovčina' originates in Ivan Gončarev's novel *Oblomov* (1859); the Russian novelist (1812–1891) described his hero, the fictitious young lord of the manor Oblomov: his principal activity is lying in bed, doing nothing. 'Oblomovčina' is a blend of laziness, apathy, lack of energy, tendency to romanticism and idle thought, and a general unwillingness and incapacity to make decisions and act upon them. The concept has a negative connotation.
[66] The closure of the Slovak educational institutions came along with the confiscation of property. The lawyer Štefan Marko Daxner (1822–

support, which, unfortunately, turned out to be rather realistic. Was it really worth paying the high membership fee, given that the authorities could close down the association and confiscate its property at any time? In 1895, Klema Ruppeldtová wrote to the chairwoman:

> "I do hope that you will not accuse me of being brazen if I openly express my opinion, which nobody has asked me to: I am strictly against paying the membership fee: that they could take away even more from us?" [67]

The members were aware that their donations were not safe in legal terms; they could not rely on the unbiased application of the law. One could describe the rule of law running along the lines of

1892) protested against the closure of the Slovak *gymnasium* in Veľká Revúca on 24 August 1874. There was no chance to appeal against the decree issued by the Hungarian Ministry of Religious Affairs, yet Daxner pressed charges to save at least the property of the *gymnasium*, such as the school buildings, technical equipment and educational material. He argued that although the school's board had been dissolved as an institution, the members of the former board were private persons and thus the legal owners of the property. He came forward with the records of the *gruntova kniha*, the land register, to prove the Slovak Protestants' ownership of the buildings, the library and the financial means. The confiscations amounted to a legal discrimination of non-Magyar citizens, violating their property rights by effectively robbing them of their rightfully acquired possessions; Josette Baer, "Štefan Marko Daxner (1822–1892). Law and education", in *Revolution, Modus Vivendi or Sovereignty? The Political Thought of the Slovak National Movement from 1861 to 1914* (Stuttgart: ibidem, 2010), 87-105; 95. Following this rationale, the authorities also confiscated the property of *Matica Slovenská* in 1875, which, like the *gymnasiums*, had been financed exclusively by private donations. The "peak of cynicism" was that the authorities used the confiscated property to finance Magyar national associations in Upper Hungary; Kováč, *Dejiny Slovenska*, 140.

[67] T. Suchá, "Živena v rokoch 1869–1918 (dipl. Práca)", 29, quoted from Tkadlečková-Vantuchová, 34.

loyalty to the assimilation policy: those citizens expressing loyalty to the Magyar interpretation of the law enjoyed its proper application – and those who did not could not.

The financial difficulties of *Živena* were manifest mainly in the social area: the association could not collect enough money to build a planned diagnostic room and orphanage. *Živena's* activities were limited to welfare provided on an irregular basis such as gift bazaars at Christmas, the allocation of books and clothes to the needy and small sums of cash handed out to the poor.[68] Elena described *Živena's* situation as follows:

"She did not want to die, but was not allowed to live."[69]

A consequence of the Hungarian law for associations was the territorial limitation of *Živena*: originally projected as a network that should incorporate all districts in the Slovak-speaking territories of Upper Hungary, the law forbade the national clubs to open branch offices. A high school for girls and a home economics school (*gazdinská škola*) instructing the girls in cooking, sewing and budgeting was not able to open until 1918. During its fifty years of existence, *Živena* attempted several times, in 1884, 1899 und 1910, to obtain the approval of the authorities; the association had the necessary funds at its disposal, but the authorities ignored it for political reasons.[70]

In regard to the liberation and emancipation of women *Živena's* publications proved to be counter-productive, since the donations of the members were also used to publish texts of a conservative attitude that were generally hostile to female emancipa-

[68] Tkadlečková-Vantuchová, 34.
[69] Štefana Votrubová, *Živena. Jej osudy a práca* (Martin: Živena, 1931), 22, quoted from Tkadlečková-Vantuchová, 33.
[70] Kodajová, "Živena ...", 220.

tion; most of them were written by men.⁷¹ Yet, the journal and the publications of *Živena's* own printing office played a crucially important role in the education of girls and women in their Slovak mother tongue, in particular in the harsh years of the assimilation following the Education Act of 1907.

From today's perspective, one can criticize the association's goals, organization and activities, but one should take into consideration the political situation. Feminism, the idea of women's liberty and equality with men, was not popular; for this, men were to blame, since they opposed the idea of the modern woman, in particular her right to education and public activities. In 1872, the philosopher Pavel Hečko wrote contemptuously:

> " ... about the so-called emancipation of women, that is their liberation from male dominance in public life. ... These dreamers would perhaps also like to liberate women from the guiding order of marriage and household, which is to every reasonable person quite obviously a nonsensical and anti-Christian idea."⁷²

The traditional Christian view promoted the relationship of man and woman as a moral one; the Christian faith considered women the potential destroyers of the good and natural order. Their emancipation was not interpreted as a legal demand, but as an interference with the Christian moral order, an attempt to destabilize the natural God-given balance of the sexes.⁷³ This conservative view would dominate *Živena* until 1918; it was a general Christian conservative position and not a confessional issue since Protestants and Catholics alike held almost identical views about female emancipation. The Lutheran members dominating *Živena's* board,

[71] Kodajová, "Živena ...", 220.
[72] Pavol Hečko, "Určenie ženy, v duchu a v svetle kresťanskej pravdy uvážené", in *Živena. Národní almanach I* (1872): 131-167, quoted from Kodajová, "Živena ...", 220.
[73] Tkadlečková-Vantuchová, 24.

however, were more responsive to social progress than the Catholics who conceived of divorce as a moral problem.

In 1897, the poet and author Svetozár Hurban Vajanský (1847–1916), who would become the editor-in-chief of the *National News* (*Národnie noviny*) in 1900, was appointed general secretary of *Živena*. Immediately, he ran into open conflict with the chairwoman. Elena considered emancipation a moral task and not a political demand; yet, even to her, Vajanský's romanticist glorification of the woman as the vestal virgin of the family was painfully backward and, although she would not have used this modern concept, plain sexist.

Vajanský suspected that behind the tiniest attempts at modernization there lay socialist, hence godless, ideology. He it was who controlled the association; furthermore, he was adept at extending his influence to the most prestigious Slovak journals and newspapers. He was a master of networking, flattering those he thought could be of advantage to him, among them Masaryk, whom he befriended in 1887, only to attack him for his critical views about Russia in 1891.[74] For politics and pragmatism he had only contempt, hoping that Russia would liberate the oppressed Slavs in Central Europe.

Vajanský was tirelessly working for the high quality of Slovak literature and poetry – and it was he and his associates who determined that quality.[75] He was conservative to the bone, elitist,

[74] On Vajanský's relationship with Masaryk in the 1890s and their falling out with each other see my "Thomas G. Masaryk and Svetozár Hurban Vajanský. A Czecho-Slovak friendship?", *KOSMAS. Czechoslovak and Central European Journal 26*, no. 2 (2013): 50-62.

[75] Vajanský about the intellectuals in 1897: " ... the spark of spiritual life is glimmering in us ... We are no political party, we are the nation, pars pro toto, like the head that guides the body"; Svetozár Hurban Vajanský, *Nálady a výhlady* (Turčiansky Sv. Martin: Kníhtlačiarsko-účastinarský spolok, 1897), 12. See also my "Svetozár Hurban Vajanský

hungry for power and not shy to use base language when vilifying his adversaries. At least once, as I have shown, he did not deem it below his dignity to deliberately plagiarize: he condemned Nietzsche in a lengthy article, but shamelessly copied Nietzsche's philosophical method of enquiry to warn Slovak youth about that dangerous German thinker.[76]

He was unfairly critical of the texts and poems women submitted to *Živena,* condemning them high-handedly as superficial and of low artistic quality. One example: in 1885, Elena submitted to the *Almanac Živeny* her prose piece *The Dying Child* (*Umierajúce dieťa*), a first draft, which she would later extend to her famous novels about her son and her children. Vajanský published a review in *Slovenské Pohľady* in 1886 insinuating "that a dying child is no work of art".[77] He declared that he knew only two kinds of women: the ideal woman committed to household chores and the emancipated one.[78]

Vajanský's fiercely anti-modernist views, however, did not extend to his family: his daughter Olga enjoyed an expensive education at the prestigious Smolny Institute for young ladies in the Russian capital St. Petersburg. In the spirit of Slavophile thought, Vajanský's Russian friends and associates financed Olga's education.

(1847–1916). Messianism, Panslavism and the superiority of art", in *Revolution ...,* 151-177.

[76] Josette Baer, "Twilight of the Idols in Slovakia – or using Nietzsche's hammer to strengthen the nation", in *Kapitoly z histórie stredoeurópskeho priestoru v 19. a 20. storočí. Pocta k 70-ročnému jubileu Dušana Kováča* (Bratislava: Historický ústav Slovenskej Akademie Vied SAV, 2012), 64-85.

[77] Kusý, *Vyznam ...,* 11.

[78] Kodajová, "Živena ...", 220.

I. 7 New times and old issues

Stability was a characteristic feature of *Živena*: chairpersons stayed in office for a very long time, Vajanský was general secretary for twenty-two years and Elena chairwoman from 1894 to 1927. The women's association can be seen as a continuation of *Matica*; in spite of internal conflicts and financial problems it was the only Slovak institution that resisted the pressure of Magyarization.

Štefana Votrubová, the first biographer of *Živena*, explains the association's survival with the fact that the Hungarian authorities simply did not take it seriously: in their view, *Živena* was but a group of little women and no political organization, hence no threat to the authorities.[79] Jarmila Tkadlečková-Vantuchová, the second biographer, thinks that the authorities expected *Živena* to dissolve owing to the lack of activity of her members.[80] With the foundation of the Czechoslovak Republic on 28 October 1918, *Živena* would experience a new era: Alice Masaryková, the founder and chairwoman of the Czechoslovak Red Cross, would support the association with funds and a new organizational structure.

How seriously Elena took the education of women and girls is also visible in her fight against alcoholism. In the liberal atmosphere of the First Republic efforts to educate the citizens fell on fertile ground, not only because the pressure of Magyarization had collapsed with the Czechoslovak troops being in control of the Slovak territory. Now, Slovak was the language of communication in Slovakia, and the building of institutions such as primary schools, *gymnasiums*, hospitals, universities, technical universities and state welfare began in the first months of 1919.

Elena must have been enthusiastic about the new political regime: *Živena* was no more a little women's club, but an institution

[79] Votrubová, 21.
[80] Tkadlečková-Vantuchová, 32.

that was acknowledged by the Prague government. Now, they could work without the fear of being closed down, taking care of women's issues – for the good of all, the emerging Czechoslovak democratic nation.

On 17 February 1922, the Czechoslovak parliament adopted the law of Holitscher (*Holitscherový zákon*), which forbade the selling of any kind of alcoholic beverages to persons under the age of sixteen on the entire territory of the Republic.[81] With Karol Lányi, a professor of medicine, Elena edited volume XIX of the *Library for Sobriety* (*abstinentná knižnica*). Alcoholism was caused by the lack of education and the abysmal poverty in the countryside. The people were desperate, and the home-made *palenka* the only remedy they had. They beat each other up, ran debts at the pubs and neglected their children. Also, the people considered alcoholism as a characteristic male feature, a kind of manliness. In the poorer north and eastern regions abstinence was the exception. Those who drank regularly and sometimes too much were considered the social norm.[82]

The physician Vavro Šrobár was a native of Lisková in the vicinity of Ružomberok. He was also Minister of Public Health in 1919 and would be appointed tenured professor of social medicine in 1935. Prior to the foundation of the Republic he had held lectures in the villages, educating the peasants about hygiene, first aid and the fatal consequences the home-made *palenka* had for the human body and brain. Šrobár remembered a typical encounter

[81] "Zákon na ochranu mladistvých osôb pred alkoholem", in *Niekoľko slov k slovenským ženám* (Bratislava: Krajinské ústredie pre Slovensko, Čsl. Abstinentného sväzu, 1932), 46-56; 46.

[82] Anna Falisová, "Medzivojnové zmeny v zdravotníctve", in *V medzivojnovóm Československu 1918–1939. Slovensko v 20. storočí. Tretí zväzok* (Bratislava: Veda, 2012), 102-114; 108.

after a lecture on alcoholism in Ružomberok around the turn of the 20th century:

> "One of the youngsters asked me what to do in the holidays and on Sundays, when they were not working in the fields. I replied: 'Read books or the newspapers!' And I told him about the importance of newspapers, how one can learn from them about the world, politics and economics."[83]

According to Šrobár, alcoholism would diminish only with the improvement of social conditions, the housing situation in particular. Courses instructing housewives how to cook healthy meals on a small budget would also help to lower the consumption of alcohol.

To Elena, addressing Slovak women as "my sisters", mothers and wives were instrumental in the fight against alcoholism.[84] She was aware that WWI had caused great grief, poverty and physical and mental problems, yet one of the most moral tasks of mankind was to be in control of oneself. The healthier children were being brought up, the healthier and brighter the nation's future. Children should grow up in pristinely clean homes; the smoking of tobacco in the house would damage their health, but alcohol was the family's biggest enemy:

> "Do we not much too often witness how a poor labourer, who could feed with his modest earnings not only himself but also his wife and children, drinks away his salary on payment day – and at home then there is only poverty, quarrelling, crying and desperation. ... In the villages, peasants drink away their land and property, condemning their wives and children to poverty."[85]

The worst possible situation was, however, when women drank. Men who drank were destroying themselves, their wives and innocent children, but if the wife was orderly, sober and willing to work,

[83] Vavro Šrobár, *Z môjho života* (Praha: Fr. Borový, 1946), 383.
[84] Elena Šoltésová, "Slovenským matkám!", in *Niekoľko slov ...*, 3-9; 3.
[85] Šoltésová, "Slovenským matkám!", 5.

she could bring up her children on her own and make sure that they would later be capable of earning their bread. But if the wife joined the husband in drinking, everything collapsed; the children of parents who drank were the most unhappy ones, because a drinking mother afflicted damage on them even before they were born. Elena's cruel experience of having lost her son who died of tuberculosis explains her efforts to educate women about alcoholism:

> "That is why you, our women, mothers and future mothers, are bound by duty to strictly abstain from drinking any alcoholic beverages (avoid not only the usual palenka, but also rum, any kind of liquor, wine and beer). And, once the children are born, you still have the holy duty not to give to your children any drop of alcohol, no wine and no beer, because alcohol poisons their bodies. They cannot grow up healthily and their minds are damaged."[86]

I. 8 Conclusion

What did *Živena* contribute to the liberation and emancipation of Slovak women? We can answer this question, first, from a historical perspective and, second, from a feminist viewpoint.

The historical interpretation holds that the association supported the national movement in a pragmatic fashion: the members, in particular the chairwoman Elena Maróthy-Šoltésová, concentrated their admirable efforts on educating girls and women in spite of the dire financial situation and the political pressure from the authorities. The association also took care of the poor, trying to alleviate their hardships at least. *Živena* was able to survive that long because of the unremitting efforts of its members, yet, paradoxically, also because of the anti-feminist views of the

[86] Šoltésová, "Slovenským matkám!", 7-8.

authorities, which considered the association a harmless women's club.

From a feminist viewpoint, however, *Živena* was not successful: it could not promote female emancipation, did not prompt new initiatives for the liberation of Slovak women and was content to be at the service of the male-dominated national movement.[87] Elena's conservative views condemned female emancipation: she did not support the idea that women could have a life of their own, remain unmarried and dedicate themselves to a profession of their choice.

To Elena being a woman meant to keep everything together, to be the *Atlas* of the nation-family, literally bearing the nation's future on her shoulders: to ensure that children could grow up in a healthy, loving and safe environment, and that women were acknowledged as equal partners to men within their traditional social role. The idea that women could conquer male professions was alien to her, and her efforts did not project women's independence.

Finally, one should understand *Živena's* importance within the political context: attempts at democratization such as the right to vote were not discussed in the Hungarian kingdom until 1905. The Slovak national movement's main goal was the reform of the political system, while the emancipation of women was considered a by-product. For fifty years, however, *Živena* was an important institution that focussed on improving the lives of Slovak women and men; thanks to the unremitting enthusiasm of the members the association survived. Elena's efforts can best be described with what she thought the young generation should be concerned with:

> "Religious, social, economic, national and other problems – the successful solution to all these issues demands more wisdom, more

[87] Kodajová, "Živena ...", 229.

understanding, an indestructible sense of justice and a burning enthusiasm."[88]

[88] Eléna Maróthy-Šolésová, "Slovenskej mládeži", in *Slovenská otčina. Vlastivedný sborník pre mládež I*, no. 6-7 (1925): 94-95; 95.

II. Mária Bellová (1885–1973) – the first female physician

"A woman studying at the university was the exception, even more so at the Medical Faculty. From all nations of the old Hungary we were only five girls (a Hungarian, a Serbian, a Romanian, a Jew and me).[89]

II. 1 The historical context

What Elena deemed selfish and a mistaken understanding of women's emancipation, that is, choosing a profession, getting a university degree, working and renouncing marriage – all this Mária would do. She would dedicate her life to her patients.

Prior to 1918, the state of public healthcare in Upper Hungary was abysmal because the system had to comply with the political demands of the government; the assimilation policy affected also the medical institutions. The former Czechoslovak Minister of Public Health Šrobár remembered in a report in 1936:

> "In 1870, the government prohibited the Slovak priests from founding associations dedicated to the promotion of sobriety in the district of Upper Trenčín. At the beginning of this century, the authorities banned my activities after my third lecture; I was educating the people in the villages adjacent to Ružomberok about tuberculosis, alcoholism, trachoma, infant mortality and household hygiene with the help of pictures and drawings. The school inspector prohibited the editors of Hlas from publishing a booklet by Dr Dušan Makovický, because it was written in Slovak."[90]

[89] František Sykora, "Rozhovor s primárkou MUDr. Máriou Bellovou", in *Cesty k dnešnej medicíne* (Martin: Osveta, 1990), 9-15; 10.

[90] Vavro Šrobár, "Úlohy sociálneho lekárstva na Slovensku", in *Bratislavské lekárske listy XVI*, no 16 (1936): 1-17; 2-3.

The assimilation hindered the Slovak doctors in their philanthropic activities. The Hungarian legislation had issued many well-meant instructions about public healthcare, but the authorities hampered the initiative and activities of those who wanted to improve the population's general state of health. Patients were sent to public health officers, who were overwhelmed with administrative work and often could not or did not want to see the people's miserable state. The hospital wards in the counties' towns and villages did not employ a sufficient number of Slovak doctors; everybody aspiring to such an official position had to confirm in writing that he was neither a member nor publicly active on behalf of the Slovak national movement.[91]

The Hungarian laws issued in 1876, 1898 and 1908 had addressed many important themes of public health and provided adequate prescriptions and instructions, but the communities and towns had to finance everything on their own, which bordered on the impossible since they could hardly pay the physicians in their service. The state's financial contributions were limited to extraordinary situations that had the potential to gravely endanger the public, for example, an epidemic. At the time of the *prevrat* in 1918, 18 hospitals on Slovak territory had a capacity of 2638 beds. The hospitals were in a miserable state: primitive equipment, dirty rooms and personnel that did not speak the language of the population. The people conceived of the hospitals as a place they were ordered to go to die, not to get treatment.

During WWI, the Hungarian government changed its attitude towards female education, also because industry, agriculture and administration required personnel. WWI and the social requirements it prompted accelerated the equality of women and

[91] Šrobár, "Úlohy sociálneho lekárstva", 3.

their entry into the professional world, since women had to replace the men who were fighting in the war.

A telling example how the war affected the government's attitude in regard to female education was the decree issued in July 1915 to open high schools for girls.[92] The Hungarian Royal Elisabeth University opened in April 1915 in Pressburg/Pozsony; in 1912, it had been planned as an institution to strengthen the Magyar national spirit in Upper Hungary, but the war needed educated women to replace the men.

Pressburg's girls considered the university as a chance to get access to higher education, employment and the economic liberty that would come along with a university degree. Female students could enrol at the Faculty of Law, later at the Faculty of Philosophy; training at the Medical Faculty started in September 1918.[93] The language of instruction was Hungarian. During the war, the number of female students at Hungarian high schools was continuously rising: in 1913/14, female students amounted to 4% of the student body, and by 1916/17 already 18% of the students were women.[94]

To the Slovaks WWI proved a catastrophe, a chaos in intellectual and moral terms; but the war also opened up a window of political opportunity:

> "The daily life of the majority of peasants, workers and small scale craftsmen was determined by hunger and very long working hours. ... The [psychological and political, add. JB] distance to the Hungar-

[92] Elena Mannová, "Kultúra vo víchrici ukrutenstva'", in *Prvá svetová vojna 1914–1918. Slovensko v 20. storočí. Druhý zväzok* (Bratislava: Veda, 2008), 186-204; 192.

[93] Mannová, "Kultúra ...", 193. For the changes in schooling from 1918 to 1945 covering the education systems of the First Republic and the Slovak state see Ľubica Kázmerová a kol., *Premeny v školstve a vzdelávaní na Slovensku (1918–1945)* (Bratislava: HÚ SAV, 2012).

[94] Mannová, "Kultúra ...", 193.

ian state became manifest at the end of the war with the burning of Magyar school books, the burning of Hungarian school buildings and the removal of Magyar titles on official state buildings as well as private houses ... On the hills, people lit spontaneous fires of joy and removed the border stones at the border to Moravia. ... Many Slovaks had personal contact with Czechs, and a positive relationship with the Czech culture was dominant, also thanks to the Czech army physicians [serving at the north-eastern front, add. JB]. ... In general, however, the idea of Czechoslovakism, of a unity of Czechs and Slovaks, was not widespread among the Slovaks; this was due to the lack of information about the activities of the Czechoslovak exile organisation [caused by war censorship, add. JB]."[95]

The conditions during the first years of the war had led to a weakening of the civic spirit: exhaustion, the general lack of order, the non-democratic social hierarchy, the lack of information caused by widespread illiteracy, but also censorship and dysfunctional families affected the citizens' relationship to the state.[96] Furthermore, the lack of experience how to organize public life and the fact that the authorities had arrested potentially dangerous patriots at the beginning of the war caused an increasing loss of legitimacy on the part of the government.

With the Central Powers losing the war, the intellectual and political elite became aware that the supra-national Habsburg Empire would no longer be in a state to decide the future of the Slovaks. At the end of the war, the Magyar oppression of the Slovak language and the new perspective of a common state with the Czechs gave Slovak identity a boost. People began to support cooperation with the Czechs. The reaction to the death of Emperor

[95] Elena Mannová, "Krízy lojality", in *Prvá svetová vojna*, 205-214; 208-209.
[96] Mannová, "Krízy lojality", 209-210.

Franz Joseph I on 21 November 1916 in Slovakia was reserved and rather cold.[97]

In 1918, when the Czechoslovak government took over, the state of public health in Slovakia was miserable: influenza was decimating the people all over Europe and Great Britain. The Czechoslovak government, represented by Šrobár, established the Ministry of Public Healthcare, which did not enjoy popularity in political terms: from 1918 to 1938, eleven ministers would head the institution.[98] The ministry's main goals were to contain infectious diseases, lower the high rates of infant mortality and improve the population's general state of health.

When the thirty-three-year old Mária Bellová, who had served in a frontline hospital in the Transylvanian Marosvásárhely (today Târgu Mureş in Romania), returned to her native Slovakia after WWI, she could not find a position in the capital Bratislava.[99] There was the first female Slovak physician eager to work – and all doors were closed. How to make sense of this situation in view of the fact that the new government was in dire need of loyal personnel?

II. 2 "Medicine is not for you. Find yourself an occupation suitable for a woman!"

The first female doctor in Austria-Hungary was Gabriele Possauer (1860–1940), an Austrian who had graduated at Zurich University in 1894.[100] Some twenty years later, in 1910, Mária Bellová would

[97] Mannová, "Krízy lojality", 210.
[98] Falisová, "Medzivojnové zmeny ...", 103.
[99] Karol Hollý, "Mária Bellová – prvá Slovenská lekárka", in *Na ceste* ..., 633-643; 641.
[100] Ján Junas, "Zo slovenského asklepiónu Mária Bellová", *Slovenský Lekár* 7, no. 1 (1997): 50.

become the first female Slovak doctor. She was born on 10 November 1885 in Liptovský Sv. Peter in Northern Slovakia; her father, a Lutheran pastor and adherent of the Hlasists, would support her in her professional plans.

Young Mária's observation of how tuberculosis decimated the people of her village created in her the wish to become a doctor. The men of Liptovský Sv. Peter were world-famous masons.[101] In the spring, they used to leave for Budapest, Vienna and Bucharest, where they were building city houses and palaces. The women took care of the hard work in the fields and the woods; the children stayed at home and often suffered from hunger, because the mothers sold eggs and milk to the local castle to be able to pay for clothes and taxes. When the men returned in late autumn, they brought with them not only their salaries, but also tuberculosis.

Young and old were dying; at the turn of the 20th century, tuberculosis had reached epidemic proportions in the Austro-Hungarian Empire. There was no cure, no help and no hope; coughing blood was a death sentence. The healthy avoided contact with a *tuberák*, a sufferer from tuberculosis; the ill lost their positions and could no longer support themselves.[102]

Mária went to primary school in Liptovský sv. Mikuláš. Thanks to the rector, who was an acquaintance of her father Ján, she was accepted as an extraordinary student at the Evangelical Lyceum in Banská Štiavnica, where she accomplished the *matura* in the autumn of 1905. The language of instruction was Hungarian. Mária's father suggested that she enrol at the Medical Faculty of Charles-Ferdinand University in Prague. But this plan did not succeed: as a Hungarian citizen, Mária had to apply for Austrian citizenship to study at Prague University. This was a very complicated

[101] "Sedemdesiate vianoce prvej slovenskej lekárky", *Ľud 8*, 24 December 1955, 5.

[102] "Sedemdesiate vianoce ...", 5.

procedure, and had the further drawback that with a degree from Prague, she would not be allowed to practise in Slovakia.[103] She thus decided to enrol at the Medical Faculty of Budapest University.

Ján Bella and his twenty-year-old daughter, in her modest homemade clothes, presented themselves to rector Antal Genersich (1844–1918), a native of Trnava. He spoke Latin with her father, obviously glad to meet people from Slovakia.[104] Genersich, who would help Mária find a place to stay, warned her that medicine was a physically and psychologically demanding profession, but he accepted her as an extraordinary student.

Two years into her studies, her excellent performance earned her the status of a full student, equal to the male students. During her studies, she had to put up with misogynist prejudices that were dominant among professors and students alike. Mihály Lenhossék (1863–1937), the director of the Institute of Anatomy, reprimanded her during a training session with the words "find yourself an occupation suitable for a woman".[105] Mária about her years at university:

> "Young Slovaks studying in Budapest met at the Slovak association. We organized lectures on different topics such as Slovak and world literature and current themes of philosophy and sociology. We staged plays and had parties. Declaring that I was not religious, I once held a lecture about the emancipation of women, which the law student Markovič mercilessly criticized. ... We used to meet weekly at different restaurants in order not to draw the authorities'

[103] Eulália Sedláčková, "MUDr. Mária Bellová – prvá slovenská lekárka", *Lekárnik 9*, no. 7 (2004): 21.

[104] Mária Bellová v televíznom dokumente *Život pre druhých*, quoted from Hollý, "Mária Bellová", 638. Mária's father spoke Latin fluently, but almost no Hungarian. He and the rector conversed in the ancient language because Slovak was a forbidden language.

[105] Hollý, "Mária Bellová", 638.

attention to us. Yet, the Hungarian state bodies were much more generous in Pest than anywhere in Slovakia."[106]

Milan Hodža (1887–1944), the future leader of the Agrarian Party and Czechoslovak Prime Minister from 1935 to 1938, was a fellow student of Mária's; he studied law. Her colleagues at the Medical Faculty were Ivan Stodola (1888–1977) and Jozef Uram (1885–1944),[107] who would become the head physician of the state hospital in Košice. Mária graduated in the autumn of 1910. She remembered this important day in her usual matter-of-fact way, but joy and sadness alike are palpable in her account:

> "It was 26 November 1910 ... Quiet, almost mystically quiet in the auditorium and in our hearts. Upon a signal, the student hymn began to play. We all stood up, the chandeliers were lightened, candles were glowing on the podium. The doors opened, the masters of ceremony strode in, wearing their festive historical uniforms ... the rector in his black robe, professors and assistants. A pompous procession as the tradition of Pest University demanded in those days. And then, it was my turn. With a throbbing heart, I went up to the podium, facing the rector who gave me the crucifix, and with my fingers on the cross, I repeated the rector's words, swearing my oath to act always according to my conscience, according to Him the Highest ... I received my doctor's diploma in medicine as the first Slovak woman; I keep it safely guarded to this day. I regret that I was alone at my doctoral graduation, my father had recently died."[108]

In spite of this great achievement the reactions of the Slovak media were quite restrained. Mária had openly declared being a feminist, but she did not receive any support from *Živena*, most probably because nobody at home knew her. The only persons that supported

[106] Sykora, "Rozhovor ...", 11.
[107] Juliús Vájo and Marta Jirouškova, "Jozef Uram – prvý riaditeľ Štátnej nemocnici v Košiciach", on http://www.snk.sk/swift_data/source/NbiU/Biograficke%20studie/34/Vajo.pdf; accessed 2 April 2014.
[108] Sykora, "Rozhovor ...", 11-12.

her, that is, persons she mentioned in the rare interviews she gave, were men: her father and her fellow student Jozef Uram from the times at Budapest University.

I think there were two reasons that explain this reserve on the part of the Slovak women's association and the media: first, Mária had gained her doctorate at Budapest University, which some must have considered a betrayal of the national cause. Second, as a pioneer of feminism, her success must have provoked envy and also the usual anti-feminist conservatism, shared by both women and men. Her achievements clearly demonstrated that it was possible for a Slovak woman to get a university degree, in spite of the harsh assimilation. The daughter of a Hlasist, that despicable group of atheist intellectuals under the spell of Masaryk and Prague, graduating from Budapest Medical Faculty – a very unpatriotic endeavour, or so some of the conservative intellectuals following Vajanský must have thought.

The journal *Živena* that was now published monthly mentioned Mária's graduation in one sentence, with no photo added; *Prúdy (Currents)*, the journal of the progressive movement edited by former Hlasists, was equally brief.[109] Only *Dennica (The Daily)* published a picture of the young doctor and a longer article, written by Mária's colleague Jozef Uram. After a few sentences about the difficulties she had had to face to get high-school education, Uram stressed the importance of Mária's doctorate for Slovak society:

> "We are proud of our first female doctor and admire her dedication, determination and persistence: against all the difficulties and obstacles, she accomplished the demanding studies in due time and with a good result, breaking the ice and demonstrating that our Slovak girls can study too – if they want to. May her example be-

[109] Hollý, "Mária Bellová", 639.

stow will and courage on those whose thirst for knowledge is secretly burning."[110]

II. 3 Medicine, not politics – Mária's life-long dedication

After graduation, Mária started her practical training in a psychiatric hospital in the south-western Hungarian town of Pécs. After six months she left for Trenčín in Upper Hungary. Thanks to the financial support of her uncle Karol, the brother of her late mother, she was able to go abroad: from 1911 to 1912 she studied in Berlin, Paris and Brussels. From 1913, she practised as a surgeon in the children's section of the hospital of Marosvásárhely. The board appointed her chief physician (*primárka*) of the children's section as an expression of gratitude of the local Romanians.[111]

At the beginning of WWI, the unit was transformed into a frontline hospital where Mária faced the death of young men on a daily basis:

> "The war machinery was hurting the human body and soul to such an extent that our medical science was of no avail … I had in my care three rooms with tetanus patients, where soldiers, fully conscious, were almost dying of pain because we did not have any anti-tetanus serum at our disposal. Daily, limbs infected with gangrene were amputated, gunshot wounds to the head, stomach and rib cage examined – it was a horror of almost apocalyptic proportions, centred on the ruins of what once had been a human being."[112]

[110] URAM, Jozef. Prvá slovenská lekárka (K našim obrázkom), in *Dennica*, 13, 1911, 1, s. 13-14, quoted from Hollý, "Mária Bellová", 640.

[111] JESOM, Ján (Štefan Krčmery). Prebytok slovenskej inteligencie?, in *Národnie noviny*, 51, 1920, 177, s. 1, quoted from Hollý, "Mária Bellová", 640.

[112] Sykora, "Rozhovor …", 13.

For her service, the Hungarian Red Cross awarded her the Cross of the War and the title *Pro patria et humanitate* (For Fatherland and Humanity).[113] When the Austro-Hungarian Empire capitulated on 27 October 1918 and the Czechoslovak Republic declared its independence on 28 October 1918, Mária was looking for employment in her native Slovakia. According to her curriculum vitae,[114] she went to the capital Pressburg[115] just after the *prevrat* and was told that there were no open positions.

To her, this was unimaginable, and she could not understand why the new Czechoslovak institutions kept refusing her. I think that the unwillingness to employ her originated in a general suspicion of her person, a particular blend of misogynist and nationalist attitudes.

Hospitals had no experience with female doctors yet, and the fact that she had graduated from Budapest University and was in Hungary's service during WWI was a further reason not to employ her. Quite obviously, she was *persona non grata* in Bratislava. Mária's biographer Karol Hollý stresses that the consequence of the

[113] HUSKOVÁ, Jindra. Prvá slovenská lekárka spomíná (k pražskému sjazdu vysokoškolsky vzdelaných žien), in *Čas*, 4, 1947, quoted from Hollý, "Mária Bellová", 640.

[114] BELLOVÁ, Mária. Curriculum vitae. ALU SNK, sign. 150 BS 1, quoted from Hollý, "Mária Bellová", 641.

[115] The date of Mária's arrival in Pressburg is unknown. Pressburg/Pozsony was declared the seat of the Czechoslovak government in Slovakia on 18 January 1919. On 3 February 1919, Šrobar arrived in Pressburg and established his government. On 25 March 1919, the city's name changed to Bratislava. The building of Czechoslovak institutions began immediately after Šrobár's arrival; on 27 June 1919, Comenius University was founded as the first Slovak university. For an excellent account of how the political regimes portrayed the city on the Danube in the 19th and 20th centuries see Gabriela Dudéková a kol., *Medzi provinciou a metropolou. Obraz Bratislavy v 19. a 20. storočí* (Bratislava: HÚ SAV, 2012).

prevailing anti-Magyar attitude was to employ Czechs in the Slovak state services since they were loyal to the young Czechoslovakia.[116] Some officials might have even suspected her of being a Hungarian spy, which, in those early days of the Republic, was not unrealistic.[117] When she contacted the office of the dean of Comenius University, she was offered the position of an assistant doctor at the university ophthalmologic clinic,[118] which, given her training and professional experience, was open discrimination, a slap in the face. She refused and went back to Romania. It took her almost two years to find employment in Slovakia.

Thanks to her colleague Jozef Uram who was already head physician of the state hospital in Košice, although he had also graduated from Budapest University, Mária eventually found employment in the eastern part of the country. From 1921 to 1925, she worked as assistant surgeon (*sekundárna lekárka*) in Košice. Because of her pneumonia, *župan* (governor of a county) Dr Ruman transferred her to the "Šrobár Institute for the Treatment of Tuberculosis in Children" in Dolný Smokovec.[119] Mária would work in the beautiful village in the High Tatra until her retirement in 1957.

[116] Hollý, "Mária Bellová", 642-643.

[117] A week after his arrival Šrobár described in his report to the Prague government the anti-Czechoslovak attitude that ruled in Pressburg. The Magyar civil servants had left, and the citizens refused to acknowledge the new government. Railway personnel in the East were in the pay of Hungary. On 21 March, Béla Kun assumed power; Hungary became a 'council republic', modelled on Lenin's Soviet Union. Kun's troops had occupied half of Slovakia by June 1919, intent on moving into Bratislava; Josette Baer, *A Life Dedicated to the Republic. Vavro Šrobár's Slovak Czechoslovakism* (Stuttgart: ibidem, 2014), 79-94.

[118] Hollý, "Mária Bellová", 641.

[119] The Šrobár Institute was founded in 1920; it specializes in tuberculosis and respiratory illnesses in children; see http://www.srobarovustav.sk/sk/; accessed 5 April 2014.

"When I arrived in Dolný Smokovec, sun and fresh air were the only medication for tuberculosis. ... The children were everything to me and I tried to be everything to them: doctor, mother, sister, advisor, teacher, defender and judge. When we could not find a teacher for the section of contagious diseases, I put down my stethoscope, picked up a book and became a teacher. ... In the 1930s and 1940s, caprine tuberculosis was still widespread. I used the herb Barbarea vulgaris and had very good results."[120]

According to Thomas Hardmeier,[121] retired professor of pathology at the University of Zurich UZH, caprine tuberculosis can be compared with bovine tuberculosis, the type of TB that may be transmitted from cattle to man, or spread via the beef or milk of an infected animal. In developing countries, tuberculosis is still a serious medical issue. Prior to the improvement of hygienic conditions and therapy with antibiotics, it was a widespread and dangerous disease, also in Switzerland. Thanks to prophylactic measures and the pasteurization of milk, the disease was eliminated. Hardmeier on Mária's cure with Barbarea vulgaris:

"Barbarea vulgaris (bittercress) is a tangy plant that is rich in glucosinulates, flavonoids and saponins. One can compare it with a plant that can be eaten as a salad. Because of its appetizing and blood-purifying effects, bittercress is a medicinal plant. It is, however, not correct that bittercress can heal infectious diseases. I have no doubts that Mária Bellová was an excellent physician; she obviously took very good care of the children entrusted to her. Her care prompted therapeutic success. Psychology plays a very important role in medicine, even in our times of 'modern medicine' with the many diagnostic and therapeutic possibilities we have at our disposal."[122]

Mária would never marry; in her spare time, she would go on long hikes in the forests of the Tatra mountains. She focussed on treat-

[120] Sykora, "Rozhovor ...", 14.
[121] Conversation with Thomas Hardmeier via email, 6-14 April 2014.
[122] Conversation with Thomas Hardmeier via email, 6-14 April 2014.

ing tuberculosis with new dietetic and hygienic measures, instructed and supervised a new generation of doctors, was active in the branches of *Živena* in Košice and Poprad[123] and worked with the Czechoslovak Red Cross.

In 1947, she was appointed head physician of the tuberculosis section; at the suggestion of President Antonín Zápotocký, the seventy-year-old doctor received the award *Rad práce* (Order of Work) in 1955.[124] The Medical Faculty of Budapest University awarded her the Golden Diploma on the occasion of her eightieth birthday in 1965, and on 24 April 1967 Slovak television broadcast a documentary about her life and achievements. After her retirement, she lived in Príbovce, not far from Martin, where she peacefully passed away on 20 November 1973. Her body was transferred to the National Cemetery in Martin in 2000.[125]

II. 4 Conclusion

The population's miserable state of health and the training of doctors and healthcare personnel would drastically improve in the inter-war years. Owing to her life-long dedication to medicine under three different political regimes, Mária was a pioneer of the women's movement, yet only the Hungarian government in 1918 and the Czechoslovak Communist government, adamant to foster the emancipation of women, would award her the credentials she deserved.

What she had to fight for in her time was available to young Slovaks of both sexes starting from 1919: university education in

[123] Junas, 50.
[124] *Pravda XXXVI*, no. 333A, 2 December 1955, 1.
[125] ĎURIŠKA, Zdenko. *Národný cintorín v Martine. Pomniky a osobnosti.* Martin, Matica slovenská 2007, quoted from Holly, "Mária Bellová", 643.

medicine. The dramatic political changes from aristocratic rule to democracy also affected the public's perception of working women; university education and a professional career were no longer the preserve of men.

The young Republic was in dire need of doctors; particularly in the remote countryside in north-eastern Slovakia physicians were a rarity. From 1919 on, the Medical Faculty of Comenius University was educating students, providing also the basic requirements for scientific research.[126]

Under the guidance of Czech professors, a first generation of Slovak doctors was growing up; they went to Budapest and Prague to accomplish their basic training, but graduated in Bratislava. In 1926, 1015 doctors were practising in Slovakia; after ten years, the number had risen to 1805. They were unequally distributed over the country: in the north-eastern Slovak counties, one doctor took care of seven to eight thousand patients, whereas in the central territory of the Republic, in Bohemia, Moravia, and Western Slovakia, one physician was available for roughly 2470 patients.[127] In a European comparison, Czechoslovakia was ranked twelfth in regard to the proportion of doctors to patients.

At the beginning of the 1930s, already 17% of the medical students in the entire Republic were young women, yet only 151 female doctors were practising in Slovakia in 1935. Mostly Czech doctors held the leading positions in hospitals and the state public healthcare institutions. Qualified physicians could open up a practice wherever they wanted to; they had only to submit proof of their training at the state institutions of the district or county. After accreditation, they could also apply to state health institutions and hospitals. Czechoslovak doctors were represented through their professional association *The Central Association of Czechoslovak*

[126] Falisová, "Medzivojnové zmeny ...", 111-112.
[127] Falisová, "Medzivojnové zmeny ...", 112.

Physicians (*Ústredná jednota československých lekárov*) and the local medical chambers.[128] In Masaryk's Republic, doctors enjoyed a high social standing because people appreciated the physicians' dedication, their willingness to work long hours and the selfless observance of the Hippocratic oath: to be at the service of the sick at all times.

Mária was always modest and reluctant to talk about herself; she never complained about the difficulties she had to endure and revealed nothing about her thoughts, ideas, complaints and frustrations. As a doctor, she was a pragmatic person, dedicated to results, not words. Nothing is known about her private life; most probably she did not deem her private life interesting enough to speak about it in public.

In psychological terms, I think that she was a woman of the 19th century, modest, but eager to get an education; in feminist terms, she must have thought that a physician had to put the well-being of others first, that a woman had to choose between her profession and a family. Obviously, she decided for the former. She loved children, but did not have any of her own. Mária deemed it beneath her dignity to complain about the discrimination she had endured as a woman in the medical community. She just kept doing what she loved and was good at: treating neglected, ill and homeless children, trying to give them a home. The account of Paula Gádošiová, who was a patient in the clinic in Dolný Smokovec during WWII is perhaps the best compliment paid to this admirable woman, who was described as strict and severe, but loving:

> "'Don't be afraid. God will help you and I too. I'll take care of you and give you an education', she promised the sixteen-year-old girl. She sensed her thirst for knowledge … every day, she brought the young girl from Bratislava, who was confined to bed, a quote in Latin. Paula had not only to learn it, but also reflect about it. After

[128] Falisová, "Medzivojnové zmeny …", 112-113.

three years they learnt that Paula's parents were alive and safe, and the girl returned to them in good health."[129]

[129] Daniela Augustinska, "Bola prísna, ale láskavá", *Život 44*, no. 10 (1994): 26-27; 27.

III. Chaviva Reiková (1914–1944) – a Jewish resistance fighter

"A secret radio transmitter was hidden in the hut 'Trangoshka', operated by a girl and two young men. The girl broadcast in German, and the two men in English. Much later, we learnt that the girl was a parachutist from Israel, a native of Radvaň and her name was Chaviva Reik. The two men were English paratroopers. We had no contact with them. Only after the war we heard that the famous Chaviva Reik had been executed by the Nazis."[130]

III. 1 The historical context

Mária had achieved what women of her generation could only dream about. She put the idea of female independence into practice: she conquered the male-dominated university, graduated, worked as a doctor and, apart from being financially independent, received official recognition from the university and the state.

Chaviva Reiková would go a step further: she would get military training with the British Army in Palestine and join the resistance, military activities being hitherto a strictly male domain.

As brutal as the fight against the Nazi occupation was, WWII proved to be a significant boost to gender equality: no state fighting the Germans could afford not to rely on women who joined the men in hitherto traditional male functions. Besides their activities as doctors, nurses, translators, secretaries and workers in armament

[130] Alice Dubova, "War experiences with Slovakian partisans", Yad Vashem Archives, Wiener Library Collection, record group 0.2, file no. 668, 14 pages. Dubova was interviewed by her cousin Mr S. Smith in 1958 in London in German; Smith added a brief summary in English to the file. I quote from Dubova's original report in German, 9.

factories,[131] women now joined the fighting troops in the various battlefields of WWII. Female members of Churchill's Special Operations Executive (SOE) parachuted into Nazi-occupied France to gather intelligence, serve as couriers and commit sabotage, putting their lives at immense risk.[132] Chaviva would return to her native Slovakia in September 1944 as part of an SOE mission.

Neville Chamberlain, Édouard Daladier, Benito Mussolini and Adolf Hitler signed the Munich Agreement on 30 September 1938. Great Britain and France considered Czechoslovakia a pawn sacrifice to save the peace. In Czechoslovakia, the majority of the Sudeten Germans had been rallying against the Republic supporting the Sudetendeutsche Partei led by Konrad Henlein (1898–1945). Czechoslovak politicians were trying to save what could be saved of the Republic, but the radicals of the HSĽS (Hlinka's Slovak People's Party) pursued their own plans, considering Munich a platform to expand their personal power, pushing forward the issue of Slovak autonomy.

Munich prompted the Žilina Agreement (*Žilinská dohoda*) in October 1938, which led to Slovakia's autonomy; the Vienna Arbitration (*Viedenská arbitráž*) in November 1938 consigned

[131] Two recommendable TV series illustrate how WWII changed women's professional lives and their standing in society: the Canadian series *Bomb Girls* portrays the lives of four friends from different social classes who work in an armament factory during WWII: http://www.imdb.com/title/tt1955311/ accessed 10 April 2014. The British series *The Bletchley Circle* is excellent fiction, telling the story of four friends who worked as decoders in Bletchley Park during WWII. Frustrated by the gender conservatism ruling in post-war Great Britain, which forced women back to kitchen and child care, they use their intellectual faculties to solve crimes: http://www.imdb.com/title/tt2275990/; accessed 17 June 2014.

[132] A fascinating account of women in the SOE is Marcus Binney, *The women who lived for danger. Behind enemy lines during WWII* (New York: HarperCollins, 2003).

southern and eastern parts of Slovakia to Hungary and, on 15 March 1939, the Republic ceased to exist: Germany invaded the Czech lands and established the protectorate of Bohemia and Moravia. On 14 March, Slovakia had to proclaim independence; she was a pseudo-sovereign state at Hitler's beck and call.

The majority of the Slovaks had accepted the declaration of Slovak autonomy on 6 October 1938. A prominent signatory of the Žilina Agreement was the Catholic priest Jozef Tiso (1887–1947),[133] who was 51 years old and had been a member of parliament for HSĽS in the First Republic. The Czechoslovak government in Prague, betrayed by its former allies and in a state of disarray because of the resignation of President Beneš and his cabinet, had to accept the agreement. Czechoslovakia's status changed to a federation with a new official name for Slovakia, *Slovenska krajina*; the country's new official name was the hyphenated *Czecho-Slovakia*. The government in Prague was responsible for international affairs, defence, currency, the state budget and customs, public transport and the postal system.[134]

The agreement's rationale was that of loyalty to the Republic in exchange for autonomy. From the viewpoint of a Slovak citizen, the Žilina Agreement made sense: why would they want to support 'Prague centralism' if the capital did not acknowledge their demands for self-government within the common state? From a Czech perspective, however, 'Slovak autonomism' unnecessarily burdened the Republic at the time the state had lost the substantial territories of the Sudetenland to Germany. But in the community elections of May 1938, HSĽS had no longer been the strongest party:

[133] The best biography known to me is the re-edited study by Ivan Kamenec, *Tragédia politika, kňaza a človeka. Dr. Jozef Tiso, 1887–1947* (Bratislava: Premedia, 2013).

[134] Kováč, *Dejiny Slovenska*, 210.

"HSĽS intensified its push for autonomy, but concerns about the international threat soon strengthened the position of the centralist parties, confirmed by the course and the results of the community elections of May 1938. ... 1452 communities held elections. Slovenska Jednota [an electoral association of Agrarians, Social Democrats, the Slovak National Party and further small parties, add. JB] received the majority of the votes with 43.93%, followed by HSĽS with 26.93% and KSČ with 7.4%. ... The results of these elections were never published, but they confirm that the Slovak citizens were aware of the threat against the Republic and supported its preservation."[135]

When Hungary claimed territory in southern Slovakia, where the majority of the mixed population was Magyar, Czechoslovakia was pressed into negotiations. Slovakia lost the strategically important southern parts on the Danube, including the towns of Komarno, Nové Zámky and Košice. The people rejected the Vienna Arbitration of 2 November with general indignation.[136]

National committees (*národné výbory*) were emerging all over the country; as the prolonged arms of HSĽS, they were agitating in communities and towns. In the spirit of the "national revolution", some communities started to expel Czech and Jewish citizens.[137] The party's executive association, the notorious *Hlinkova*

[135] Kováč, *Dejiny Slovenska*, 209. *Slovenská Jednota* won the majority because SNS left the autonomist block and joined the former centralist parties. In the parliamentary elections of 1935, the autonomist block of HSĽS and SNS had won 30.1% of the vote; they had been supported by the parties of the Rusinian and Polish minorities, which also pursued autonomy issues. The ruling Agrarians had achieved 17.6% and their coalition partner, the Social Democrats, 11.3%; Alena Bartlová, "Posledné parlamentné voľby v máj 1935", in *V medzivojnovom Československu 1918–1939* (Bratislava: Veda, 2012), 439-440; 439.

[136] Dušan Kováč, *Slováci, Česi, Dejiny* (Bratislava: AEP, 1997), 78.

[137] Jan Rychlík, *Češi a Slováci v 20. století. Česko-Slovenské vzťahy 1914–1945*, vol. I (Bratislava: Veda, 1997), 147; further referred to as *Češi a Slováci I*.

garda (Hlinka Guards, HG) was formed; the name was a homage paid posthumously to Andrej Hlinka, the leader of the autonomy movement, who had died in August 1938.

The guards, whose black uniforms were modelled on those of the SS, were stirring up the population with lies, defamation and violence. Their main targets were the 'atheist and Hussite' Czechs and the 'capitalist and bolshevist' Jews. The Hlinka guards were the "symbol of the anti-Czech attitude in post-October Slovakia",[138] but not only the *Ľudáci* supported the expulsion of the Czechs: sympathizers of the Slovak National Party, the Agrarians and citizens who had vested interests in replacing the Czechs in the administration welcomed the systematic expulsion of the Czechs. Because of the demagogic activities of HG, people widely believed that the country's bad economic situation and the unemployment rates would improve once the Czechs had left. The Slovak government, however, was reluctant to implement at once the drastic measures demanded by HG, since it needed Czech capital and the revenues Czech tourists created.

The parties of the German and Magyar minorities, led by Franz Karmasin (1901–1970) and János Esterházy (1901–1957), were reliable allies of HSĽS and HG: they fought the Republic's democratic system too. In a process of *Gleichschaltung*, HSĽS imposed its ideology on sports associations, social organizations and professional unions alike. The goal was not so much to convince the citizens of the party's rightful course in ideological terms, but first and foremost to extinguish any criticism.

[138] Čarnogurský, P. 14. Marec 1939. Bratislava, Veda 1992, s. 57. Čarnogurský, P. 6 október 1938. Bratislava, Veda 1993, s. 15, 34, quoted from Valerián Bystrický, "Vysťahovanie českých štátnych zamestnancov zo Slovenska v rokoch 1938–1939", in *Od autonómie k vzniku Slovenského štátu* (Bratislava: Prodama, 2008), 184-197; 190.

Economic considerations and reasons of military strategy, not so much Hitler's personal motivation, resulted in the creation of the Protectorate of Bohemia and Moravia and the Slovak state. Hitler coveted the Czech military and civil engineering, machine-tool construction and electrical industries, but the Czechoslovak territory was also a platform for further expansion into the Balkans.[139]

On 12 February, Hitler and Foreign Minister Joachim von Ribbentrop (1893–1946) received Vojtech Tuka (1880–1946) and Franz Karmasin in Berlin. Tuka was a professor of law and a radical HSĽS member, infamous for his antisemitism and hatred of the Czechs who had imprisoned him in the 1920s on charges that he was a Hungarian spy. Tuka presented himself shamelessly as the leader of the Slovaks, stressing that the mandate to speak for the Slovaks had been given to him by Czech courts and prisons.[140] He addressed Hitler with "mein Führer" and assured him that "the fate of the Slovak nation" would be in the hands of Hitler.[141]

Prague expected Tiso, the Slovak prime minister, to distance himself from the radicals, which he did not; at the second session of the Slovak parliament, from 21 to 23 February, he advocated the building of Slovak sovereignty in steps, but failed to present a concept for Slovakia's future relations with the Czech lands.

Prague decided to establish military control: during the night of 9 to 10 March 1939, President Emil Hácha (1872–1945) unseated Tiso and declared martial law on the territory of Slovakia.[142] The military action is referred to in the literature as Homola's putsch *(Homolov puč)*, named after the commander Bedřich Homola (1887–1943), who occupied Banská Bystrica for a

[139] Ian Kershaw, *Hitler* (London: Penguin, 2008), 474, 475.
[140] Kováč, *Dejiny Slovenska*, 214.
[141] Kováč, *Dejiny Slovenska*, 214.
[142] See Tomáš Pasák, *Emil Hácha (1938–1945)* (Praha: Rybka Publishers, 2007 (2)).

short time.[143] The decision to invade was correct in constitutional terms, but it was a political mistake: the Czech attempt to prevent a Slovak secession gave Germany a pretext to act. The order to mobilize was given on 12 March with the date of the invasion set for 15 March.

The Germans needed a Slovak to proclaim Slovakia's independence. On 13 March, Tiso met party officials in Bratislava to discuss the situation; Karmasin accompanied him to Vienna, from where he and Ferdinand Ďurčanský (1906-1974), a radical supporter of the Slovak state, flew to Berlin. Tiso had no choice: Hitler threatened him with a Hungarian invasion and occupation.[144]

As regards the Czechoslovak constitution, Tiso acted correctly and called President Hácha with the request to convoke the Slovak parliament, which Hácha did. Hácha and Foreign Minister František Chvalkovský (1885-1945) were ordered to Berlin. While they were on the train to Berlin, the Slovak Assembly convened in Bratislava on the afternoon of 14 March; Tiso asked the delegates to adopt the law of the foundation of the Slovak state, which they did "without discussion or visible joy".[145] The delegate Peter Zaťko (1903-1978) described the atmosphere in the assembly and the delegates:

"I was surprised how many of them were bewildered, perplexed, how many did not know what to do after Tiso's speech. ... Martin

[143] Kováč, *Dejiny Slovenska*, 210. From 1918 to 1919, Homola had fought as a Czechoslovak legionnaire in Siberia. For an assessment of the Czechoslovak army after the Munich Agreement see Miloslav Čaplovič, "Československa armáda medzi Mníchovom 1938 a marcom 1939 s dôrazom na Slovensko", in *Rozbitie alebo rozpad? Historické reflexie zániku Česko-Slovenska* (Bratislava: Veda, 2010), 111-126.

[144] Kershaw, *Hitler*, 476.

[145] Rychlík, *Češi a Slováci I*, 170.

Sokol, the chairman of the assembly, ... told me: 'I have to proclaim independence. I'll be happy if I don't fall over.'"[146]

Tiso presided over the new government as Prime Minister; Tuka was appointed Deputy Prime Minister, Ďurčanský occupied the Ministry of Foreign Affairs, and Ferdinand Čatlos (1895–1972) the Ministry of Defence. On the afternoon of 14 March, the Slovak state became a fact, but not because of "an emancipatory process of its citizens", as the propaganda of the *Ľudáci* later claimed.[147] The Slovak state was but a by-product of Hitler's aggression; his threat of a Hungarian occupation of Slovakia was a mere bluff – he and Ribbentrop had presented Tiso with faked evidence of Hungarian troop movements in the south.[148]

Around midnight on 14 to 15 March, Hitler received Hácha and Chvalkovský, surrounded by Ribbentrop, Göring, General Keitel, and members of his personal staff. He ranted that the entry of German troops was "irreversible", and Göring threatened that "his Luftwaffe would be over Prague by dawn, and it was in Hácha's hands whether bombs fell on the beautiful city".[149] Hácha fainted; Hitler's personal physician Dr Morell revived him with an injection. The Czech president signed the capitulation; on 15 March, Bohemia and Moravia became a 'protectorate' of the Reich. Eva 'Mimi'

[146] Kováč, *Dejiny Slovenska*, 217. Martin Sokol (1901–1957) was a Slovak parliamentarian and would join a resistance group in 1943.

[147] Kováč, *Slováci, Česi, Dejiny*, 78.

[148] For a documentation of the Slovak, Polish and Hungarian negotiations from 1938 to 1939 see Dušan Šegeš, Maroš Hertel and Valerián Bystrický (eds.), *Slovensko a Slovenská otázka v Poľských, Maďarských diplomatických dokumentoch v rokoch 1938–1939* (Bratislava: Spoločnosť Pro Historia, 2012).

[149] Kershaw, *Hitler*, 477. Hácha's account of his meeting with Hitler in Pašak, 86-90, and on http://www.fronta.cz/dokument/emil-hacha-zaznam-o-jednani-v-berline-v-noci-z-14-na-15-brezna-1939; accessed 11 April 2014.

Jiránková, who was born in Prague in 1921, remembers the occupation of her country:

> "Our lawyer called my father early in the morning, which woke me up. Father and I stood at the window of our flat on Masarykovo nábřeži at the Vltava and saw the German tanks. It was snowing heavily and the tanks were heading to the Castle. I was seventeen years old. It was the end of our lives, our way of life. When the Munich Agreement had been signed in 1938, we teenagers had not thought much about it; we went swimming, skiing – it was all talk to us. Now, it was reality. What shocked us most was that we had to give up our army, and that concentration camps were established."[150]

Former Czechoslovak President Beneš had been in Great Britain[151] since October 1938, seeking the Allies' recognition of the exile government as the legitimate representative of the Czechoslovak people. In a conversation with former Prime Minister Milan Hodža in October 1939, Beneš created the legend of the Slovak betrayal:

> "It is impossible that the Slovaks are not aware of what they have done. No Czech will ever forget this. For twenty years, we have done everything for the Slovaks and when we were in the worst possible situation, the Slovaks stabbed us in the back."[152]

[150] Josette Baer, "Surviving Totalitarian Regimes. An oral history interview with Mimi Jiránková and Nataša Lišková", *New Eastern Europe 4*, no. 1 (2014): 156-160; 157.

[151] For an analysis of the activities of the Czechoslovak exile government see Vojtech Mastný, "The Czechoslovak Government in Exile During World War II", in *Jahrbücher für Geschichte Osteuropas 27*, no. 4 (1979): 548-563.

[152] Dokumenty z histórie československej politiky, c. d., dok. č. 28, quoted from Kováč, *Slováci, Česi, Dejiny*, 78. Beneš did not mention this meeting in his memoirs, dating his conversation with Hodža to July: "On 20 July 1939, Dr Milan Hodža travelled from Switzerland to London to see me. We agreed on the basic points – as I then thought – of our political co-operation ... We shall neither discuss nor quarrel about the organi-

Czech citizens were divided: some conceived of the Slovak state as another German protectorate, whose conditions did not much differ from those in Bohemia and Moravia. Others believed in Beneš's *Dolchstosslegende* (legend of the stab in the back).[153] Four days after the declaration of sovereignty, on 18 March 1939, the Slovak government started to expel the Czechs: an estimated 62,000 to 63,000 Czechs had to return to the protectorate.[154] In the spirit of Masaryk's democracy, Czech teachers, civil servants, railway workers, professors and advocates had moved to Slovakia after 1918 to build the Republic's institutions. They considered Slovakia their home and their accounts of the expulsion must have added fuel to Beneš's legend of the stab in the back. At the end of the war, only 542 Czechs were living in Slovakia.[155]

On 23 March, the Slovak government had to sign the *Schutzvertrag* with Germany.[156] Radical members of HSĽS pushed forward a course of racist antisemitism. The pogrom in the western Slovak spa town of Piešťany[157] is a good illustration of the political atmos-

zation of the state (Slovakia, the Germans etc.). These issues will be decided later ... at home [*hlavně až doma*]. I just did not want to start a discussion about issues which, I feared, would immediately prompt conflicts [*rozpory*];" Edvard Beneš, *Paměti II. Od Mnichova k nové válce a k novému vítězství* (Praha: Academia, 2008), 98.

[153] Kováč, *Slováci, Češi, Dejiny*, 78; Rychlík, *Češi a Slováci I*, 200.

[154] Bystrický, "Vysťahovanie českých ...", 191. Bystrický's figures include the entire families of the Czechs expelled from Slovakia.

[155] Bystrický, "Vysťahovanie českých...", 197.

[156] Kováč, *Dejiny Slovenska*, 218. For a documentation of the *Schutzvertrag* and the deportation of Slovak labourers to the Reich see Michal Schvarc, Ľudovít Hallon and Peter Mičko, *Podoby nemecko-slovenského 'ochranného priateľstva'. Dokumenty k náboru a nasadeniu slovenskych pracovných sil do Nemeckej ríše v rokoch 1939–1945* (Bratislava: HÚ SAV, Fakulta humanitných vied UMB, 2012).

[157] Eduard Nižňanský, "Pogrom v Piešťanoch roku 1939", in *Z dejín demokratických a totalitných režimov na Slovensku a v Československu v 20.*

phere created by the HG and German fascists. The pogrom occurred on 1 March 1939, when Slovakia was still a part of the common state.[158] Nobody was killed, but Jewish citizens were temporarily interned in a cellar and Jewish shops looted.

On 29 March, Slovak citizens critical of the new regime were deported to the Ilava prison[159] near Žilina. On 9 September 1941, the government issued the Jewish codex, which deprived Jewish citizens of their civil and religious rights. On 15 May 1942, a further constitutional law was adopted: the Slovak Jews lost their citizenship, which justified their deportation to the concentration camps in Poland and Germany.[160]

The Tiso government was under no pressure from Germany and paid the Reich 500 reichsmark for every deported Jew.[161] The Germans told the government that the Jews would be deported to labour camps, but this does not diminish the government's full responsibility for the violation of the Jews' civil rights and the confiscation of their property. Starting in February 1942, approximately 60,000 Slovak Jews were deported, among them the student Rudolf Vrba (Alfred Rosenberg, 1924–2006) from Topolčany and the worker Alfred Wetzler (1918–1988) from Nitra. They would escape

storočí. Historik Ivan Kamenec 70-ročný (Bratislava: HÚ SAV, Prodama, 2008), 77-93; 78.

[158] An excellent movie portraying the activities of HG and the antisemitic atmosphere in the Slovak state is *Obchod na korze* (*The Shop on Main Street*); http://www.imdb.com/title/tt0059527; accessed 6 May 2014. The Czechoslovak film won the Oscar for the best movie in a foreign language in 1963.

[159] Ilava is a former monastery complex in the north-western district of Trenčín; today, it is Slovakia's second largest high-security prison; http://www.zvjs.sk/?ustav-vykonu-trestu-vykonu-vazby; accessed 11 April 2014.

[160] Kováč, *Dejiny Slovenska*, 228.

[161] Kováč, *Dejiny Slovenska*, 228-229.

from Auschwitz in April 1944 and inform the Allies about the camp.[162] In the early autumn of 1942, the thirty-year-old Chaviva was training in Palestine to prepare for fighting in her native Slovakia.

III. 2 A Slovak Jew and a patriot

Chaviva Reiková was born Adele Rosenbergová on 21 July 1914 in the Upper Hungarian town Sajóháza (today Nadabula in Slovakia), located between Banská Bystrica and Košice.[163] Her parents moved the family to Radvaň in 1921. After compulsory education, she studied at the Banská Bystrica business school (*obchodná škola*) from 1929 to 1931. Because of financial problems, she had to leave the school and then worked in various functions at Norberg's, a company dealing in hardware.

Adele was described as being always on the move, going to Hebrew lessons on her bike – she had never a free minute.[164] She was an ardent adherent of Zionism and the leader of *Somrim*, a group of young Jews in *Hašomer Hacair* (Protection of the Young), the Jewish scout movement; she was also active in the Jewish National Fund *Keren Kaymeth Leisrael*.

With the foundation of the Slovak state, the institutions and media of the Zionist movement were the first to be liquidated.[165] Adele left for Bratislava to support the local branch of *Hašomer Hacair* and worked also at the secretary's office of the Central Zionist Association. In September 1939, she and some ten young Slovak

[162] Vrba and Wetzler's report on http://www.holocaustresearchproject.org/othercamps/auschproto.htlm; accessed 11 April 2014.
[163] Zlatica Zudová, "Žena menom Chaviva", *Smer*, 18 May 1990, 12; http://www.wertheimer.info/family/GRAMPS/Haapalah/ppl/c/f/bc99ecd717b332009fc.html; accessed 11 April 2014;.
[164] Zudová, 18 May 1990, 12.
[165] Zudová, 18 May 1990, 12.

Jews left for Palestine; they stayed at the kibbutz *Meanit* and tried to improve their meagre income with the production of etheric oils and various handicrafts. They also worked in a stone quarry. She changed her name to Chaviva. In 1941, she joined the *Hagana* (Defence) and a year later the *Palmah* (striking forces), the Haganah's commando unit.[166] Her initial training was at the foot of Mount Carmel;[167] she criss-crossed Palestine with her platoon and accomplished an officer's training course in Galilee in the winter of 1942 to 1943. Under the name of Ada Robinson, she became a member of WAAF (Women's Auxiliary Air Force), a section of the RAF. She and another young woman were the only female soldiers; with 29 men, they attended a further training course in Egypt. The Jewish Agency had started negotiations with the British in 1942 to send its soldiers to train at the RAF base in Cairo. The SOE was in contact with the Palmah, and young Jews from the occupied countries of Central Europe volunteered to fight with the Allies.

Chaviva married Raphael Reisz, a friend and confidant from Slovakia, most probably in the kibbutz in Palestine. The date is unknown. The two of them were also very close to Zwi Ben Yakov, a native of Bratislava, and Chajim Chermes, born in Banská Bystrica.[168]

At the beginning of 1944, Raphael left for Yugoslavia to join Tito's partisans, most probably as part of an SOE operation. On his way back to Palestine, he learnt about the planned uprising in Central Slovakia.[169] This was an opportunity to save the few surviving Jews in Slovakia. It was decided that the four volunteers would be dispatched to Slovakia under the command of H. M. Seymour, also

[166] Zudová, 18 May 1990, 12.
[167] Bernhard Reich and David H. Goldberg, *Historical dictionary of Israel* (Scarecrow Press: Lanham, Toronto, Plymouth, 2008 (2)), 375.
[168] Zudová, 18 May 1990, 12.
[169] Zudová, 18 May 1990, 12.

known as Sehmer or Schennor. London informed them about the details of the operation: the men would parachute into Slovakia, while Chaviva would not be allowed behind enemy lines, because she was a woman.

According to the official SOE policy, women were not to be sent on missions in Nazi-occupied territories, but the reality was quite different: female SOE agents were parachuting on a regular basis behind enemy lines, most of them into occupied France. A possible explanation is that the SOE was concentrating its efforts on France and was not very familiar with the planning of the Slovak National Uprising and the Slovak territory.

On 14 September 1944, the three men flew out from the RAF airbase Campo Casale near Brindisi, Italy, and landed in the north of Považská Bystrica, which was in German-occupied territory. After a week, they managed to reach the area of the uprising in Central Slovakia. On 17 September, Chaviva and a platoon of US soldiers from the OSS (Office of Strategic Services) flew from Bari in Italy to the Tri duby airport, which was in the area already liberated by the uprising.[170]

This was Chaviva's home, the part of Slovakia she had grown up in; it remains unclear when she learnt that her mother, brother and sister had been deported to a concentration camp, but, in psychological terms, I deem it likely that this terrible news had reached her in Palestine and prompted her to join the Jewish underground army, training with the British to fight in her native Slovakia. Why leave the relative safety of the kibbutz if not to return to Europe to take revenge?

She and her group, which was called AMSTERDAM, established contact with the British military mission in Bari from Pod-

[170] Zudová, 18 May 1990, 12; Soňa Švacová, *Humanistické tradície v literárnom odkaze Slovenského národného povstania* (Banská Bystrica: ŠVK, 2004), 33-34.

brezova and reached Banská Bystrica, the centre of the uprising, around 21 September 1944.[171] Little did Chaviva know – little does anybody in such a situation know – that she would have only two months left to live.

III. 3 Women in the Slovak National Uprising (SNP)

The historian of law Katarína Zavacká[172] has a convincing explanation for the fact that the SNP happened at all: compared with Germany and the Soviet Union, totalitarianism could not take deep-seated roots in Slovakia, paradoxically because of the regime's lack of ruthlessness. In its efforts to establish a totalitarian state, the Tiso regime overestimated its ideological power and attraction. It was simply not as thorough as the Nazis and Stalin. The government and the HSĽS hierarchy failed to understand that they had to rid themselves of a large number of qualified personnel.

The Slovak process of *Gleichschaltung* was not as absolute as the German and Soviet totalitarian systems. Party officials thought that those Slovaks who had been trained by the Czechs in the First Republic and were in the state's service since the forced declaration of independence in March 1939 were as committed to the Slovak state and its ideology as the party elite and the government were. They were wrong in their belief that the mere liquidation of the political opposition would be sufficient.[173]

[171] Jiří Šolc, "Na italské a balkanské fronte", in *Bylo málo mužů* (Praha: Merkur, 1990), 237-269; 250.
[172] Katarína Zavacká, "Totalitarian systems in Czechoslovakia as liquidators of the rule of law", in *Slovak Contributions to 19th International Congress of Historical Sciences* (Bratislava: Veda, 2000), 85-99; 87.
[173] Zavacká, "Totalitarian systems ...", 87.

With the Red Army advancing, people started to switch sides and join the partisans. A further factor that led to the increasing resistance against clerical fascism was the Czechoslovak exile government, regularly broadcasting on the BBC. In spite of the fact that listening to the BBC was a capital offence, the broadcasts of President Beneš and Jan Masaryk (1886–1948), foreign minister and the president's son, were a source of psychological comfort, boosting the resistance of Slovaks and Czechs alike; they knew that the exile government was committed to fighting the Germans and the Tiso regime – and to restoring Czechoslovakia after the war.

Analysis of the SNP has been established by Slovak historiography.[174] The role of women in the uprising is less known; a brief summary will put Chaviva's activities into the historical context.[175]

In every country occupied by Nazi Germany resistance grew stronger after the Allies had landed in Normandy on D-Day, 6 June 1944. Also, the attempt on Hitler's life of 20 July 1944 that high-ranking Wehrmacht officers had planned and carried through,

[174] Marxist-Leninist historiography ascribed all the credit for the SNP to the members of the Communist Party, systematically ignoring the activities of centre-right politicians and non-Communist resistance groups. Recommendable are Jozef Jablonický, *Z illegality do povstania. Kapitoly z občianskeho odboja* (Banská Bystrica: Múzeum SNP, 2009 (2); Jablonický could publish his independent research in the liberal atmosphere of 1969; his book has been re-edited in 2009. The latest analysis is Miroslav Pekník (ed.), *Slovenské národné povstanie 1944. Súčať europskej antifašistickej rezistencie v rokoch druhej svetovej vojny* (Bratislava: Veda, 2009).

[175] Terézia Kováčiková, "Ženy v národnooslobodzovacom zápase (1939–1945)", in *Zborník múzea Slovenského Národného Povstania 7* (Osveta: Martin, Múzeum SNP v Banskej Bystrici, 1982), 5-24. Kováčiková puts too much emphasis on the achievements of the Communist Party, but she provides important information about the conditions of women in the Slovak state and the SNP.

raised the hopes of the oppressed. German officers, aware that they were losing the war, were eager to get rid of the Führer in order to start peace negotiations with the Allies.

The attempt failed and Hitler survived. London broadcast on 6 August 1944 that the Red Army had reached the Carpathian mountains; on 29 August, Germany sent troops to occupy Slovakia, officially an allied state. President Tiso agreed with Hans Eluard Ludin (1905–1947), the German ambassador to Slovakia, to muster troops to block the advance of the Red Army and fight the partisans in the Tatra and Beskydian mountains. The German occupation of Slovakia on 29 August 1944 was the initial spark for the uprising.

Most touching in my research was a list of the women who fought in the uprising, which the Nazis managed to put down by November 1944 only with the support of additional troops called in from Hungary. Women of every social class and profession put their lives at immense risk: doctors, nurses, factory workers, housewives, teachers, farmers, civil servants, students, journalists and editors. If captured by the Germans, a cruel fate awaited them: torture, execution or deportation to a concentration camp, with a minimal chance of survival. Some survived, many died.

Very sad is the fate of the Chuťka family: of the two parents and three daughters, only the father Michal (1898–1964) and one daughter Elena (1924–) survived. The mother Katarína (dates unknown) and the daughters Katarína (1927–1945) and Margita (1922–1945) were executed by the Gestapo in March 1945.[176]

Referring to the Tiso regime as clerical fascism (*klerofašism*), which I think is an apt concept, Terézia Kováčiková divides the SNP into three phases: the first phase started with the outbreak of war in 1939 and lasted until 1941, the German attack on the Soviet Union. Phase two started in 1941 and lasted until the

[176] *Dejiny SNP 1944, 5. sväzok* (Bratislava: Pravda, 1984); Kováčiková, 21.

weeks preceding the uprising, and phase three is dated from 29 August 1944, the start of the uprising, and ends in May 1945, the end of the war in Europe.[177]

Women were active in the women's association of HSĽS, the Hlinka Youth, but also in the forbidden Slovak Communist Party KSS, the Catholic Women's association and *Jednota*, the Evangelical women's association. Women and members of the national and cultural minorities were systematically discriminated against; in 1939 the regime issued law no. 246/1939, banning married women from work: they had to leave their positions in schools and the civil service.[178]

Bereft of the civil and political rights they had enjoyed in Masaryk's Republic, Slovak women were also increasingly angered by the food shortage and their discriminatory treatment in the healthcare system. In March 1941, the regime issued constitutional law no. 66/1941 that forbade abortion.[179] The law had a similar goal to that of the SS programme of *Lebensborn*.[180] The idea to

[177] Kováčiková, 5.
[178] Kováčiková, 7.
[179] Kováčiková, 9.
[180] *Lebensborn* on https://www.jewishvirtuallibrary.org/jsource/Holocaust/Lebensborn.html; accessed 4 May 2014. From a Nazi viewpoint, the Slovaks were Slavs, *Untermenschen*, but a useful ally as long as the war was going on. They were no Aryans and would be dealt with later. Hitler revealed his plans for depopulation of the Slavs in a conversation with the Prussian diplomat Hermann Rauschning (1887–1982) in 1934: "What, you may ask, does depopulation mean? Do I propose to eliminate whole population groups? Yes, indeed, something like that will have to be done"; Rauschning, Gespräche mit Hitler, 128 f, quoted from Diemut Maier, *"Non-Germans" under the Third Reich. The Nazi Judicial and Administrative System in Germany and Occupied Eastern Europe, with Special Regard to Occupied Poland, 1939–1945* (Baltimore, London: Johns Hopkins University Press, 2003), 624. The anti-abortion law issued by the Slovak government did not mean that

determine how women had to spend their lives originated in Catholic conservatism: Slovak women's lives should centre around the three Cs, that is, cooking, children and Catholicism; they should produce more children for the fight against Bolshevism. With the continuing war and the prices for food rising, women increasingly took to the streets, initiating strikes and protesting against the regime.

Following the formation of partisan groups in Central Slovakia in the summer of 1943, peasant women in the countryside supported them with the usual female activities such as providing food, medical assistance, washing and clothing. When the uprising began, women of all social classes and origins participated; their role models were the Soviet women and girls who were fighting as partisans in the Red Army.[181]

Two groups of women fought the Germans and the Tiso regime: first, the women who joined the 1st Czechoslovak Army Corps in the Soviet Union. This was formed by Czechs and Slovaks, mostly Communists, who had fled to the Soviet Union when the Slovak state came into being. The second group consisted of women and girls who supported the partisans in the mountains as couriers and radio operators. The 1st Army Corps was led by General Ludvík Svoboda (1895–1979), a veteran of WWI; Svoboda would be elected Czechoslovak President in 1968. 55 women were active in the corps as nurses, doctors, snipers, couriers, translators, editors and radio operators; the unit fought with the Red Army in Charkov and Kiev and later in Slovakia. Others parachuted into Slovakia with the 2nd Czechoslovak Paratroop Brigade.

the Germans considered the Slovaks as their equal, as Aryans; the law simply met the interests of the Catholic church and the clerical-fascist government. The Tiso regime and the Nazis had common enemies: the Bolsheviks, modernity, democracy and the emancipation of women.

[181] Kováčiková, 17.

Of 14,500 partisans fighting in the uprising, 10,384 were Czechoslovak citizens, 4500 of other European nationalities; the Czechoslovak citizens numbered 10,220 men and 164 women.[182] The international element of the uprising is visible in the nationalities of the women who engaged in battle: Czech, Russian, French, Hungarian and Polish. The Germans showed no mercy and took cruel revenge after the oppression of the uprising: more than four hundred women were interned in Banská Bystrica prison.

Two examples demonstrate what those fighting in the SNP had to expect: for her support of the partisans, Karolína Bullová was burnt in her house; in Kocihská Dolina, in the county of Rimavská Sobota, the Gestapo shot the sisters Agneša Halajová, Emília Pupalová and Margita Šuleková, all mothers of young children.[183] 4000 victims were buried in 176 mass graves, among them 211 children and 720 women; in the mass grave found in the village of Kremnička, 233 women were among the 604 victims murdered by the Germans.[184]

III. 4 Chaviva's last days

Chaviva's activities in the SNP are known, but not in detail. We have one eyewitness, Mrs Alice Dubova, formerly Bruder, née Steiner, from Bratislava, who had met Chaviva in a cabin in the mountains.[185]

Alice had worked in a hardware shop when Czechoslovakia was dissolved in 1939. She managed to get a fake identity card (*Taufbrief*) that concealed her Jewish origins. Thanks to her good command of German, she was able to find a position in a company

[182] Kováčiková, 18.
[183] Kováčiková, 21.
[184] Kováčiková, 21.
[185] Dubova, 9.

trading in timber;[186] the timber industry was important to the Reich's war effort, so Alice's position was safe. Since her husband was a civil engineer, the regime considered him as *wirtschaftswichtig*, important for the economy; he received a special legitimation issued by Tiso, which protected them from being deported. The special legitimation allowed them to go on holidays; in August 1944, they left for Liptovský sv. Mikuláš to spend two weeks in the lower Tatra.[187] Alice recalled that feeling of freedom and happiness with the start of the uprising. After two weeks, however, the Germans reconquered Mikuláš; Alice and her husband fled with the partisans to the mountains. They ended up in a little cabin, where Chaviva and two English soldiers were operating a radio transmitter.

Chaviva was not only broadcasting, but also occupied with organizing a Zionist group that helped the few remaining Jews in Banská Bystrica with clothing, food and shelter. She was a principal figure in the military training of young Jews, who would form a Zionist partisan group.[188] She and her co-fighters had left for the mountains on 27 October 1944, where Alice had met her in the cabin. On 31 October, German platoons attacked the cabin and many of her group died. The Germans arrested Chaviva, Raphael and the few survivors and interned them in the prison of the district court building in Banská Bystrica.[189] Chaviva was prisoner no. 392 and did not hide that she was Jewish. The Gestapo's interrogation methods were notoriously brutal; after twenty days of torture, she, Raphael and the other prisoners were transferred to Kremnička, where they were shot on 20 November 1944.

[186] Dubova, 5.
[187] Dubova, 7.
[188] Zudová, *Smer*, 25 May 1990, 2.
[189] Zudová, 25 May 1990, 2.

III. 5 Conclusion

Of the Slovak Jewish platoon that fought in the uprising, only Chajim Chermes survived; he moved to Palestine after the war. Chaviva and Raphael's bodies were exhumed from the mass grave in Kremnica in April 1945 and transferred to the Olšany cemetery in Prague, where they were buried in the Royal Air Force section.[190]

At the request of the Israeli government, their mortal remains were transferred to Israel; Michael Dekel (1920–1994), a representative of the Israeli Ministry of Defence, and Dan A. Reisz, Raphael's brother, arrived at Prague airport in a special El-Al plane. Hundreds of Prague Jews paid their respects to Chaviva and Raphael. On 11 September 1952, they were buried with full military honours on Mount Herzl.[191]

Chaviva's courage is remembered in the Slovak book *Chaviva*, edited by David Goldstein and published in 1947 by the Central Zionist Union. In Israel, a kibbutz, an educational institution and a ship that brought survivors from the Shoa to Palestine in 1946 carry her name.[192] Since 1994, the Israeli Institution *Givat Haviva* has issued the annual Chaviva Reik peace award.[193] Streets in the USA and Canada are named after the courageous young woman.

[190] Zudová, 25 May 1990, 2.

[191] Zudová, 25 May 1990, 2.

[192] The ship *Haviva Reik*, no. 115, registered as *Agios Andreas*, departed from Piräus, Greece, on 28 May 1946 and reached Palestine with 462 persons on board on 8 June 1946; see http://paulsilverstone.com/immigration/Primary/Aliyah/ShowShip2A.php?shipno=115&pic=ShipPix/115.%20Haviva%20Reik%20at%20Haifa%20%20CZA.jpg&shipname=%3Ci%3EHaviva%20Reik%3C/i%3E&rowno=16; accessed 5 May 2014.

[193] The foundation's webpage is http://www.givathaviva.org.il/english/; accessed 5 May; see also http://web.archive.org/web/20071014043203/; http://www.givat-haviva.net/htm/01_aktuelles/download/HRP_Doku.pdf; accessed 5 May 2014.

Was Chaviva a Slovak patriot? Yes. As a Zionist, she could have stayed in Palestine, worked in a kibbutz and fought in the Palmah, since Jews were threatened in Palestine too. She could have witnessed the foundation of the state of Israel in 1948, completed her education with a university degree, had children or gone into politics like Golda Meir (1898-1978), a native of Ukraine.[194] She could have led the normal life of a modern young Jewish woman of European descent, who had made Palestine and then Israel her home. But Chaviva decided to return to her native Slovakia to fight the Germans and the Tiso regime, which proves her commitment to her country of origin.

[194] On Golda Meir's life see http://www.jewishvirtuallibrary.org/jsource/biography/meir.html; accessed 29 May 2014.

IV. Anna Štvrtecká (1924–1995) – a courageous historian

"'Many of our scientists who were involved in the destruction of society and the social order in 1968 and 1969 will not be able to publish or write ...' The directors [of the departments of the Slovak Academy of Sciences, add. JB] were responsible for strict compliance with these orders; the Party insistently issued recommendations on how to organize the enquiries in such a way that 'not the slightest mistakes or errors could slip into the editing procedure, not even those caused by lack of information'."[195]

IV. 1 The historical context

If Chaviva fought in the uprising, Anna Štvrtecká, née Hučková, a member of the Communist Party since her participation in the SNP, would prove her courage by criticizing the politics of normalization, the establishment of the *status quo ante 1968*. To understand the full implications of her acts we should have a brief look at what the Prague Spring and its oppression meant to Czechoslovak citizens.

After the Communist coup d'état on 25 February 1948, the brutal years of political sovietization and economic collectivization started under President Gottwald. The goal was to make the Czechoslovak citizens toe the Party line dictated by the Soviet Union, which also meant to reject participation in the Marshall Plan in

[195] ÚA SAV, f. RO SAV, l. 80, Zasadnutie Predsedníctva SAV s riaditeľmi-veducími pracovisk SAV 28. 2. – 29. 2. 1972, quoted from Adam Hudek, "Obdobie 'konsolidácie' a 'normalizácie' 1969–1989", in *Dejiny SAV* (Bratislava: Veda, 2014), 169-196; 176-177.

1948.[196] The Party's main objective was to extinguish any criticism and make the state a loyal member of the Soviet bloc. The terror of the early years of the Communist regime peaked in the show trial of Slánský and Clementis in 1952 and the subsequent trials of the 'Slovak bourgeois nationalists' Gustáv Husák (1913–1991) and Ladislav Novomeský (1904–1976).[197]

From 1957 on, Antonín Novotný (1904–1975) governed Czechoslovakia with an iron fist; fear ruled in Czechoslovakia, in spite of the *thaw*, the short-termed liberalization emerging after Nikita S. Chruščev's (1894–1971) critique of Stalin's crimes at the

[196] For a collection of documents about the Cold War starting with the Marshall Plan see Gale Stokes, *From Stalinism to Pluralism. A Documentary History of Eastern Europe since 1945* (New York: Oxford University Press, 1991).

[197] Slánský and Clementis were executed in December 1952; in 1954, Husák was sentenced to life imprisonment, and Novomeský received a ten-year prison sentence. Only nine years after his release from prison, Husák would be elected General Secretary of KSČ on 17 April 1969, replacing Dubček as the state and Party's most powerful politician. For an assessment of Husák's extraordinary talent for political survival, his superb understanding of Soviet politics, his complete lack of moral principles save for power and his talent for tactical moves see Zdeněk Doskočil, "Cesta Gustáva Husáka k moci (1963–1969)", in *Český a slovenský komunismus (1921–2011)* (Praha: Ústav pro studium totalitních režimů, 2012), 156-173. See also the excellent political biography of Husák by Slavomír Michálek, Miroslav Londák a kol., *Gustáv Husák. Moc politiky. Politik moci* (Bratislava: Veda, 2013). Very recommendable about Clementis are Zdenka Holotíková and Viliam Plevza, *Vladimír Clementis* (Bratislava: Vydavateľstvo politickej literatúry v edícii Postavy slovenskej politiky, 1968); in 1972, a censored edition was published by the Pravda publishing house. On Novomeský see Miroslav Pekník and Eleonora Petrovičová (eds.), *Laco Novomeský. Kultúrni politik, politik v kultúre* (Bratislava: Veda, 2006).

XX Party Congress in 1956.[198] Novotný's regime provoked increasing criticism from party members, who recognized that the economy required urgent reform. Two reasons eventually led to Novotný's forced abdication as First Secretary at the Party meeting in January 1968: first, his refusal of economic reforms, and second, his personal involvement in the show trials of the 1950s. He had no interest in supporting the investigating commissions. Most of the prisoners were released in the early 1960s and rehabilitated in 1963.

The Slovak Communist Party KSS had emerged in 1939, when the Communists saw themselves forced to reorganize; many Czech leaders of KSČ had fled to Moscow to evade persecution by the Germans in the protectorate.[199] KSS was not an autonomous party, let alone independent; during the war, it was in line with KSČ that received its orders from Stalin.

The years of limited democracy from 1945 to 1948 were dominated by the politics of the National Front, a system that excluded opposition and united all political parties, save for HSĽS and

[198] An interesting account of the way Slovak citizens reacted to the deaths of Stalin and Gottwald in March 1953 can be found in Marína Zavacká, "Whispered rumor as a kind of independent political news service in Slovakia in 1953: People and state reacting on the death of J. V. Stalin and Klement Gottwald", in *Slovak contributions ...*, 229-240. A telling joke from those early years of Communism in an English version slightly corrected by me: "A citizens buys *Pravda* on a regular basis, day after day, year after year. He always looks at the front page and then throws the newspaper away in disgust. Finally, one day the shop girl asks him what he is looking for. He replies: 'For an obituary.' 'But obituaries are always on page five', the shop girl instructs him. But the citizen knows better: 'The one I am waiting for will be on the front page.'" Zavacká, "Whispered rumor ...", 229.

[199] Stanislav Sykora, "KSS a čiastočná liberalizácia režimu na Slovensku počas predjaria (1963-1967)", in *Český a slovenský komunismus*, 132-144; 132.

the parties of the German and Hungarian minorities that had been banned. In March 1945, Stalin had invited Czech and Slovak politicians to Moscow; the four negotiating parties that signed the Košice Agreement (*Košický vládny program*) were the London exile government, Czech centre-right parties, the SNR and the Communists exiled in Moscow.[200] The intention of the National Front was to concentrate forces for the difficult post-war reconstruction, but did not allow for democratic rivalry between the parties. An idea and instrument of Stalin's, the National Front was subjugating the Central European states under Soviet control; the Communist Parties began to dominate the Front, occupying key positions such as the army, secret service and broadcasting, positioning themselves to assume power at a later point in time.

The SNR and the Democratic Party DS, a conglomerate of centre-right politicians, were the strongest representative institutions in Slovakia; they opted for self-government within the common state, which would have led to a federation. The negotiations[201] for a new constitutional arrangement started in May 1945 and ended in July 1946. KSS first supported the SNR, wanting to strengthen Slovak self-government, but the Communists were not as popular in Slovakia as the KSČ in the Czech lands.

After the victory of DS in the parliamentary elections of May 1946,[202] KSS joined forces with KSČ, weakening the SNR to a

[200] Stalin and Beneš were not involved in the negotiations. The Košice Agreement was declared on 5 April 1945 in the eastern Slovak town; the reconstruction of the Czechoslovak Republic had to be announced on territory liberated by the Red Army.

[201] The negotiations are referred to in the literature as First, Second and Third Agreement of Prague; for a detailed assessment see Kováč, *Dejiny Slovenska*, 248-253, and Rychlík, *Češi a Slováci II*, 27-51.

[202] Had KSS won the elections in 1946, it would have been on an equal footing with KSČ, hence in a position to negotiate for a federation or at least a power-sharing system when the Communists took control of

considerable extent. The three Prague Agreements demonstrated not only the failure of the Slovak non-Communist politicians and the SNR to drive a hard bargain at the negotiating table; a prospective federal constitutional status or at least minimal independence of the Slovak governmental institutions from Prague was not popular. Centralism as the belief that the state would be strong only if governed from Prague won the upper hand over considerations of constitutional equality of Slovaks and Czechs.

On 29 July 1948, KSS and KSČ merged; from then on, KSS was but an executive organ that realized on Slovak territory whatever KSČ decided in Prague, often to the disadvantage of the Slovak citizens. KSS could not even independently issue the calls for the meetings of the Central Committee and the presidency of the Central Committee – Prague had the last say in everything.[203] The Czech mistrust of the Slovak comrades, ever suspect of 'bourgeois nationalism' as a relic of the Slovak state, was the main reason for the centralization of the Party.[204]

The year 1963 presented a caesura in Czechoslovak domestic affairs: the two rehabilitation commissions, the Kolder Commission and the Barnabite Commission,[205] published their results

the country in February 1948. This is speculation, yet, considering that Husák and Clementis were the leading figures of KSS at the end of WWII, a victory of KSS in 1946 in Slovakia might have prevented the show trial against the 'Slovak bourgeois nationalists', saved Clementis' life and spared Husák and Novomeský torture and imprisonment.

[203] Sykora, "KSS a ... ", 132.
[204] Sykora, "KSS a ... ", 143.
[205] The Kolder commission was named after its chairman Drahomír Kolder (1925–1972) who would be one of the signatories of the letter submitted to the Brežnev government, asking the Soviet Union for military assistance against the reformers in August 1968. The Barnabite commission was named after the former monastery of the Barnabite order in the Prague district Hradčany, where the commission was

about the way the show trials in the 1950s had been organized and, more importantly, who had been involved. The reports led to a slow thawing of the totalitarian ice that was emerging in society. This thaw was not the result of reforms issued from above by the Party leadership, all the more so as the concealed critique of Stalinism had left behind a "vacuum of ideas": the old ideological norms and rules had collapsed, but new ones were not yet in sight.[206]

The commissions' reports, the Party's semi-official acknowledgement that injustice had been done in the past, prompted the hitherto predominant "barrier of fear" to crumble – the citizens were no longer afraid.[207]

A further consequence of the commissions were changes in personnel at the highest echelons of KSS: Party members compromised in the commissions' reports such as Karol Bacílek (1896–1974) lost their positions. Against the will of the almighty Novotný in Prague, the Central Committee of KSS elected Alexander Dubček (1921–1992) First Secretary on 8 April 1963 in a courageous emancipatory move.[208]

Dubček had been Secretary for Industry at the Central Committee in Prague from 1960 to 1962 and lost this position because of his rift with Novotný. He was from a good Communist family, had a spotless Party record, had grown up in Soviet Kyrgyzstan and

in session; Bystrický a kol., *Rok 1968,* 28. For analysis of the beginnings of the liberalization in the 1960s see Miroslav Londák, Stanislav Sykora and Elena Londáková, *Predjarie. Politický, ekonomický a kultúrny vývoj na Slovensku v rokoch 1960–1967* (Bratislava: 2002).

[206] Sykora, "KSS a ... ", 133.
[207] Sykora, "KSS a ... ", 143.
[208] Sykora, "KSS a ...", 134. For a selection of Dubček's speeches, articles and interviews see Jozef Žatkuliak and Ivan Laluha (eds.), *Alexander Dubček: Od totality k demockracii. Prejavy, články a rozhovory, vyber 1963–1992* (Bratislava: Veda, 2002).

fought as a partisan in the SNP; he would perform like a "Slovak politician", not a "politician in Slovakia".[209] His loyalty to the Communist cause was beyond doubt and he was expected to represent Slovak interests in Prague – not Prague's interests in Slovakia, as his predecessors Viliam Široký (1902–1971) and Bacílek had done in the past.

Novomeský and Husák, who had been released in 1960, openly criticized the Stalinist methods and beliefs that predominated in Party and government; Stalinism was the origin of the trials of the 1950s, and in their articles they were hinting at Novotný. The journal *Kultúrny život* (*Cultural Life*) became the platform of the critical voices of artists and writers.[210] Party members were also concerned with a constitutional change of Slovakia's status in the common state; Slovak institutions of self-government had been liquidated by the Gottwald government. From a Slovak viewpoint, Novotný was the symbol of Czech bureaucratic centralism and anti-Slovak resentment alike, his arrogance proof of the Czech feeling of superiority and contempt for the Slovaks. The First Secretary did nothing to rectify that perception – on the contrary.

Public anger peaked during Novotný's visit to Slovakia in August 1967.[211] He was supposed to attend the centenary festivities of the first Slovak *gymnasium* in Martin, which was a crucial date, remembering their resistance to Magyar oppression in the 19th century. Novotný refused to invite Slovak politicians and representatives of culture and art, which prompted Dubček to stay in Brati-

[209] Sykora, "KSS a ... ", 134.
[210] Kováč, *Dejiny Slovenska*, 281. About the journal and the intellectual atmosphere in the years of the harshest political oppression see Vlasta Jaksicsová, "'Pokolenie v útoku'. *Kultúrny život* v zrkadle ideologickej (ne)kultúry v rokoch 1948–1953", in *Slovensko v labyrinte Európskych dejín. Pocta historikov Milanovi Zemkovi* (Bratislava: HÚ SAV a Prodama, 2014), 424-441.
[211] Kováč, *Dejiny Slovenska*, 283.

slava in protest, boycotting the visit. Thousands of Slovak citizens awaited Novotný in the Martin national cemetery, where he should have laid a wreath to honour prominent Slovak *národovci*. He ignored the cemetery, did not show up at the hotel either and offended the cultural institution *Matica* with the words that it was a nationalist institution.[212] When half of the invited guests boycotted the festive lunch in protest, he left Slovakia the same day, threatening to have this matter investigated. His wife made an ostentatious show of returning the gifts they had received from the Slovak people.

The Party could not afford to have a politician in its leadership who was so obviously driving a wedge between Slovaks and Czechs. At the Central Committee meeting in December 1967, Dubček sharply criticized the conditions prevailing in the Party, which was losing touch with society. Novotný sought the support of Leonid I. Brežnev (1906–1982), but the Soviet leader who travelled to Prague on 8 December refused to get involved. His famous words *Eto vaše delo* (That's your matter) signalled that the Czechoslovaks should resolve this matter on their own.[213]

With opposition in the Party increasing, Novotný even considered calling in the army. He had lists prepared of those who should be arrested: Party members, intellectuals, army officers, officers of ŠtB (*Štátní bezpečnosť*, the domestic Czechoslovak State Security Service), scientists, writers and artists.[214] Yet, high ranking officers of the army and ŠtB wanted to get rid of him too; at the meeting of the Central Committee on 3 to 5 January 1968 he could no longer muster the support of the majority of the delegates.

The group of reform-minded Communists consisted of economists and intellectuals, whose intention was to reform the

[212] Kováč, *Dejiny Slovenska*, 283.
[213] Bystrický a kol., *Rok 1968*, 36.
[214] Kováč, *Dejiny Slovenska*, 284.

entire system, with the object of finding, within the ideological, economic and military confines of Marxism-Leninism, the COMECON and the Warsaw Pact, an independent Czechoslovak road to Socialism, which would become known as *Socialism with a human face*. The reformers had been grouping since the mid 1960s; in January 1968, they won the upper hand against the conservative bureaucratic faction, voting Novotný out and Dubček in.

Dubček was the first Slovak general secretary in the history of KSČ and quite different from his predecessors:

> "From him radiated what one calls the magic of charisma. He conquered people by taking a genuine interest in them and with a pure and direct smile. From his eyes sprang kindness and benevolence. He was not ashamed to admit that he did not know a thing. He was not a convincing speaker, rather the opposite, but it was wonderful that people believed him. For the first time, the people had a Communist leader before them who they felt had a human heart."[215]

The Prague Spring started.[216] Zdeněk Mlynář (1930–1997) remembered in his discussion with Michail S. Gorbačev (*1931), whom he had met at a Party cadre course in the Soviet Union in the 1950s, how the reform movement had started in the Soviet Communist Party and how Novotný had refused to replace the old Stalinist

[215] Jozef Banáš, *Zastavte Dubčeka! Príbeh človeka, ktorý prekážal mocným* (Bratislava: Ikar, 2009), 148.

[216] Recommendable are Gordon H. Skilling, *Czechoslovakia's Interrupted Revolution* (Princeton University Press: Princeton NJ, 1976), and Kieran Williams, *The Prague Spring and its Aftermath. Czechoslovak Politics 1968–1970* (Cambridge: Cambridge University Press, 1997). See also Dubček's memoirs, *Hope Dies Last. The Autobiography of Alexander Dubcek* (London: HarperCollins, 1993). For a chronology of events see *Rok Šedesáty Osmý. V usneseních a dokumentech UV KSČ* (Praha: Svoboda, 1969); the 'black book' edited by members of the Institute of History at the Czechoslovak Academy of Sciences, *Sedm pražských dnů. 21.–27. srpen 1968. Dokumentace* (Praha: Academia, 1990) and Bystrický a kol., *Rok 1968*.

party cadres with a young generation of reform-minded functionaries.[217] Dubček was the symbol of a new era.

Nataša Lišková who was seventeen years old in 1968 remembered the atmosphere of liberty: nothing could be compared to the Prague Spring, not the music of Jimi Hendrix or The Beatles or love at first sight.[218] Jo Langer on the Prague Spring and invasion in Bratislava:

> "It is difficult if not impossible to explain to a westerner why we sat in front of the TV in a trance of gratitude ... Total strangers exchanged smiles, listened to each other's transistor radios in the streetcar and discussed events. ... I felt the charm of all this. I wanted to rejoice so much that there were times when I almost did. ... I felt increasingly that this 'new socialism' was only skin deep. The Party remained infallible. ... I jumped out of bed and saw the boy [the boyfriend of Jo's daughter Tania who was serving in the military, add. JB] in the garden, asking with excited gestures to be let in. Shortly after leaving us he had run into a man who had shouted at him to hide for God's sake, uniformed as he was, because the tanks were rolling up our hill. . We could hear already the rumbling quite near and a few shots from afar. Then telephones started ringing all over town. 'Is it true?' – 'Are you mad?' – 'You must be drunk!' – 'It can't be!' Many who got the news thought it was a bad joke."[219]

The liberty of voicing one's opinion without being afraid of arrest, the possibility of travelling to the West, the abolition of censorship, the economic reforms that projected workers' involvement in the management of their factories, and, above all, the genuine impression that the government really cared about what the people thought – these intoxicating feelings of liberty and hope swept the

[217] Michail Gorbačov and Zdeněk Mlynář, *Reformátoři nebývají šťastni* (Praha: Victoria Publishing, 1995), 23-25.
[218] Baer, "Surviving ... ", 157.
[219] Langer, 214.

Czechoslovaks from their feet. They ended in the night of 21 August 1968.

IV. 2 Anna Štvrtecká, a Party historian critical of the Party

Anna Štvrtecká was born on 14 October 1924 in the Western Slovak community of Vaďovce in the Trenčin district into a farming family. She went to the *gymnasium* in Nové Mesto nad Vahom. From 1943, she was a teacher at various schools in the region and also a member of the resistance group led by Captain Miloš Uher (1914–1945),[220] who died fighting a German platoon in the SNP. From 1948 to 1953 she studied philosophy and history at Comenius University in Bratislava and concluded her studies with a doctorate.

Her talent for languages was extraordinary: she read texts in Latin, French, German and Russian. Besides her studies she worked in the library and administration of the Slovak Academy of Sciences and Art SAVU (*Slovenská Akadémie Vied a Umení*), which would later be renamed the Slovak Academy of Sciences SAV (*Slovenská Akadémie Vied*). After gaining her doctorate, she started her scientific career at the Institute of the Slovak National Uprising (*Ústav Slovenského Národného Povstania*), the future Institute of the History of KSS (*Ústav Dejín KSS*).[221]

[220] Michal Dzvoník, "Osud lojálneho občana", *Historická revue VI*, no. 8 (1995): 28-29. Dzvoník was a colleague of Anna's and knew her from the Institute of the History of KSS; he belonged to the reform-minded intellectuals who published in *Kultúrny život* and supported Husák in the early 1960s; Juraj Marušiak, "Slovenská spoločnosť a normalizácia", in *Česká a slovenská spoločnost v období normalizace. Slovenská a česká spoločnosť v čase normalizácie. Liberecký seminar 2001* (Bratislava: VEDA a Ústav politických vied SAV, 2003), 122.

[221] Michal Barnovský, "Za PhDr. ANNA ŠTVRTECKOU, CSc., (1924–1995)", *Historický časopis 43*, no. 2 (1995): 414-416; 414.

In her first study in 1954 she analysed Hungarian electoral practice and electoral laws; then she focussed on the history of the SNP and published two monographs: *The Activities of the First Illegal Central Committee of KSS (Činnosť prvého ilegálneho Ústredného výboru KSS)* in 1959 and *Ján Osoha* in 1970.[222] She contributed scientific articles to various studies about the SNP and Communist activities in the national fronts of Czechoslovakia, Poland and Yugoslavia.

Anna was a historian who had started her career in the dire years of early Communism and, as a participant in the SNP and Party member, she was most interested in the Party's history. But she was also aware how Stalinist historiography distorted the historical events, ignoring the efforts of the non-Communist groups fighting in the SNP, which resulted in scientific mistakes and errors; with the beginning of the liberalization in the early 1960s, she published several articles in newspapers and journals such as *Práca (Work)*, *Pravda (Truth)* and *Kulturný život (Cultural Life)*, concentrating on a revision of the history of the SNP. She represented Czechoslovak historians at several international conferences that took her to Milan, Berlin and Belgrade.[223]

In an article, Anna criticized the failure to realize the constitutional equality of Slovaks and Czechs as projected in the Košice Agreement – which angered Novotný to such an extent that he had her name deleted from the list of historians who had access to the Prague archives from 1963 on, in particular the archives of

[222] Barnovský, "Za PhDr. ANNA ŠTVRTECKOU", 415. Osoha (1901–1945) was a leading member of the Central Committee of the forbidden KSS during the war and wanted to incorporate Slovakia into the Soviet Union. A detailed account of Osaha's activities and political thought in Róbert Arpáš, "Metamorfózy vzťahu slovenských komunistov k československému štátu v rokoch 1939–1945", in *Český a slovenský komunismus*, 59-67.
[223] Barnovský, "Za PhDr. ANNA ŠTVRTECKOU", 415.

the former Barnabite monastery.[224] Her critical views about the trial of the 'Slovak bourgeois nationalists' would not yield the research results the Novotný regime deemed appropriate. With the Prague Spring in full swing, she left her position at the Institute of the History of KSS and got a job at the Institute of Political Science at the Philosophical Faculty of Comenius University in Bratislava. She submitted her thesis *Slovakia at the Crossroads of Political Systems* (*Slovensko na rázcestí politických systémov*) to obtain the title of a Candidate of Sciences and later her post-doctoral thesis, but she did not receive her rightfully earned diplomas. The political winds changed in the night of 21 August 1968, when Warsaw Pact troops began to occupy Czechoslovakia.

IV. 3 *Normalizácia* – the politics of normalization in Slovakia

The chronology of events leading to the invasion of 21 August has been analysed.[225] Let me therefore focus on the months after the invasion, when Anna stood up for the reform course.

The Czechoslovak people first heard the term *normalization* in Dubček's broadcast of 27 August, after he and his government had returned from Ukraine. The First Secretary conveyed a confusing message to the citizens, trying to convince them that not all of the Prague Spring was lost, but he was visibly under duress. The government's situation was immensely difficult, meandering between its projected reform course while trying to fulfil the stipulations it had signed in the Moscow Protocol:

[224] Dzvoník, "Osud ...", 28.
[225] The most detailed analysis is Jan Pauer, *Prag 1968. Der Einmarsch des Warschauer Paktes. Hintergründe – Planung – Durchführung* (Bremen: Edition Temmen, 1995).

"We are concerned to prevent any bloodshed, but this does not mean that we are going to passively subject ourselves to the current situation. On the contrary, we shall be doing everything, and we are convinced that we shall find the ways and means to do so, to develop and realize with all of you a policy, which eventually will lead to the normalization of the current conditions."[226]

No bloodshed, fine. But no passive submission either – would the government resist actively and how? What range of action did the Czechoslovak government have at its disposal? What did normalization exactly mean? To the Czechoslovak citizens, in particular the elder generations that had vivid memories of Masaryk's Republic and the civil liberties it had granted, Dubček's reform course had been a normalization *par excellence*, that is, strict application of the rule of law, abolition of censorship and the opening of the borders; in their way of thinking, the conditions under Novotný's Stalinism had been abnormal and the Prague Spring only a much-needed correction of a wrong course.

In Czechoslovak historiography, the concept of normalization connotes two distinct eras: first, the years 1968 to 1971, with the reconstitution of KSČ's full control of Czechoslovak society and, second, the period from 1968 to 1989 with the Soviet troops being the principal legitimation of the government.[227]

The only explanation and description of the normalization course could be found in the document issued by the Central Committee in December 1970, the infamous *Lessons Learned from the Critical Developments in Party and State Following the XIII Congress of KSČ* (*Poučenie z krízového vývoja v strane a spoločnosti po XIII. zjazde KSČ*).[228] The people conceived of the document as "the normalizers' simplistic catechism" and a "manifesto of neo-Stalinism"

[226] Bystrický a kol., *Rok 68,* 209-210.
[227] Marušiak, "Slovenská spoločnosť a normalizácia", 109.
[228] Kováč, *Dejiny Slovenska,* 300.

alike[229] that advocated the return to the old Stalinist methods of governing: oppression of civil rights, censorship, closed borders, Prague's dominance in Slovak matters and a centrally planned economy according to the Soviet model. Workers, teachers, scientists and intellectuals in leading positions had to publicly express their consent with the *Lessons*; those who refused lost their positions.[230]

The Soviet leadership's main reason to invade was based on its view that the Dubček government was losing control and a counterrevolution was in the making, with Western imperialist forces entering the country and disrupting the achievements of Socialism – which presented a threat to the entire bloc. According to Dubček,[231] the main reason for the invasion and occupation was the XIV Party Congress, which the reformers had planned for September 1968: the plenum of the KSČ, that is, all Party members, not just the executive Central Committee, was expected to vote for the *action programme* (*akční program*), the reform package of the Dubček government that should determine the political course for the next five years until the next Party congress would take place. The XIV Party Congress, which the reformers had scheduled a year early, would have provided the reform course with a legitimate nationwide basis, presenting a precedent and incentive alike for the other Communist Parties and nations in the Soviet bloc.[232] From a Soviet

[229] Kováč, *Dejiny Slovenska*, 300.
[230] Kováč, *Dejiny Slovenska*, 300.
[231] Alexander Dubček, *Leben für die Freiheit* (München: Bertelsmann, 1993), 257.
[232] Dubček's conviction that the XIV Party Congress would approve of his reform course conveys his honesty, true belief in Marxism-Leninism and, also, his naivety, which is very easy to say with hindsight. To be politically legitimate in terms of Socialist democracy, the reform course required the consent of the majority of the Party members. The Soviet Union, however, was not interested in reforming Marxism-Len-

viewpoint, so Dubček thought, the XIV Party Congress had thus to be prevented from coming into session.

The Soviet-Czechoslovak negotiations in Čierna nad Tisou on 1 August 1968 and the meeting of the general secretaries of the bloc states on 3 August in Bratislava, who signed a declaration about future cooperation and guarantee of Czechoslovakia's territorial integrity and independence on 4 August[233] were the last attempts to convince the Dubček government to initiate a radical change.

inism, on the contrary: after the 'aberrations' in East Berlin in 1953 and Hungary in 1956, she had to defend the Socialist hegemonic sphere in her fight against the Capitalist world. The Cold War was no time for experiments. Brežnev who used to address Dubček with the fatherly and somewhat condescending *Saša* had to consider the future of the bloc. Paraphrasing Lenin's saying that you can't cook an omelette without breaking eggs one could describe Brežnev's thinking as follows: if the omelette that was cooking in the pan (Socialism) should ever achieve perfection (Communism), the cook (Brežnev) had to chuck out the foul eggs (East Germany in 1953, Hungary in 1956 and Czechoslovakia in 1968), thrown mischievously into the pan by the Imperialist West. Like the other general secretaries, János Kádár knew the date of the invasion; only Romania's Nicolae Ceauşescu (1918–1989) refused to participate. Kádár had had ample experience with the Soviet way of treating her allies; he had been involved in the Hungarian uprising in 1956 and tortured by the AVO (*Allamvedelmi Osztaly*, the Hungarian domestic secret service) for his support of Imre Nagy's (1896–1958) reform course. After a bilateral Czechoslovak-Hungarian meeting in the border town Komárom/Komárno on the Danube on 7 August 1968, he almost desperately warned Dubček on the platform of the railway station with the words "Do you *really* not know the kind of people you are dealing with?" Bryan Cartledge, *The Will to Survive* (London: C. Hurst & Co., 2011), 476; Bystrický a kol, *Rok 68*, 179.

[233] Brežnev had warned Dubček on 1 August: "After these negotiations, we trust you, but do not dare to disappoint us. Otherwise, we would have to take the worst possible action;" Bystrický a kol, *Rok 68*, 171.

The Czechoslovak people were euphoric, believing that the compromise found in Čierna signified the bloc states' approval of the reform course. There would be no military invasion by the Warsaw Pact troops. Yet, while Brežnev, Władysław Gomułka (1905–1982), János Kádár (1912–1989), Walter Ulbricht (1893–1973), Todor Živkov (1911–1998) and Dubček were in session, members of KSČ's conservative wing submitted a letter to Brežnev, which is referred to in the literature as *pozývajúci list* (letter of invitation).[234]

Alois Indra (1921–1990), Drahomír Kolder, Antonín Kapek (1922–1990), Oldřich Švestka (1922–1983) and Vasil Biľak (1917–2014) signed, asking the Soviet leader for brotherly help and intervention, since the Czechoslovak government was no more capable of controlling the situation.[235] A second letter of invitation was signed by the Chairman of the Central Committee Kapek and addressed to Brežnev, asking him to extend brotherly help to the Party and the Czechoslovak people, as the current political situation posed a serious threat to Socialism in Czechoslovakia.[236]

The period of normalization started with the invasion and occupation.[237] The Czechoslovak citizens vehemently resisted the

[234] Bystrický a kol., *Rok 68*, 172.
[235] A copy of the original letter in Russian in Pauer, 196-197. The letter is typed and undated; it had most probably been written before the negotiations in Čierna; Bystrický a kol., *Rok 68*, 172-173.
[236] Bystrický a kol., *Rok 68*, 173.
[237] Historians give various dates for the beginning of the normalization, for example on Dubček's abdication on 17 April 1969, or even the constitutional law on the federation adopted in December 1970. According to Marušiak, the normalization started in the night of 21 August with the invasion, since from then on the Dubček government was no more at liberty to act independently; Marušiak, "Slovenská spoločnosť a normalizácia", 111. Sykora speaks of an 'intermezzo' that lasted from August 1968 to April 1969, dating the beginning of the

occupation, but when Dubček and the leading members of the government, who had been held captive in an unknown location in Ukraine, eventually signed the Moscow Protocol on 26 August 1968 the die was cast.[238] In a step-by step strategy, the conservative wing of the Party took matters in hand, executing Moscow's directives.

There were hopes that some reforms of the Prague Spring could be saved.[239] The situation was paradoxical and confusing: the

'hard normalization' on Husák's election as general secretary; Stanislav Sykora, *Po Jari krutá zima. Politický vývoj na Slovensku v rokoch 1968-1971* (Bratislava: HÚ SAV, 2013), 163.

[238] Bystrický a kol., *Rok 68*, 204-205. Brežnev agreed with Dubček on a 'compromise': the reformers could return to their functions in Party and government, but had to undertake radical changes that boiled down to a complete revision of the political and economic reforms. The action programme was a thing of the past.

[239] A good illustration of the citizens' psychological state and political views is the famous debate between Milan Kundera (*1929) and Václav Havel *The Czech Fate* (*Český úděl*) from January 1969. Since most members of the Dubček government were formally still in power, hopes that some reforms could be saved were not unrealistic. Kundera, a Party member, expressed these hopes, calling for optimism and the continuing fight for the civil rights the Czechoslovaks had been enjoying in the months preceeding the invasion. Havel, by contrast, had no illusions about the future; in his reply, he condemned Kundera's optimism and called for daily and peaceful protests; an English translation of the most important parts of the debate in my *Preparing Liberty in Central Europe. Political Texts from the Spring of Nations 1848 to the Spring of Prague 1968* (Stuttgart: ibidem, 2006), 140-164. Kundera's optimism would prove him wrong: he lost his job and Party membership and emigrated to France in 1975. In his famous essay "The Tragedy of Central Europe", Kundera elaborated on the occupation as an act of *de-Europeanization* of Czechoslovakia by its powerful Eastern neighbour. Russia's Asian despotism excluded her from Europe and European culture; *The New York Review of Books 31*, no. 26 (1984): 33-39. The essay prompted a lively debate among Western and Central European intellectuals about the meaning of the concept 'Central Eu-

people were still engaging in resistance activities, while the Czechoslovak army was not allowed to interfere, a stipulation of the Moscow Protocol. The government was trying to save as much of its reform politics as possible, acting seemingly independently and attempting to somehow circumvent the directives it had signed in the Moscow Protocol.

The federation was the only reform that survived the normalization, yet it was bereft of its true meaning to an extent that it almost presented an intrinsic contradiction. The federation granted Slovakia equal status with the Czech lands in the common state, whose new name was ČSSR. On 14 March 1968, the SNR had issued constitutional law no. 143/1968 about the federation; the Central Committee incorporated into law the action programme, which was adopted by the majority of the Central Committee members at the beginning of April.[240] The majority of the Czech reform Communists had spoken out for a wider democratization of society; they wanted to postpone the federation to a later point in time. The Slovak reform Communists, however, wanted the federation first, considering the constitutional equality of the Slovaks and Czechs the very basis of the democratization process. These differing viewpoints

rope'; see Czesław Milosz, "Central European Attitudes", *Cross Currents* 5 (1986): 101-108; György Konrád, "Is the Dream of Central Europe Still Alive?", *Cross Currents* 5 (1986): 109-121; Timothy Garton Ash, "Mitteleuropa?", *Daedalus 119*, no. 1 (1990): 1-21; Jacques Rupnik, "Central Europe or Mitteleuropa?", *Daedalus 119*, no. 1 (1990): 249-278, and Vladimír Goněc, "Z exilových diskusí 80. let: pojem střední Evropy", in *Česko-Slovenská historická ročenka 2012. Češi a Slováci 1993-2012* (Bratislava: Veda, 2012), 203-233.

[240] Kováč, *Dejiny Slovenska*, 290. The federation was declared at the end of October 1968, which made some centralists voice the absurd thesis that the Slovaks had achieved the federation, which everybody knew was not a real one, with the help of Russian bayonets; Kováč, *Dejiny Slovenska*, 290.

are referred to in the literature with the slogan *First democratization, then federation* (*Najprv demokratizácia, potom federácia*).²⁴¹

After the invasion, the federation was also subject to normalization: it existed only on paper since the Party did not federalize. Although institutions of self-government were established in Bratislava, the directives came from Prague, and positions were filled with functionaries loyal to the new regime, regardless of their national identity.²⁴² *De jure*, the state was a federation, but in reality

²⁴¹ Kováč, *Dejiny Slovenska*, 290.

²⁴² About the legal and political details of the establishment of the federation see Jan Rychlík, "Normalizačná podoba česko-slovenské federace", in *Česká a slovenská společnost v období normalizace*, 59-92. In the early 1970s, the Party dismissed all members suspicious of not strictly following its revisionist course; it recruited among the young and went to great lengths to shower those willing to join with a promising career in the state administration, scientific institutions and factories, material perks such as flats equipped with modern facilities and trips abroad included. One could describe the new cadres' thinking with the following slogans that distinguish the enthusiasm for Marxism-Leninism at the end of WWII from the 'realist' thinking of the 1970s: 'We are in power because we want to build Socialism' turned into 'Because we are in power, we want to build Socialism' – which epitomizes the post-68 lack of appeal of the Marxism-Leninist doctrine. The widespread absence of political motivation eventually led to the swift collapse of the regime in 1989; the Party cadres, used to slavishly following Moscow's directives, could no longer deal with the nationwide mass protests in November 1989. They simply did not know what to do. Because of the normalization, people considered Party membership a necessary nuisance to build their career and live a quiet life without constant harassment by the authorities, which is very understandable in psychological terms. The Party put pressure on coveted members *in spe*: according to Jozef Banáš (*1948), Czechoslovak diplomat to East Germany in the 1980s and today Slovakia's best-selling author, he joined the Party because his wife Mária was expecting their first child and they were in dire need of a flat with the facilities to bring up a baby, a supply of hot water, a bathroom and a functioning kitchen.

the old centralism was ruling again. The Central Committee elected Husák General Secretary on 17 April 1969; Dubček stepped down.

A brief look at some figures illustrates the despair of the citizens who withdrew from public life. The consumption of hard liquor, that is, drinks with an alcohol content of 40% and higher, increased dramatically after the occupation of 1968: in the Czech lands, in 1965 a citizen consumed an average of 2 litres of liquor per annum, in 1970 it was already 4.2 litres and in 1978 6.8 litres; the equivalent statistics for Slovak citizens' intake were: 4.3 litres in 1965, 9.5 litres in 1970 and 14.1 litres in 1978.[243]

The opposition in Slovakia was not as brutally persecuted as in the Czech lands, mainly because the protests against the Husák government in the Czech part involved many more citizens. Yet, it would be misleading to state that the majority of the Slovaks gained from the normalization or even supported it. Slovak citizens were subject to the *čistky* (purges) at the beginning of the 1970s as much as the Czechs. Many spoke out against the regime of the so-called realists, the conservative faction supporting Husák.[244] Among the protesters was Anna, who published in 1969 a call for solidarity of Slovaks and Czechs; she reminded her readers of the common history of the two nations and criticized the occupation as a violation of Czechoslovak sovereignty.

They had lived in a small room without these facilities before. I quote from my conversation with Banáš in 2011: "After the invasion of 1968, not even a dog in Slovakia believed in Socialism. I once even heard policemen making fun of the Husák regime in a pub."

[243] Marušiak, "Slovenská spoločnosť", 136.

[244] An excellent account of the opposition to the normalization and the persecution by the government see Jaroslav Pažout, "Trestněprávní perzekuce odpůrců režimu v období tzv. Normalizace (1969–1989) – factor stability a indikátor rozkladu kommunistického režimu", in *Český a slovenský komunismus*, 174-192.

IV. 4 Anna's critique of the normalization

In her article *The Slovak National Uprising and the Idea of the Czechoslovak State*, published in the newspaper *Life of the Party (Život strany)*,[245] the historian called for support for Dubček's reform course, protesting against the normalization. She did so with an admirable mastery of the art of circumventing censorship, driving home her point without drawing the attention of the censors to her text.

I think that Anna's text qualifies as *exoteric*. In his famous treatise *Persecution and the Art of Writing* the German-born political scientist and philosopher Leo Strauss (1899–1973) defined the exoteric text as follows:

> "An exoteric book then contains two teachings: a *popular teaching* of an edifying character, which is in the *foreground*; and a *philosophical teaching* concerning the most important *subject*, which is indicated only between the lines. ... Exoteric literature presupposes that there are basic truths, which would not be pronounced in public by any decent man, because they would do harm to many people who, having been hurt, would naturally be inclined to hurt in turn him who pronounces the unpleasant truths. It presupposes, in other words, that freedom of inquiry, and of publication of all results of inquiry, is not guaranteed as a basic right. This literature is then essentially related to a society which is *not liberal*."[246]

Anna concealed her critique of the normalization, that is, the *philosophical teaching indicated between the lines* as a historical essay about the SNP. She alternated the two teachings, weaving into the foreground text passages and sentences that hinted at the principal subject, her critique of the regime. If one does not read between the

[245] Anna Štvrtecká, "Slovenské Národné Povstanie a československá štátna myšlienka", *Život strany 36*, no. 35 (1969): 4, 11.

[246] Leo Strauss, *Persecution and the Art of Writing* (Chicago and London: The University of Chicago Press, 1988), 36, italics by me.

lines, the essay is a lengthy description of Czechoslovak history, focussing on the often complicated relationship of Slovaks and Czechs and the issue of the equal status of Slovakia after 1945. If one does read between the lines, the author's critique of the regime and the normalization is obvious. Let me present the most important passages that caught my attention.

After a brief introduction recapitulating the Munich Agreement and the subsequent dissolution of Czechoslovakia by Hitler in March 1939, Anna questioned the state's responsibility: how could the small country in the dangerous Central European region possibly have prevented its own destruction? Czechoslovak sovereignty, the pluralist political system, the political parties, the constitutionally granted liberty and the national and social policies (viz: the reforms of the Prague Spring) were too weak to resist the aggressive power politics of Germany (viz: the Soviet Union and the bloc states). The Soviet Union's decision to fight the Nazi regime convinced the Czechs and Slovaks who were deeply disappointed by the betrayal of the Western allies to look towards the East – "ex oriente lux" was then the slogan Czechoslovak citizens believed in; I think that this sentence is a part of the foreground text, since it makes no sense in the terms of 1968 and the normalization.[247]

By now, the attentive reader already understood that this text was not about the past, since Anna used key concepts that were as relevant for Czechoslovak politics after Munich as for the current situation in 1969: *great power* (*veľmoc*), *aggression* (*nasílie*), *old civilizational cultural and emotional connections with the West* (*staré civilizačné kulturnopolitické i citové zväzky so západnými krajinami*), *all layers of society* (*všetky vrstvy národa*) and *transformation* (*prebudovánie*). By cleverly setting markers in her text, that is, key concepts that hinted at the recent events and were

[247] Štvrtecká, "Slovenské Národné Povstanie", 4.

also used in the regime's 'realistic' newspeak the attentive reader could well understand the concealed message:

> "Although some politicians (viz: reform Communists) from the times prior to Munich (viz: the invasion) represented the rightful opinion that Czechoslovakia got into a critical situation (viz: invasion and normalization) only as a consequence of foreign pressure (viz: the occupation), simple people and, above all, the Party of the revolutionary proletariat KSČS (viz: the anti-reform wing of the Party), did not at all share this view."[248]

The Communists (viz: reform Communists), so Anna continued, were concerned with the future of the state, eager to embark on a course of transforming nation (viz: constitutional change to a federation) and society (viz: democratization). A few paragraphs further down, Anna addressed the illegal KSS (viz: the reform Communists) that had founded the SNR in 1943: the highest organ representing the Slovaks (viz: the SNR in 1968) adhered to the idea of the common state, which should be "reconstructed [obnovený]" on the principles of equality of the two nations (viz: the federation), projecting new, democratic, social, economic, educational and cultural policies (viz: the reforms of the action programme), but also a foreign policy oriented towards the Soviet Union (viz: the Dubček government's loyalty to the Soviet bloc).[249]

The ethnic and linguistic closeness of Czechs and Slovaks played a positive role in the re-building of the common state (viz: the reforms intent on building a new political system, *Socialism with a human face*). The SNR's declaration of the common state (viz: the true federation projected in the action programme) was a political act, yet it failed to formulate political guarantees to accommodate Slovak constitutional equality (foreground text); the issue of equality lacked a corresponding constitutional equivalent –

[248] Štvrtecká, "Slovenské Národné Povstanie", 4.
[249] Štvrtecká, "Slovenské Národné Povstanie", 4.

the old practice (viz: centralism) was repeating itself in a different historical situation (viz: now in 1969, with the federation being stripped of its democratic character by the normalization).[250]

The Communists (viz: the faction of the realists-normalizers) did not accept the federation as a state-building principle (viz: the re-building of the state into a federation); the Košice Agreement and the Slovaks' right to equality, which Husák back in 1945 had referred to as the *Magna Charta of the Slovak nation*, was a compromise that did not prompt any legal guarantees (foreground text).

In her conclusion, Anna addressed the current political situation with clear words: the adoption of the Czechoslovak federation in 1968 presented the end of half a century of struggle for the independent existence of both nations within the common state.[251] If the federation had come into being "in times of international and domestic difficulties, with Czechoslovak sovereignty on very unstable grounds [*v období mezinárodne i vnútorne tak komplikovanom, pre suverenitu cs. štátu tak labilnom*]", it was certainly determined by these difficult circumstances.[252]

It was in the general interest of society that the current conditions would join the two nations even tighter together. The uprising (viz: the reform course) had destroyed the dictatorship of the totalitarian Slovak state (viz: the Novotný regime); it had first and foremost fought a military battle (foreground text), but it had also laid the political grounds for the renewal of Czechoslovak democracy, a new political organisation (viz: democratisation) and a new social-economic policy (viz: the economic reforms projected in the action programme) that was orientated towards the "Socialist transformation of society [*socialistickému prebudovaniu*

[250] Štvrtecká, "Slovenské Národné Povstanie", 4.
[251] Štvrtecká, "Slovenské Národné Povstanie", 11.
[252] Štvrtecká, "Slovenské Národné Povstanie", 11.

spoločnosti]".²⁵³ The idea of democracy, individual and national liberty, social justice and cultural development had never ceased to be politically attractive to the Czechoslovak citizens.

Anna's essay qualifies as exoteric text, and three main goals or intentions can be found. First, the foreground text informs the reader about the history of the SNP, reminding him or her of the Slovak courage to have taken up arms against an inhuman and cruel regime. Second, the concealed main subject is Anna's critique of the normalization and occupation, woven into the foreground text. Third, she makes it perfectly clear that she is a Slovak patriot in support of the federation projected in the action programme of 1968. In the last sentence, she calls for peaceful resistance against the normalization.

The fact that a copy of the declaration of the SNR calling citizens to join the uprising on 1 September 1944 appeared in the centre of the page was common practise; the author added a document of proof and Anna was also listed with her full academic titles. Yet, in respect of the concealed subject, the copy might be interpreted as reminder and call alike: the Slovaks had proven courageous against an occupation in the past – why not do it again now with peaceful means protesting the normalization?

In a rough summary, one could therefore identify the SNP as the Dubček government's reform course and the call for resistance against the normalization. References to the Nazi regime are veiled references to the Warsaw pact troops' invasion and occupation.

According to Adam Hudek, it had been common practice to write and read between the lines since the second half of the 1960s. It was also easier and safer to conceal one's critique in a historical text, the SNP and the years of the First Republic being the most fre-

[253] Štvrtecká, "Slovenské Národné Povstanie", 11.

quently used.²⁵⁴ Furthermore, neither Slovak patriotism nor nationalism nor the support of the federalization were reasons for persecution. It was the normalizers under Husák who pushed through the federation; those supportive of Slovak patriotism in 1968 were not much interested in Dubček's democratization, but pragmatically hid their conservatism with reference to the need for the federation. Those who ceased to express their criticism of the regime once the issue of the federation was solved were left alone. The normalization government tolerated Slovak nationalism since it was not connected to the political regime.

Yet, so Hudek stressed, we cannot know what Anna thought of Husák in 1969 when she likened the leadership of KSS in the times of the SNP in 1944 to the reform government in 1968 and the opposition against the occupation in 1969. She could not yet know that one of the main representatives of KSS during the uprising would become the embodiment of the normalization, in particular the dysfunctional federation.

The abolition of censorship in June 1968 had prompted a wave of independent historical analysis, correcting the most obvious lies and misleading interpretations of the Czechs and Slovaks' past the Party had systematically applied to historiography since 1948.²⁵⁵ Anna's main intention was to remind the reader of Slovak

[254] Discussion with Hudek in Bratislava, July 2014. See Samo Falťan, *Slovenská otázka v Československu* (Bratislava: Vydavateľstvo politickej literatúry, 1968); Ľubomír Lipták, *Slovensko v 20. Storočí* (Bratislava: Vydavateľstvo politickej literatúry, 1968). I thank Hudek for recommending these studies to me.

[255] For an analysis of KSČ's doctrine on scientific research from the 1930s to the collapse of the regime see Antonín Kostlan, "KSČ a věda. Hlavní koncepty vědní politiky v Československu 1945–1989", in *Český a slovenský komunismus*, 239-249; with a focus on Slovak scientific institutions Adam Hudek, "Dilemy kommunistického pristupu k vedeckej politike na Slovensku v 50. rokoch 20. storočia", in *Český a slovenský*

courage in the past and call the public to stand firm against the normalization. As a Party member she might have shared with Kundera the optimistic view that some of the reforms could be saved. Her critique of the normalization would not go unnoticed.

IV. 5 Conclusion

At the end of 1968, it was quite obvious that the government could not continue the reform course; after Husák's election as General Secretary in April 1969 the Party machinery intensified its pressure.[256]

Censorship was not yet officially re-introduced, but the Party organs found a way of controlling the mass media. *Kultúrny život* had been shut down already in September 1968; Czech and Slovak journalists and their professional organizations expressed their support for the government's line, caving in to political pressure. The weekly *Nové slovo* (*New Word*) became the platform of the normalizers.

Party members had to undergo verification; if they refused to openly express their approval of the "international assistance

komunismus, 250-260. On the ideological implications of Marxism-Leninism for Slovak historiography see Milan Zemko, "Medzniky slovenských dejín podľa marxistickej historiografie do roku 1989", in *Český a slovenský komunismus*, 161-269.

[256] Kováč, *Dejiny Slovenska*, 298, 299. After his resignation in April 1969, Dubček was assigned the chairmanship of the Federal parliament, but the normalizers made sure that he lost this position as early as October. For brief months the Czechoslovak ambassador to Turkey, Dubček was finally banned from political life for good and worked as a technician in a forest in Bratislava until his retirement; Kováč, *Dejiny Slovenska*, 297. The humiliating way the regime treated a man formerly most powerful Czechoslovak politician is a good illustration of the normalizers' anxiety and eagerness to behave politically correctly in Soviet terms.

[*internacionálnou pomocou*] of August 1968" they lost their Party card, and as a consequence, their jobs in the state administration, factories, educational institutions and army.[257] They were then employed in jobs they were over-qualified for and received a significantly lower salary. The higher positions were filled with personnel less qualified but reliable in political terms.

The purges did not hit the Slovaks as hard as the Czechs; while many Czech intellectuals were condemned to manual labour, for example Havel, who worked in a brewery in Trutnov, the Slovak intellectuals were able to find niches. The politically persecuted lost their positions at the Academy of Sciences, the universities, technical universities and schools but they could find employment at libraries and museums, which left them at least a minimal chance of continuing to use their professional qualifications in private.[258] The ban on publication hit the Slovaks and Czechs scientists and intellectuals equally hard.

Anna's academic career was practically finished with the invasion, not only because she had actively participated in the reform politics in 1968. While some two hundred historians had been fired in the Czech part, she was still employed at Comenius University and a member of the board of the *Slovak Historical Society* (*výbor Slovenskej historickej spoločnosti*); in this function, she wrote a letter to the chairman in May 1970:

> "I am concerned about the future work and subsistence of our fellow historians, whose downgrading to positions they are over-qualified for is not only damaging them on a personal level, ... but is also damaging historiography as an academic subject. Since the Czech colleagues are already in a desperate situation, I would like to suggest, indeed, to ask that you ... find an appropriate way of expressing your opinion about the future development of Czechoslo-

[257] Kováč, *Dejiny Slovenska*, 298-299.
[258] Kováč, *Dejiny Slovenska*, 300.

vak historiography. I would like to hope that you stand up for those persecuted for their views ... enabling them to continue their scientific work."[259]

She did not have to wait long for an answer: she was sacked and lost her Party membership the very same year. She managed to find employment as chief archivist at the Slovak State Scientific Archive (*Slovenský štátny vedecký archív*) in Bratislava on 1 February 1971. Naturally, she was banned from publishing, but continued her research in private. Her manuscript *The End of the Political Parties, Professional Organizations and Associations in the Years 1938–1940* (*Zánik politických strán, odborových organizácií a spolkov v rokoch 1938–1940*) had to remain in the drawer.

Anna and her husband Štefan, who was also a historian and former Candidate of Science, received very low salaries since they had been accused of "rightist opportunism [*pravicový oportunizm*]".[260] In the hope that she could financially support the family of her daughter, she submitted a request for a raise of salary to the management of the archive in June 1979, which was rejected on grounds of budget shortage.[261] Anna would work in the archive until her forced retirement in 1982. She then found part-time employment at the *Matica Slovenska*, where she participated in the project of the *Slovak Bibliographical Dictionary* (*Bibliografický slovník Slovenska*) until 1989.[262] In the mid 1980s, members of ŠtB started to pay her visits and summon her for interrogations; they were looking for a manuscript of Jozef Jablonický (1933–2012), a persecuted colleague and the famous author of a critical analysis of

[259] Dzvoník, "Osud ...", 28.
[260] Dzvoník, "Osud ...", 29.
[261] Dzvoník, "Osud ...", 29.
[262] Barnovský, "Za PhDr. ANNA ŠTVRTECKOU", 415.

the SNP. After an interrogation on 17 April 1989 she suffered two brain haemorrhages.[263]

With the Velvet Revolution and the collapse of the Husák regime, material conditions did not improve for Anna and her family, but she was at least professionally and politically rehabilitated: on 25 January 1990 she received a letter from the rectorate of Comenius University with the attached diploma of Candidate of Science, dated 7 April 1969. The Rehabilitation Commission of the Faculty of Philosophy of Comenius University informed her in an official letter sent on 22 January 1991 that the political surveillance of her person had led to "twenty years of publication ban, professional downgrading, obstruction of scientific and educational development and financial duress. All these measures were deeply unjust. For these injustices the faculty truly apologizes."[264]

Like thousands of Slovak citizens persecuted by the regime her husband tried to receive an extra-judicial rehabilitation in the form of a financial compensation, but according to the law they were not subject to a raise of their pensions.[265] This was the last cruel blow; after long illness, Anna died on 8 January 1995 in Bratislava.

Anna could have lied, declared publicly her consent with the rightfulness of the invasion and normalization, kept her position, continued her scientific career and led a quiet and untroubled life with a good salary, allowed to represent Czechoslovak historians at scientific conventions abroad. Yet, she spoke up in protest. Her attempts to improve historical research with a critical approach that defied the ideological confinements of historical materialism, her defence of civil liberties and her courage in defending

[263] Dzvoník, "Osud ...", 29.
[264] Dzvoník, "Osud ...", 29.
[265] Dzvoník, "Osud ...", 29.

her colleagues resulted only in hardship. She is remembered as a loyal and courageous colleague and an excellent historian.

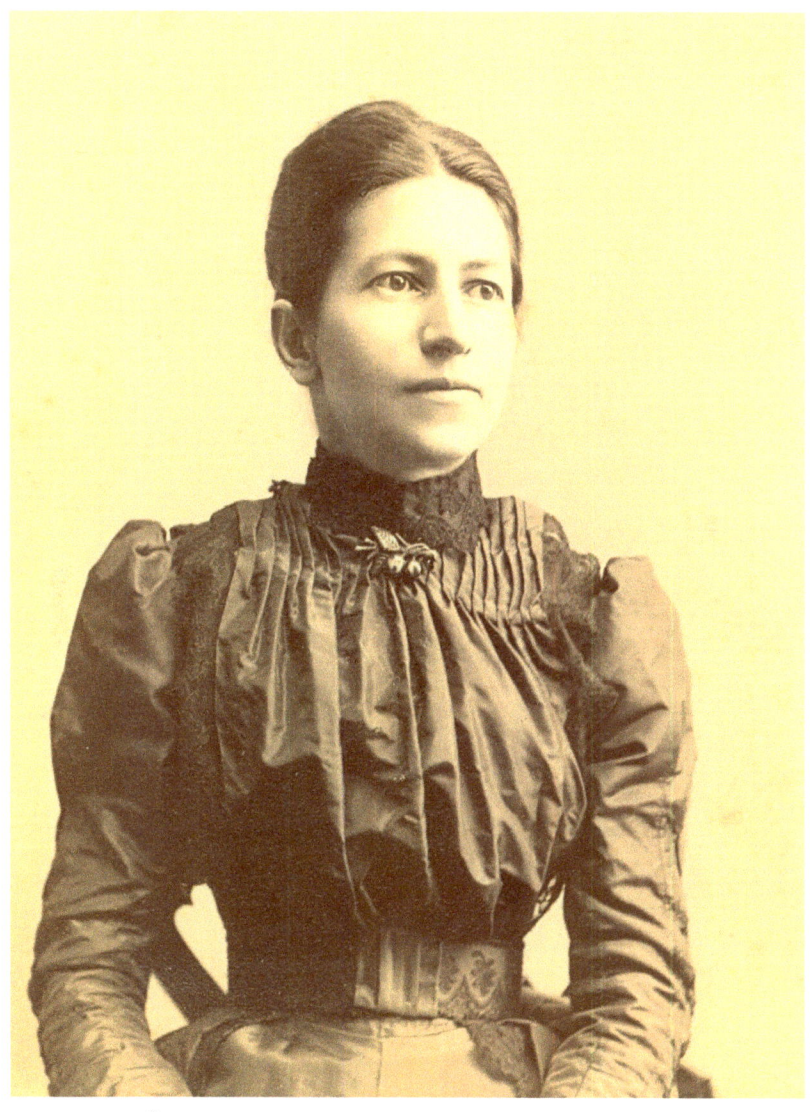

Elena Šoltésová, née Maróthy, in 1897, at the age of forty-two
© SNK Martin, Slovakia

Elena's writing room in her house in Martin, undated
© SNK Martin, Slovakia

A Bouquet from Grateful Readers, festive album issued on the occasion of Elena's 70th birthday in 1925
© SNK Martin, Slovakia

Festive edition of Elena's most famous novel *My Children*, published by the Hviezdoslav Library in 1952
© SNK Martin, Slovakia

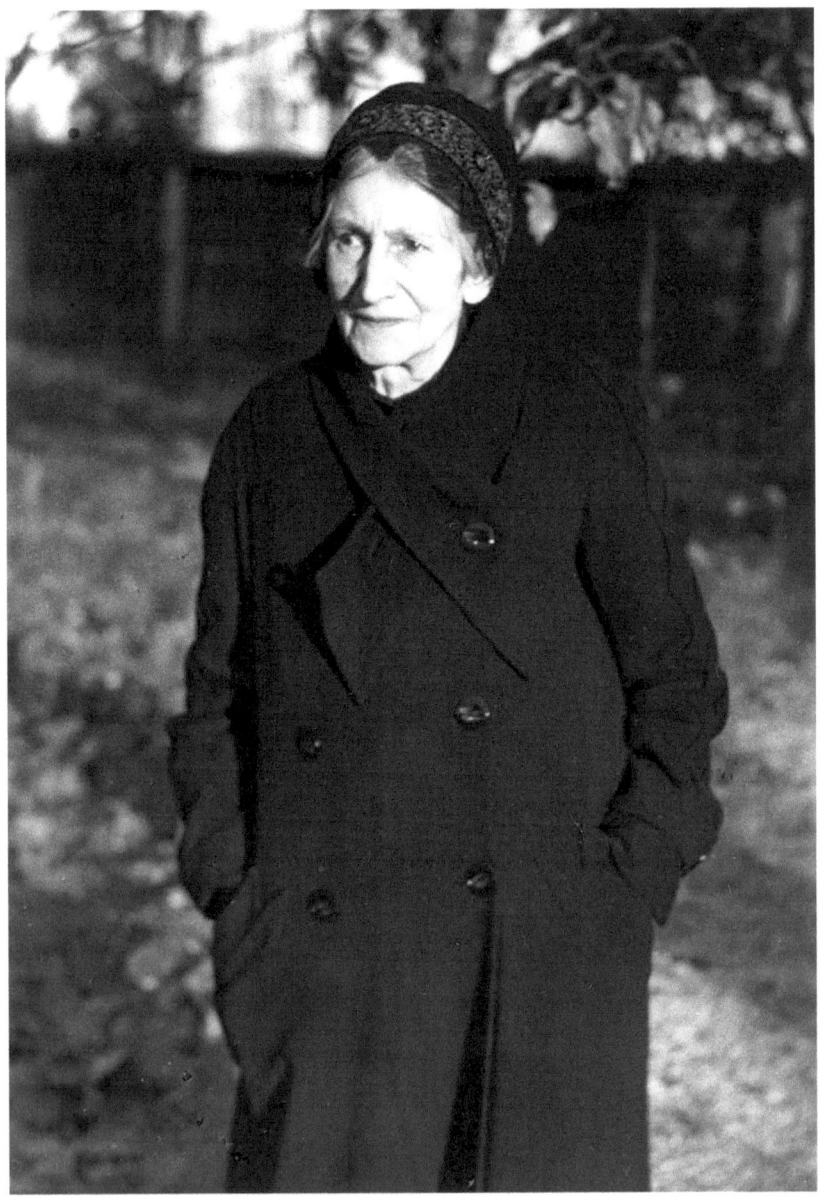

Elena in her garden, undated
© SNK Martin, Slovakia

Mária Bellová with her sisters in the family garden in the Evangelical
parish in Liptovský sv. Peter in 1895,
from left to right: Žalmira, Oľga (married Chalupková) and Mária, undated
© SNK Martin, Slovakia

Mária Bellová, the first female Slovak physician, undated
© SNK Martin, Slovakia

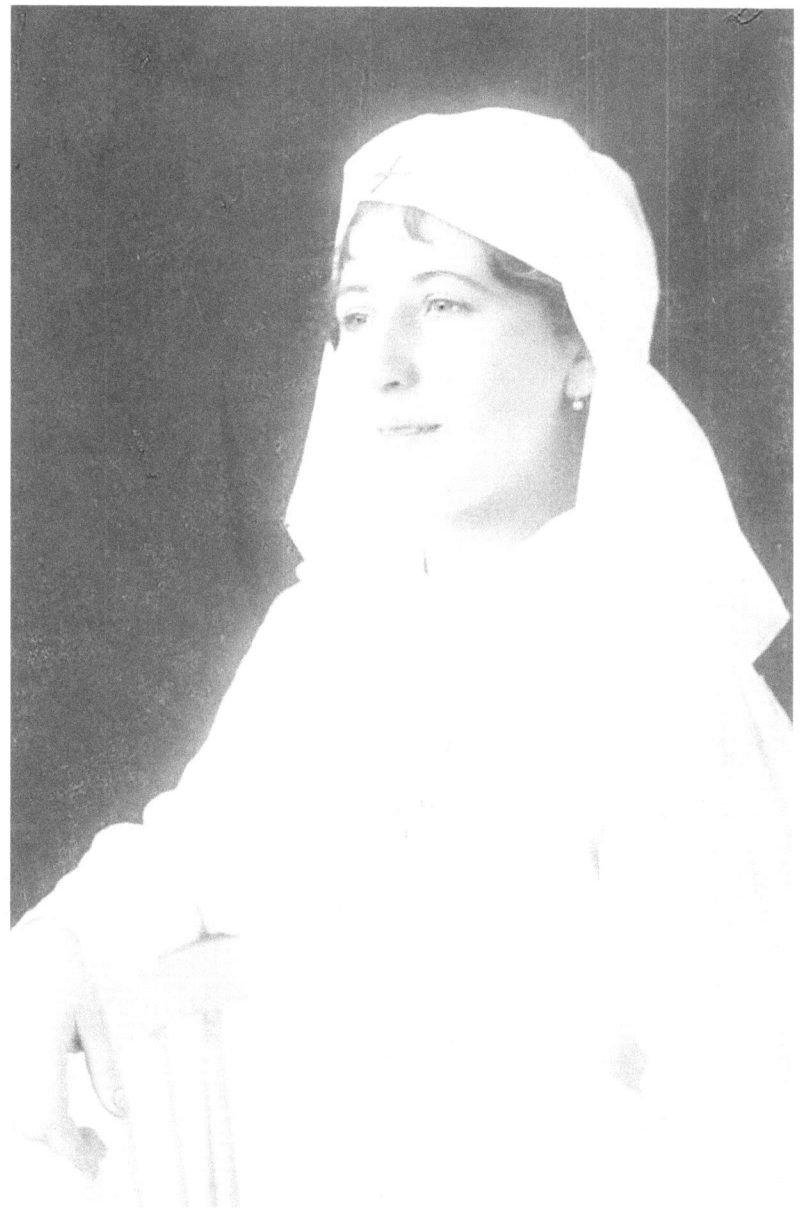

Mária serving in a front-line hospital
in Mármarossziget in Transylvania in 1916
© SNK Martin, Slovakia

Mária's 88th birthday at her home in Príbovce in 1973
© SNK Martin, Slovakia

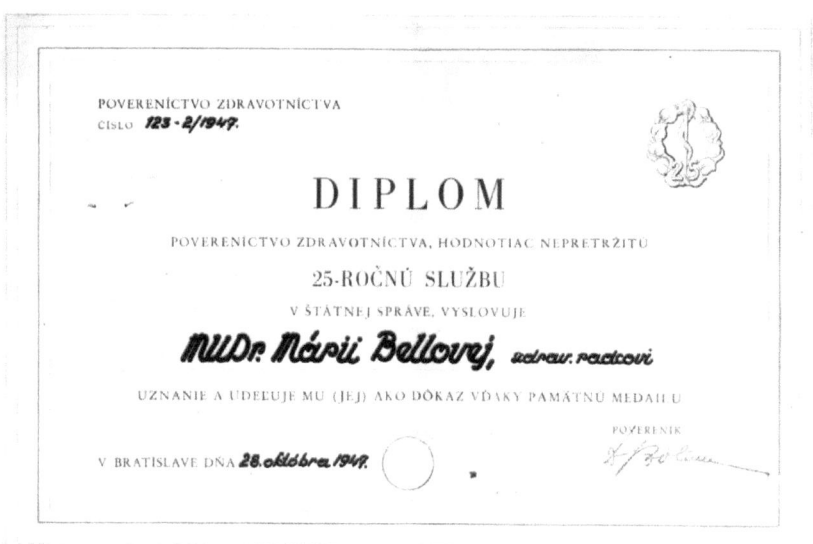

Festive diploma of the Deputy Ministry of Health in Bratislava issued on the occasion of Mária's 25 years in service on 28 October 1947
© SNK Martin, Slovakia

Festive diploma of the Medical Faculty of Budapest University issued on the occasion of Mária's 50 years of service on 31 August 1961
© SNK Martin, Slovakia

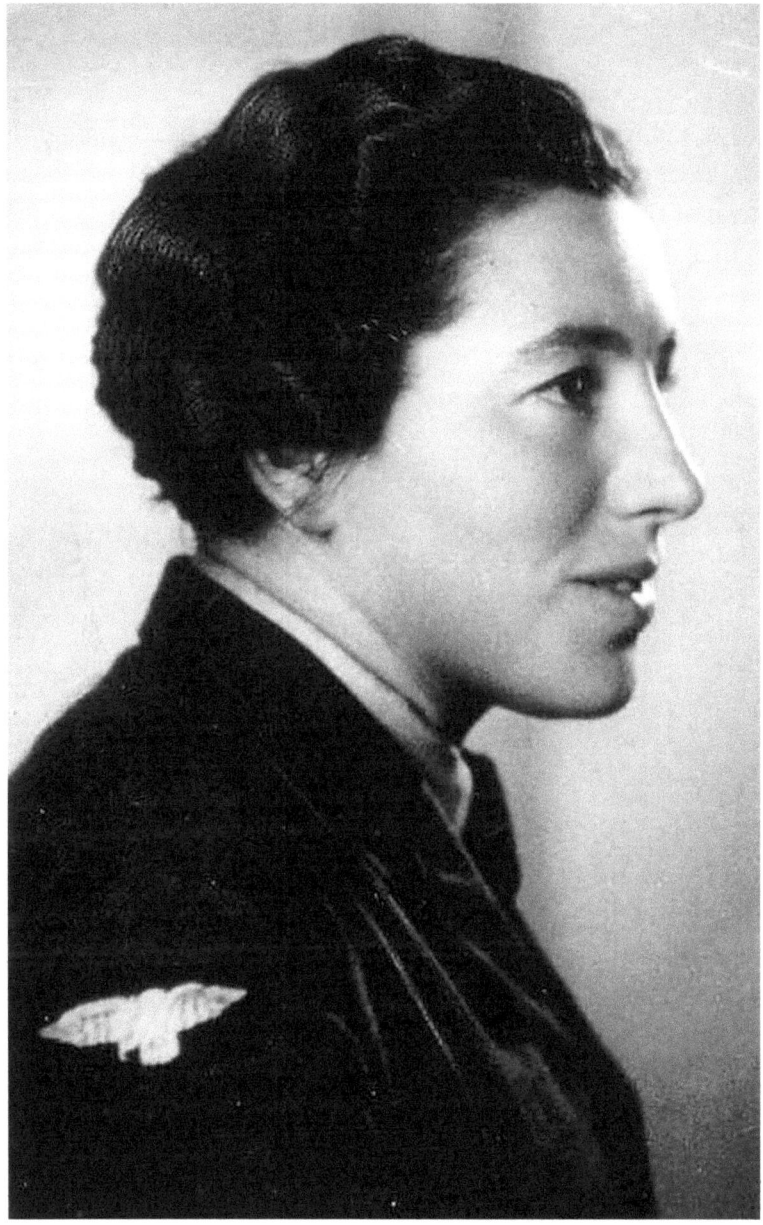

Chaviva Rejkova aka Ada Robinson in the uniform of the WAAF, 1943/44

Instead of a picture

Despite searching through all the available Slovak archives and libraries, I failed to find a picture of Anna Štvrtecká. This might be a telling sign of the workings of the normalization period, when those critical of the regime were eradicated from the collective memory. Yet, there may be another explanation – who knows?

The young Magdaléna Vášáryová, undated
© SNK Martin, Slovakia

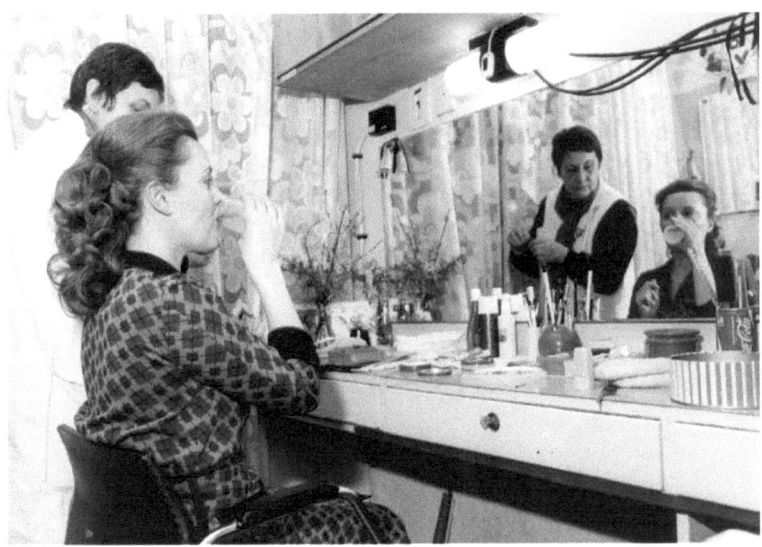

Magdaléna Vášáryová in the make-up room before a performance, undated
© SNK Martin, Slovakia

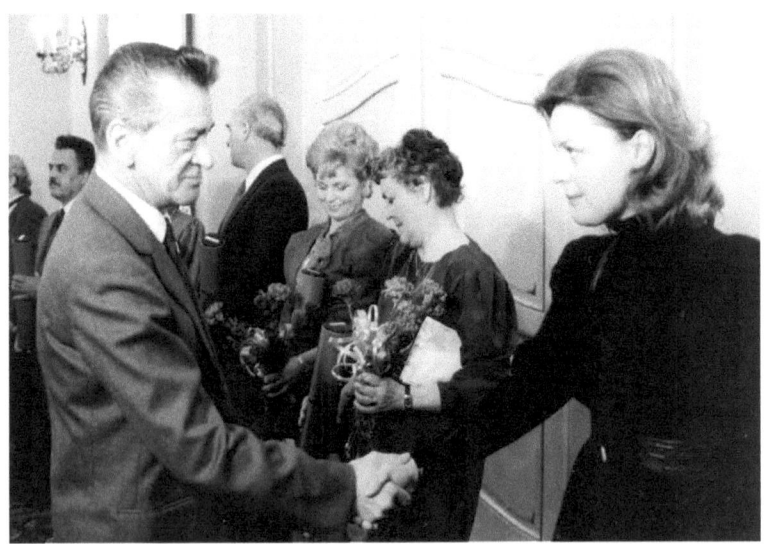

Magdaléna Vášáryová receives the title of merited artist from Miroslav Válek, Minister of Culture of the Slovak Socialist Republic on 2 May 1988
© SNK Martin, Slovakia

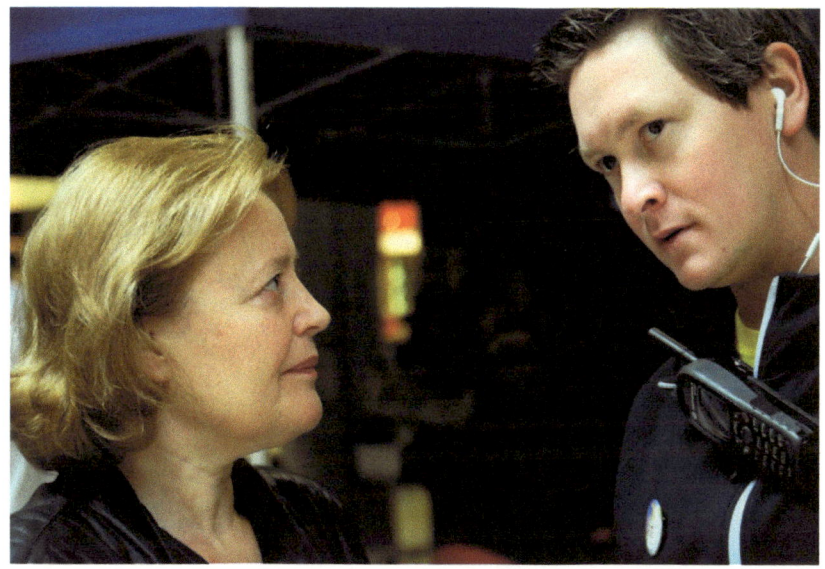

Magdaléna Vášáryová on 26 September 2010,
Ladies RUN, Aupark Bratislava
Foto: Bratislavsky kraj, licensed under CC BY 2.0
(https://creativecommons.org/licenses/by/2.0/deed.de)

Iveta Radičová during EPP Summit in October 2010
Foto: European People's Party, licensed under under CC BY 2.0
(https://creativecommons.org/licenses/by/2.0/deed.de)

Adela Banášová
© Adela Banášová

V. Magdaléna Vášáryová (*1948) – actress, diplomat and politician[266]

JB: Mrs Vášáryová, what were your reasons for becoming an actress?[267]

MV: I never wanted to become an actress. I graduated from high school (*matura*) in mathematics, descriptive geometrics and physics, coming as I do from a family that has a talent for mathematics. I got an offer to study acting; they were eager to enrol me because at the age of fifteen I had already made one significant movie, that is, a film for children. After 1968 I studied sociology, gaining a diploma in 1971. I am a theoretical sociologist with a focus on methodology.

In 1971, the political conditions were already different: as I wasn't a member of the Communist Party, I couldn't stay at university, and I certainly did not want to join the Party. The little theatre *Divadlo na korze* that had been founded in the more liberal atmosphere of the 1960s made me an offer to join them. It was later closed down for political reasons, and we were transferred to the official *Divadlo Nová Scéna*. I thought that I would stay on for two or three years until the political situation improved, but I ended up staying for nineteen years, until 1989, because the situation was getting worse and worse.

[266] Oral history interview, Bratislava, 9 July 2014, 12.00-12.50, conducted in Slovak.
[267] Information about Mrs Vášáryová's life, books, speeches in parliament, blogs, political comments and articles and cultural activities can be found on her website: http://www.magdavasaryova.sk/; accessed 5 July 2014.

JB: How was daily life during normalization, in particular for women?

MV: First, there was a new and strong Iron Curtain. Not only did I not have a passport, hence could not travel, but we had no access to information. My only source of information were the Yugoslav newspapers[268] and a few Polish ones. We could not establish contacts abroad – impossible. In those nineteen years I was only twice in the West: the first time for two days, the second for three days. We were completely cut off from a world that was quickly moving forward. Luckily, we had Austrian television here in Bratislava, which was a very important source of information for those who spoke German, which I do. Austrian TV was our school of democracy.

Second, the atmosphere of surveillance we lived in can be compared with what people today might be experiencing in the West. The feeling that you are constantly followed and monitored, that pictures are being taken of you, that you are being listened in to. To me, that was nothing new as I had experienced this already in the 1950s because my father, who was a Catholic teacher, was under the surveillance of the ŠtB. The constant need for caution, alertness, the feeling that you have to be careful what you say and to whom, that you are being persecuted for your democratic views. You are simply not free.

Third, we spent our daily life with chores that are banalities today. We lived in conditions of material scarcity. Just to get what you needed for subsistence, food, clothes and so on, meant investing lots of time, sometimes also resorting to petty methods of corruption. Today, you go to a shop and buy oranges, back then,

[268] Mrs Vášáryová refers to Yugoslav newspapers, since in those years the Tito regime was more liberal in political terms than Czechoslovakia under Husák.

imported goods were limited. In the 1980s, my children were small, and just buying meat or oranges to give them a healthy upbringing took up hours.

The result of the lack of information, the constant surveillance and the time-consuming daily life was that people retreated into their private lives, into their families. Famous authors planted trees in their little gardens; I grew carrots for the children. The family was the only space where one had at least a bit of freedom, so we spent our time with the family. People today have no idea how we lived back then. But look at North Korea – you'll get an insight into how such a regime operates.

JB: Your films and theatre plays are a significant part of Czechoslovak cultural life. You said that you are a 'natural' on the stage, that you therefore ask yourself whether acting can be seen as a form of art. How did you prepare for your roles? What method did you use?

MV: First, an actor is an object; he or she is not the primary source of creativity. The principal creative person is the author, then the director who chooses the play, develops the concept, that is, how to stage the play, and finally casts the actors. Actors are in the third rank of a production, but because they are the only ones visible when the play or film is shown, they appear to be the ones carrying the play – often provoking envy and jealousy on the part of directors and screenwriters. Although I write books, I had never any ambition to write a play, nor did I want to become a director.

As an actress, especially in the theatre, you manipulate people, forcing your emotions on them, your way of looking at things. That was one of the reasons I left acting. I knew that I had that ability to manipulate people – and I didn't like it. Talented actors send out a kind of energy, waves of energy to the audience, and people are fascinated by them. There are, of course, good and bad ways of influencing people.

Second, in contemporary politics we have a problem: on the one hand, people adore actresses and actors, on the other they also have that medieval feeling that actresses and actors are a bit too free-thinking and pretentious. And, as I am a real blonde, people assumed that I had no intellect. For example, I was able intellectually to analyse a play by Chekhov, but had to focus only on my acting from the moment I was on stage. I was in constant fear that my brain would overshadow my talent. On stage or set, talent was the most important thing, something like a divine gift.

Third, as an intellectual – my father was a professor of literature – I was interested in mathematics, philosophy, logic; my reading was quite different from the plays directors and screenwriters were reading. I was always focused on the political conditions. For the theatre and cinema, I had to change my language; when speaking with my colleagues I had to change my way of expressing myself.

And fourth, I left acting after twenty-five years, when I was at the peak of my career; I did not want to be an object anymore. In 1980 I failed to get the leading part in the movie *Sophie's Choice*,[269] thus the prospect of an international career was closed to me. I didn't have a passport, I was forty years old. My decision to leave acting was very liberating: finally, I could use my brain.

JB: President Havel appointed you Czechoslovak ambassador to Austria in February 1990. You were catapulted onto the international stage with a picture that showed you in a transparent blouse. How did that happen? And what problems had the young Czechoslovak democracy to face in international relations in the 1990s?

[269] *Sophie's Choice* on http://www.imdb.com/title/tt0084707/; accessed 13 July 2014.

MV: President Havel had known me since I was sixteen. He also knew my family, so he was well informed about our activities related to a non-Communist position. He also knew that I was interested in politics and that I spoke several foreign languages. He was looking for personalities who could change Czechoslovak foreign policy towards the West immediately, without a long preparation process. I thought about his offer for some time, how this position would affect my family life, but, in the end, I accepted. Three months after the Velvet Revolution I was appointed the first female Czechoslovak ambassador and posted to Vienna. I was blonde, university-educated and no Communist – all of which resulted in the unusual amount of international interest in my person.

That picture you mentioned was, of course, a fake, a photomontage; somebody painted on my breasts, which was only possible with a black-and-white picture back then. But I am used to the fact that certain persons and sections of the media do this to make money out of me against my will. I could fight them, but I am rather resigned to it; I simply don't have time for such nonsense. But many people remember me only for that picture.

Much more important was that, during forty years of the Iron Curtain, Austria had forgotten about us; the Austrians certainly knew something about the Czechs, but looked down on us Slovaks like we were new animals from a zoo. When the borders opened up, they were surprised to find that we drove cars, had fridges and TV sets and looked like normal people. We did, of course, have enormous problems: some 100,000 Czechoslovaks a day were travelling to Austria, some of them to engage in criminal activities, which prompted great anger.

That is why some Austrian politicians initiated a referendum against the construction of new bridges and highways connecting our countries; older people were missing the past, they wanted us to stay put. In certain respects, this perception of us as a

threat lasted a very long time. A telling example is the Austrian government's criticism of the safety of our nuclear power stations; the Soviet nuclear plant Paks in Hungary, also built under Communism, was never subject to criticism because the Austrians and Hungarians are close, sharing a common past as the ruling nations of the former Empire.

Our thirst to be like the West was enormous, but we were not prepared for the many negative reactions after the quick and deep transition process in our republics. After we had joined the EU in 2004, Austria and Germany hindered the free movement of labour, the mobility of people from the Slovak and Czech Republics for another seven years. Austria presented itself as the potential *Drehscheibe* (hub) of Central Europe; in reality, however, it was blocking our advance to the West, putting obstacles in the way of our integration into the EU. Central Europe is a difficult region: many nations, many minorities, the abrupt end of the monarchy and the two totalitarian regimes. In Slovakia, the feeling of being the perennial victim suffering under the rule of others still prevails. There is a lot of work to do in terms of overcoming the past and being an active member of the EU. We have accomplished economic and social change, now we need cultural change as well.

JB: After the dissolution of ČSFR, Slovakia became, for the first time in its history, a sovereign state. How do you remember those early years of independence, specifically the economic and political situation? How do you see the political atmosphere in those years, in particular the everyday life of women?

MV: As the ambassador closest to Prague and very familiar with the political situation, I was absolutely against the dissolution of Czechoslovakia because I feared that it would push Slovakia towards the East. The forces of reaction, in other words the government of Vladimír Mečiar, were powerful and had immense influ-

ence on the people. The period from 1994 to 1998 was very bad, hindering democratic development for many years.

I received an offer to represent the Czech Republic as ambassador, but I returned to Slovakia and founded the *Slovak Foreign Policy Association SFPA*,[270] with the intention of informing people about the possibilities of a new pro-Western foreign policy. I hoped that this would build a consensus in political circles about Slovakia's political orientation towards the West. In 1998 we were successful, with the centre-right coalition winning the parliamentary elections and voting the Mečiar regime out. We have to thank especially the young voters that we did not turn back to the East. Slovakia was no longer a Russian appendage.

I am used to being a female pioneer, the first female Czechoslovak ambassador, first female candidate to run for the presidency of Slovakia. I opened up the male-dominated sphere of power to the younger generation of women. Slovakia today is undergoing a lightning-fast development, but some basic characteristics remain. We did not have a Havel, a person with international standing who could promote Slovakia's interests in international relations. As far as the rest of the world is concerned, we are still something of an unknown quantity.

Life has changed, in particular for young women. Their life strategies are different from ours: they marry and have children at a later stage in their lives, they travel a lot and are able to study in countries all over the world. Slovak women have always been very busy: our mothers worked and shared with the men the responsibility for the family's finances. Women nowadays are mainly working in education, as doctors and nurses, in retail and state institutions, but the problem is that their salaries are 20% lower than those of men in the same jobs.

[270] About the history and current activities of SFPA see http://www.sfpa.sk/en/; accessed 13 July 2014.

Some elderly women, among them the *babky demokratki* (democrat grannies),[271] want to turn back the wheels of time. As chairwoman of *Živena*, I think that the association should unite active and educated women of all generations and convey to them the message that it is us who decide about the future, about the social, economic and political conditions we and our children want to live in. In the next ten years, there must be a consensus among women and a clear agenda about the future of Slovak society. That is the reason why we want to renew *Živena* as an association that unites active women and represents their interests in society and their social engagement.

JB: You speak, I think, eight languages, which is admirable. You are engaged in many international cultural projects, one of which is *Via Cultura*. How do you see cultural developments in Slovakia today and what do you wish to see developing over the next twenty years?

MV: That's a good question. I founded the association *Via Cultura* because I am convinced that our political reforms, finances, new institutions, economy and adherence to the eurozone were successes. But in terms of our civilization, our culture – and I understand culture not only as the arts, but in the wider sense, encompassing education, human relations, lifestyle, moral values and an educated social environment – we are lagging behind.

[271] A Slovak term of contempt, referring to elderly female citizens who grew up under Communism and enthusiastically conceived of Mečiar's HZDS in the early 1990s as the epitome of the nation's sovereignty. Rumour has it that some of them even used to beat up Mečiar's political adversaries at rallies with umbrellas and sticks. Today, they usually vote for the social-democrats of SMER, the former Communists, chairman Robert Fico being their new hero and a kind of political son of Mečiar.

As a society, we are moving forward at lightning speed, but in civilizational terms we still exhibit a sinusoidal tendency: up and down, up and down. We should invest more time in creating a cultivated atmosphere to slow down that radical sinusoidal curve. I doubt that we can rid ourselves forever of that up and down movement, but I hope that we can make it more balanced, less radical.

That is why we need to think carefully about a well-defined cultural policy that takes care of the younger generation, a generation that has become *homeless in cultural terms*. We should radically change our system of education – which is very old-fashioned and led by the state administration; this is the source of the strong opposition against any deeper reforms. What is interesting is that artists initiated the change to democracy, but they are the first to vehemently oppose any reforms in cultural policy. Our culture is open to the world, but it does not have the ambition to invade Europe. I did not succeed in becoming Minister of Culture, but I strongly believe that we ought to convince the European countries of the fact that Slovak culture is an inseparable part of European culture.

JB: My last question: Mrs Vášáryová, as former diplomat and politician, member of parliament, what advice would you give to young women who want to go into politics?

MV: First, women still have to do twice as much to achieve what men achieve without the extra effort. To me, it makes no sense to complain.

I think there is only one way: to build solidarity among women. Women should help other women, help them achieve positions of power, the very positions men naturally conquer without any effort since they have their network. A particular attitude often displayed by successful women is not helpful at all: I have achieved

this, so can the young ones, let them fend for themselves. I think this is a big mistake. It's pure mathematics: if every generation of young women has to start from scratch, at zero – it will take us a very long time to achieve what we could accomplish in no time if we joined forces.

Second, it's wrong to refuse responsibility for the state we women are in. Today, one cannot speak of a double or multiple burden women have to bear, since housework has become so easy, with all the electric goods like washing machines, vacuum cleaners, computers and so on. Really, taking care of the household is no longer an excuse not to engage in political and social activities on behalf of our society.

Third, it is us women who are bringing up our sons, that is, the men our daughters are going to marry one day. We should have clear ideas of what kind of men we want in the next generation. Neither a weak loser nor a little prince. Really, it is up to us: nobody, regardless of gender, has the right to decide about our bellies and behaviour, to determine how we should live in an ideological way. We have to support all modern ideas about health, social issues, household, the bringing up of children.

The state should appreciate women's work and efforts every day, not just once a year (8 March, International Women's Day). These goals can only be achieved through widespread solidarity among women, nothing else will do. My goal as chairwoman of *Živena* for the next seven years is to make the Slovak women's association the important and influential force it was in the late 19th century.

Dear Mrs Vášáryová, thank you very much for your time and for consenting to this interview.

VI. Iveta Radičová (*1957) – the first female Prime Minister[272]

JB: Professor Radičová, you were twelve years old when the Prague Spring started. How do you remember those eight months and the invasion of the Warsaw Pact troops? Did you already have a distinct interest in politics or were you rather a normal teenager, more interested in music and meeting your peer group?

IR: Memories depend on personal environment. Your family, your friends, but mainly your parents determine your perception of the conditions you live in. Either you are aware of what is going on in society – or you are not. My father was a journalist; after eighteen years he returned to his profession thanks to the warming[273] of the political conditions that began in the 1960s. Within the natural limits imposed by my age, I asked him about his experiences and listened and learnt about the past and also current events.

We lived in the very city centre of Bratislava; in the night of 21 August 1968, I woke and my father woke when the tanks were entering the city. My father had a camera in one hand, with the other he held me and we went out into the streets and squares together. As father did not speak Russian well, and Russian was compulsory for us pupils, my translations were rather amateurish, but I nevertheless tried.

[272] Oral history interview, Bratislava, 8 July 2014, 13.00 – 13.50, conducted in Slovak.
[273] Mrs Radičová uses the concept *oteplovanie* (warming) to describe what is usually referred to in the historical literature as the 'thawing' (of the totalitarian ice), that is the slow liberalization of society and party that started in the 1960s.

There was communication with the soldiers, citizens standing around the tanks and asking them why they were here and where they had come from. There was the widespread conviction that there was no problem at all in our country. I remember the shooting on the square, people panicking. I remember also the days when father stopped taking me out to the streets since the situation was getting increasingly dangerous. But I remember also that after ten days he took me to the opposite side of the Danube and showed me the graves of people buried there and the artillery of the Warsaw Pact troops directed on the city. These are things you never forget.

For entire nights we listened to the Voice of America, Radio Free Europe and broadcasts from Vienna that we could receive in Bratislava. And add to this the passionate discussions with friends, writers, people from the theatre in our home. What to do? Do we have a chance? But it was quite clear that the only way to face the future would depend on one's individual character.

The brutal years of the normalization started; many journalists, educationists, teachers, the established intellectual elite in the widest sense of the term, all lost their positions if, unbroken, they refused to sign that grim pamphlet about counter-revolution.

JB: Was that pamphlet the Lessons Learnt from the Crisis?

IR: Partly, yes. The pamphlet was designed for the evaluation of individuals in certain functions and positions in the institutions; you had to sign that you disagreed with the political development and agreed with the official view that a counter-revolution had been in the making. Clearly, it was a procedure intended to break one's character. I don't have to stress that, of course, father was incapable of signing such a thing; he started to work in the Western Slovak printing plant.

JB: Was this a manual job?

IR: Yes, at the beginning; he later worked as a proofreader. As there was no digital technology yet available, his proofreading job also involved manual work.

JB: How can the 'Western' reader imagine the atmosphere at Comenius University in the 1970s when you were studying sociology? What plans did you have after gaining a PhD in 1979, and what professional possibilities were open to you?

IR: I joined the department in the years when Professor Alexander Hirner[274] was still there. The department had been founded in 1964; it was a small community of sociologists who had an international reputation. Hirner had a professorship from Charles University in Prague; in the 1950s he had been accused of Slovak bourgeois nationalism. In the 1960s, in the years of the warming that was an attempt to democratize, he had the opportunity to get a position at the newly founded department of sociology in Bratislava. Besides him, there were young assistants who had just graduated and been trained by him. There was Sonia Szomolányi, Vladimír Krivý, and also Juraj Schenk, plus the entire research group focussing on the large-scale project on social control and a strong research group concentrating on the regions headed by Ján Pašiak.

That was the environment I joined; during my studies, I think it was in 1978, the normalization hit our department too. It was renamed the department of Marxist-Leninist sociology and Professor Hirner left. I cannot say how the department functioned over the next few years since I had no contact with it. I was in pri-

[274] Regarding the history of the Department of Sociology at Comenius University see http://www.fphil.uniba.sk/index.php?id=845; accessed 14 July.

vate contact with Mrs Szomolányi and Mr Krivý, Martin Bútora, Zora Bútorová and also Stano Radič, a fellow student and later my husband.

With Mr Hirner we formed a so-called 'scientific circle'; he invited terrific guest lecturers, for example the future Czech president Miloš Zeman, Fedor Gál, Jozef Alan and the philosopher Miloslav Petrusek. That is how the teaching and research in alternative sociology[275] emerged. The journal *Sociologický obzor* (*Sociological Review*) appeared as a samizdat publication, and a network of independent sociologists involved with the journal emerged. We met at various locations, in the mountains, in cabins, and exchanged books that had been banned from the libraries, for example Sergej Machonin's work about the social stratification of Czechoslovakia.

In those years, the Slovak Academy of Sciences was a kind of quiet backwater of sociologists who could not be officially employed. Just to be clear: the university was the institution and working place of the nomenklatura under the direct control of the Central Committee of KSS. The SAV was not; some of us were not even members of the Communist Party. There, I met terrific people such as Róbert Roško, the aforementioned Mr Pašiak, Dušan Provaznik and many others.

Now, how to survive? This was an individual choice. I made a rational choice and started to concentrate on methods of sociological research and statistics. In 1989, I came to understand that I had made a good choice back then. In the 1980s, we bought an SMEP computer from Bulgaria that extended to three rooms, like those one can see in old movies. We had to wear special clothes and plastic boots, and in the summer, when it was hot, it stopped func-

[275] In the sense of sociology unrestrained by the ideological confines of Marxism-Leninism.

tioning. This SMEP required an entire week for what a laptop can do in two minutes today.

Thanks to the medium of the computer and my knowledge of how to use it for statistics, I was able to participate in large, international research projects, for example a project led by Milan Tuček in Prague, who was the head of the excellent department of statistics. The international contact allowed me to get away from statistics, and I learnt a lot about other fields of sociological research. After perestroika had begun in 1985, I started to focus on the sociology of the family, since a regime's decline can best be understood in its relation to the family as a social unit or element. The family has an immense influence on an individual's moral orientation and ethical values.

My sociological orientation in the late 1980s was an analysis of two specific Slovak concepts. First, the role of the family in state and society, and second, *zemitosť* (earthiness), the traditional Slovak perception of one's native soil, garden or plot as social security, which prompts a specific approach to decision-making based on rationalism and utilitarianism. This specific feature has made its way into democratic politics, that is, voters' decision-making in elections. Then I worked on themes such as double standards, powerlessness, xenophobia, victimology, conspiracy theory – and there I was, already in the area of political sociology!

After 1989, I accomplished an analysis and interpretation of the economic transformation. In the surveys I conducted in the early 1990s, I found three positions or polemics Slovak citizens adhered to, which led me to develop a post-89 typology. The first type of citizen expected the economic and political transformation to head towards Dubček's Socialism or 'capitalism with a human face'; a second supported the unlimited and rapid economic transformation to the system of liberal capitalism that Prime Minister Václav Klaus was promoting in the Czech lands; while a third type

did not want any change at all. It was already clear to me that the Klaus model of transformation and privatization would stand no chance in Slovakia. The fact that Dubček was the leader of Public Against Violence (*Verejnosť proti násiliu,* VPN) in the first free elections in 1990 explains the difference between the Czechs and Slovaks very well.

To us, a range of hitherto unknown freedoms opened up. I wanted to study more and went to Oxford for a postdoc. My nine months in Oxford were a good decision. To this day, I always have a copy of Sir Ralf Dahrendorf's *Reflections on the Revolution in Europe* and his *Modern Social Conflict* with me.

JB: In 1990, you stepped into Slovak public life as a spokeswoman for Public Against Violence. What were your motives for joining this organisation?

IR: I was active before November 1989; I had signed the open letter to President Husák, a Slovak version of the Czech petition *Několik vět (A Few Sentences);*[276] then, in November 1989, I was the co-organizer and an active speaker for VPN on the platforms and at the meetings that were held in various Slovak towns and cities and also at Comenius University.

After my return from Oxford, VPN represented a first step in the democratization process. Its main goal was to lead the country to the first free elections, like the Civic Forum (*Občanské Forum,* OF) in the Czech part. At that crucial point in time, VPN and OF shared the moral goal of free elections. It was only natural that after that goal had been achieved, OF and VPN dissolved, and what

[276] About the petition see http://icv.vlada.cz/en/media-centrum/tema/a-few-sentences-on-a-petition-from-1989-59398/tmplid-676/; accessed 20 July 2014.

would become the party landscape began to emerge in both parts of the country.

In Slovakia, ODU and HZDS were founded. In 1992, Mečiár's HZDS won the parliamentary elections in Slovakia, while Klaus's ODS won in the Czech part. Fedor Gál represented the centre-right wing of VPN. Gál never held as strong a position as Havel. Havel was the guarantee of continuity and stability in the Czech part, which Gál was not in Slovakia. I left VPN when I understood that it had lost its influence and was being transformed into ODU, later chaired by Martin Porubjak. Compared with the Czech part, there was no continuity in terms of keeping to the moral goal of democratization in Slovakia.

JB: And then came your entry into high politics. As a woman, you were in a minority in parliament and your party SDKU-DS likewise. Western women often consider the achievements of Communism on behalf of female emancipation greater than those of the Western democracies; in their view, men brought up under Communism seem to have greater respect for women's rights. What is your opinion? Does sexism exist in Slovak politics and, if so, how does it manifest itself?

IR: The general right to vote brought women emancipation. In Slovakia, general suffrage was established in 1918 with the Czechoslovak Republic's democratic constitution. Communism then warped the right to vote and made it into a 'vote' for one political party, 'gaining' 100% of the votes for the Communist Party. This established an authoritarian regime of the totalitarian type.

Under Communism, women had the right and the duty to work, enshrined in the constitution. The family model was based on men and women working and earning salaries. Otherwise, they had no chance of covering daily expenditure. There was no private ownership, no possibility of investment, life was based on state-or-

ganized needs and state-controlled consumption of goods, which was connected to the permanent shortage of basic goods and products. The issues of the family and quality of life, the return to private ownership and investment for one's future were subject to the regime change of 1989, as was the right to freely express one's opinion, interests, needs and preferences.

The regime change threatened the traditional model of the industrial family. In Slovakia, women at present attain a higher level of education than men and their chances of achieving a higher salary are a fact. But on average, women's salaries are still lower by 23%. Free choice does exist, but unfortunately it has also led to pressure from outside the family. And this means that neither women nor men can choose freely anymore, that, ultimately, emancipation in its true sense has ceased to exist. If you are unemployed, your range of free choice is severely limited. The career paths are changing; highly educated people do menial work for which they are over-qualified. In the current political conditions, neither women nor men are absolutely free.

We women liberated the men from the burden of being the principal nurturer of the family; we went to work and earned a salary, sharing the financial burden with the men. Yet, men much too often still expect the women to take care of the traditional chores such as household, work and care of the family. The result of this imbalance is the high divorce rate in Slovakia.

A new and Europe-wide trend can also be seen in the change of family structures: unemployed father, working mother, patchwork families, weekend father and so on. Social policy has to react to this trend, but so far, it hasn't, not in a single country. There is only talk, no adaptation of policy to reality. The idea of taking a step back and fully re-establishing the traditional family model is impossible, since that would mean abolishing the very essence of civil rights – the equality of men and women.

JB: From 2010 to 2012 you served as Slovakia's first female prime minister. What are your memories of that particular period in your life? Do you have fond memories or regrets? How should our readers imagine current Slovak politics, the atmosphere, the struggle for power and the negotiations?

IR: Slovak politics has specific features other states and societies don't have. After WWII, Slovakia, as an agricultural and undeveloped country, experienced modernization in civilizational terms, with Soviet-type industrialization that established the institutional structures of heavy industry, the economy, the army, state administration etc. At the same time, there was a significant social transfer, a movement of the population to the countryside, which fulfilled the requirements of the general employment of women and men and the housing situation.

Citizens also perceived a daily rise in the standard of living; since the system was closed in behind the Iron Curtain, the only comparison people had was with the years of abject poverty prior to WWII. That's why they felt that everyday life was improving. They were also influenced by the dominant ideological information about the 'terrible' system of capitalism based on exploitation. Each region had its own industrial enterprise that fulfilled employment needs, since everybody had a duty to work. In that light, it is understandable that opposition to the Communist Party was weaker than in, say, the Czech part of the country or Poland.

There was no widespread opposition to the regime, only what were referred to as 'islands of positive deviation'; church circles and the ecological movement were unable to gather a wide following. Put simply: there was no Slovak Havel. After 1989, the disengagement from the Warsaw Pact and the COMECON had serious consequences for the economy, so much so that a significant group of people started to promote nostalgia for the Communist

era. Many members of HZDS and later SMER-SD fed on that nostalgia.

We have 'election parties',[277] that is, parties that become active mainly before the elections. They distinguish themselves from the 'member parties' that are based on the constant activities and relations of their members. The first are not parties in the sense of an organization pursuing a political programme over years and being in touch with prospective voters and members. The election parties embark on vigorous campaigns and mobilize with all the means of political marketing, words and rhetoric.

A further specific trait of Slovak politics can be found in the rifts running through our society: Slovak citizens are divided by national, confessional and social identities. These divisions result in the continuous establishment of new political parties: the party landscape of the first decade of the third millennium is radically different from that of the second. That means the party landscape, the political scene, is not stable. The reason for this instability is the lack of commonly shared values.[278] The state institutions are being

[277] In their behaviour, the election parties can be compared with the system of *virilism* in the 19th century: virilism was a practice and institution that effectively opposed universal suffrage in the regions of the Hungarian kingdom inhabited by non-Magyar citizens. Only a distinct number of wealthy tax payers, the so-called *virilists*, had the right to run for office in the councils of the towns and counties; they were not elected, but appointed according to their financial weight and loyalty to Budapest. They started to campaign only shortly before the elections; in the time between the elections their contact with the citizens was reduced to a minimum. This practice survived until 1918; Ľubomír Lipták, "Elitenwechsel in der bürgerlichen Gesellschaft der Slowakei im ersten Drittel des 20. Jahrhunderts", in *Bürgertum und bürgerliche Gesellschaft in der Slowakei 1900–1989* (Bratislava: AEP, 1997), 67–80; 67, 70.

[278] Mrs Radičová agrees with the term I coined in 2010: *dysfunctional pluralism* is a specific feature of Slovak political behaviour, it is ineffective,

colonized by the ruling party or coalition: we have the system of the 'winner takes it all'. This system and the concomitant behaviour it creates essentially threaten the survival of political parties.

A consequence of HZDS rule under Mečiar in the 1990s was that the oligarchs could establish their power, concealed by pseudo-transparent media and the various political parties competing for power. To the common citizen this oligarchic power of economic interest groups is invisible; they remain in the background. Timothy Garton Ash spoke of a 'nomenklatura democracy', I called it 'oligarchic democracy': old Communists and those involved in the wild privatization of the 1990s became rich in the social market economy. They wield real political power because of their wealth, since they can pay off parties, institutions and the media.

JB: My last question: You are the first female professor of sociology at Comenius University, you have been the first female prime minister of Slovakia, you are teaching at Oxford University. Your academic career is, in itself, a huge success. What would you say to a young Slovak woman, or any young woman around the world, who plans to go into politics? What can young women learn from you?

IR: First, don't repeat my mistakes. I thought that it is possible to have friends in politics, to have politicians as friends. It is not. I thought that it is possible that, as a female politician, you can trust your political partner. You cannot. I thought that appropriate and modest behaviour, admitting to one's errors and not showing one's muscles would be accepted – it is not: it is interpreted as weakness.

not goal-oriented, and distracting. It creates counter-productive factions in political situations that require a minimal consensus to reach a goal.

I thought that we have overcome the gender-specific stereotypes – we haven't. If a man shouts, he is determined, focussed; if a woman shouts, she is a hysteric. If a man radically changes his political views, he is considered a dynamic realist, a woman moody. To master all this and not to shout at them requires a lot of energy. We can change this only if we bring up our sons accordingly, because that's where it all begins.

Dear Professor Radičová, thank you very much for your time and for consenting to this interview.

VII. Adela Banášová (*1980) – the face of young Slovakia

Adela Banášová is a celebrity in the Slovak and Czech Republics. She is the daughter of Jozef Banáš (*1948), Slovakia's bestselling author, former Czechoslovak diplomat and former chairman of the NATO Parliamentary Assembly.[279] Her mother Mária Banášová (*1953) is a very successful artist-potter whose ceramics have been exhibited all over the world.[280] In 2008, Mária received the *zlatý gunár* (Golden Gander) international prize for her work.

Adela graduated from the Faculty of Philosophy of Comenius University, Bratislava, with an MA in Cultural Studies and in 2004 embarked on a career in the Slovak media. She first appeared in a show with Matej 'Sajfa' Cifra (*1979) on Fun Radio – an early-morning radio feature that is listened to religiously by young people all over Slovakia. From 2004 to 2011 she was voted the most popular presenter by the public in the annual OTO survey that covers all TV channels.[281] She presented the popular shows Slovakia's Superstar, Czechoslovakia's Superstar and Let's Dance. She is a brand in her own right, better known in Slovakia than Coca-Cola.

JB: Adela, everything you do succeeds, you have a huge following in Slovakia. Can you reveal the secret of your success to our readers?

[279] Jozef Banáš's website http://www.jozefbanas.sk/index.php/English; accessed 26 July 2014.

[280] Mária Banášová on http://www.artgaleria.sk/sk/ponuka/socha/socha_m_banasova.aspx; accessed 27 July 2014; http://zena.sme.sk/c/5768927/maria-banasova-clovek-je-ako-oliva.html; accessed 27 July 2014.

[281] The OTO survey on http://anketaoto.cas.sk/archiv/; accessed 27 July 2014.

AB: Success is relative, of course, but I can say that I've achieved a few things in the media industry. I assume success is simply the result of the way you plan your life, the goals set by the soul. I didn't focus too much on being successful. I just did what I thought had to be done; in spite of my anxieties and insecurities I came through many challenges, always trying to give my best without too much effort.

Naturally, my parents' influence should not be underestimated. How you fare in life is always determined by the family, how your parents brought you up. Since I was a little child, my parents kept explaining to me what is important in life and what is not. That is the reason why I am not addicted to success. And often, when one is addicted to something, things go wrong.

JB: Your father was Czechoslovak diplomat in East Berlin in the 1980s. What did you like about living there, what not? How did the life of a child of Czechoslovak diplomats in East Berlin look back then?

AB: As a child, you perceive only the environment you live in. Since you don't know anything else, you think that the stressful first day in a German kindergarten is simply normal. I was rather traumatized, but I coped with it and the shock helped me to learn German. After that, everything was easier.

Generally speaking, I had a good childhood. Most of my friends were children of families of diplomats. I used to go shopping in the local indoor market, although I couldn't count yet. My mother always gave me the family wallet, from which the stallholder took the money to pay for my shopping. I don't know if it's considered normal today that a five-year-old goes shopping on her own. I was happy in Berlin, even though I wasn't quite aware where Berlin was exactly and how my Czechoslovak fellow citizens lived.

Yet, under Socialism, the lives of people in the Eastern Bloc were very similar, as we know from history lessons.

Life in East Germany was, I think, a bit better than in Czechoslovakia. My mother had her first contact with artists working in ceramics, so my parents felt at ease in Berlin, naturally, within the confines of the political situation. And something important: I learnt to ride a bike by the statue of Lenin. So he really was my teacher[282] and remains a strong albeit funny memory.

JB: In 1988, when you were eight years old, your family returned to Czechoslovakia. How do you remember the separation of the country in the summer of 1992? How did young Slovaks conceive of that crucial political event?

AB: I was very young, eleven years old, and everything I was consciously aware of was connected with a feeling of grief, a kind of mourning. My parents were sad, my mother called her sister in the Czech part, both cried on the phone. I can remember this scene vividly, as if it happened only yesterday. In the months that followed we had to cross an odd border, a border that had never existed before. As the years go by, these feelings are vanishing, but we Czechs and Slovaks are still close, like an older and younger brother.

JB: Your first job in the media was at Fun Radio. Did you already know what career you wanted to embark on, what profession you would choose?

[282] Adela Banášová jokingly refers to the popular Marxist-Leninist dogma of Lenin as the teacher of mankind in general and children in particular: "Give me four years to teach the children and the seed I have sown will never be uprooted;" on http://www.brainyquote.com/quotes/quotes/v/vladimirle153238.html; accessed 26 July 2014.

AB: My first job was on the morning broadcast of a commercial TV channel. I was sixteen and worked there as an assistant to the production assistant. I prepared short TV clips like the ones that are shown on the news, going with the cameraman to locations, learning about cutting and sound, basically everything one can learn about TV productions. But I didn't think much about my future. And as I don't have what are referred to as 'conventional' good looks, I didn't think I stood a chance of appearing on screen, of becoming a presenter on TV. So I just did what came along in the production area and I did it as best I could.

Then, a couple of years later, I entered a competition my favourite radio station organized. I was nineteen years old – and I won. From then on, my further education in the school of life and my life in the media started. I was very fond of the radio as a medium and really saw my future in radio.

The producers of the show 'Slovakia's Superstar' (*Slovensko hľadá superstar*), a talent show for singers, comparable with the British and US 'The X Factor', invited me to participate in the contest; they were looking for a presenter who could front the first series of the show. I had no clue what that was all about; I had seen a show on German TV and thought that the Slovak version would be something similar, nothing much to do for a presenter.

When I won the competition, a long period of major projects began. I just told the people in charge what I wanted and what I wanted to look like – they were not used to such frankness at all.

In the following years I was very popular; I was everywhere. But one really tires of that extreme celebrity. All the hype no longer made sense to me; I had seen enough, I was tired of being everywhere. When I started my job in the media, it made sense to me. Later, it didn't anymore. People's euphoria turned into a habit, while the TV producers saw me as a stable source of income, nothing more. I didn't want to continue like this.

JB: How did the collapse of Communism in 1989 affect the media? What possibilities opened up for you young people? And who were the sponsors?

AB: The commercial media started to operate almost immediately after the fall of Communism. All of a sudden, censorship was gone and one had to learn slowly to speak normally and express one's wishes openly. Today, of course, there is the censorship of money. Naturally, you can't say anything that is in the slightest critical of the sponsors. That is the power and the manipulation of the media, which is linked to higher spheres of power. Yet, you have to be aware of this and find your way all the same. In the beginning, the media often entered into the new spirit of the times in a funny way, but as time went by we learnt a lot. And now we find ourselves in an extreme situation of a different kind. Today, our media are commercialized as never before; nothing but reality shows, singing contests, talent shows etc.

JB: Your new show 'A Bit Different' (*Trochu jinak*), recorded at the Slovak National Theatre and broadcast by TV channel TA3, is very successful. The show's concept is quite courageous: you invite not only celebrities such as the famous actor Robert Roth, but also nobodies, people who are completely unknown. Yet the public loves the show – why?

AB: I would say that *Trochu jinak* is aimed at a specific, small yet loyal public. The show's concept is to present people who live in an inspired way, who do something valuable, but remain human and have a sense of humour. Our guests are scientists, ecologists, artists, people engaging in alternative medicine, 'simple' organic farmers, female lumberjacks, recycling designers, people who chose to do something good. And I also choose persons because they are likeable, people one wants to take home after the show.

JB: You are number one in the Slovak media – when you take your well-deserved summer holidays, the Slovak newspapers want to report about you, also because they sell more copies with you on the cover. How do you cope with that attention, how do you manage to find a balance between your private life and the media?

AB: That kind of attention is now rare since I have withdrawn from the large commercial projects. They still write a lot about me, but I also think that the journalists communicate with me in a different, more respectful tone. I have good relations with tabloid journalists, simply because I understand their profession, because I have never called them nasty or primitive.

In the end, publicity is a legitimate part of life in the media, of an existence in the media. One cannot be angry when things are written that are not true. Or things that are not very nice. But these articles have no influence on my private life, because I simply do what I want to, I act upon my desires and if somebody is interested and takes a picture – that's their business. As I don't read these pieces, they are no part of my reality.

JB: What are your plans for the future?

AB: To live as much as possible in the present.

JB: Dear Adela, thank you very much for the conversation.

Conclusion

This study is the first account in English of the life stories and personal experiences of seven Slovak women who rendered or are still rendering outstanding service to their nation. I tried to convey to the reader the complicated and often cruel history Slovak women had to deal with, situations of economic and political hardship 'Western' women cannot even begin to imagine.

From the second half of the 19th century to this day, Slovak women have lived through seven political regimes. The Magyar assimilation in the last decades of the 19th century, two world wars, interwar democracy, the SNP, the brutal years of early Communism, the Velvet Revolution of 1989, the unconstitutional dissolution of Czechoslovakia in 1992 and the semi-authoritarian regime of Vladimír Mečiar from 1994 to 1998 affected their views of politics and economics.

In 1998 however, Slovak citizens decided to set the young state on a Western course, voting the Mečiar regime out and the centre-right coalition of Mikuláš Dzurinda in, which resulted in EU and NATO membership in 2004. The young Republic was now firmly in the West and the traumatic experience of the Soviet occupation a thing of the past.

It is probably one of the biggest paradoxes in the history of Slovakia that the first steps towards female emancipation were taken in the years when the cultural institutions such as the high schools and the *Matica* were dissolved by the Hungarian authorities. Led by the chairwoman, Elena Maróthy-Šoltésová, the association *Živena* managed to survive in the harsh years of the assimilation exactly because of gender conservatism: the Hungarian authorities did not consider the little women's club as politically sig-

nificant. Thus, for many years, the association was the only representative of the Slovak nation, publishing books and journals in Slovak and taking care of the poor, striving to educate the nation and instil a sense of cultural independence and national consciousness.

Elena believed that female emancipation had to serve the nation, that women certainly had the right to be culturally active and appear in public, that is, not to be confined to their houses anymore. Yet, I think one cannot speak of a distinct Slovak women's movement, since, back in those years, the liberation of the nation was the principal goal of female and male patriots alike. Živena opened up the public sphere to women; however, as long as the nation was oppressed, the ideas of studying at the male-dominated universities, getting a job and being financially independent were but expressions of egocentricity. Women, so Elena thought, would fare best as mothers, taking care of their children and the nation alike. Compared with female emancipation in the Western European countries, Slovak women were more conservative, restraining their aims for constitutional equality with men. However, this was due to the political situation. Campaigning for female emancipation and resisting the pressure of assimilation at the same time would have meant fighting on two fronts.

Let us just remind ourselves that the British suffragettes, led by Emmeline Pankhurst (1858–1928), were force-fed after some of them went on hunger strike in the first years of the 20th century; their fight for the female right to vote was considered a brazen disruption of God-given order. Switzerland, one of the oldest democracies, adopted the female vote only in 1971; the referendum was supported by the majority of male citizens, since Swiss women were not allowed to cast their vote in the referendum that would prove so important for their political participation in the fu-

ture.²⁸³ I can vividly remember the description of my relative G. H. of what married Swiss women had to put up with before the right to vote was enshrined in the Swiss constitution: married women could not make purchases on their own. If they bought a piece of furniture with their own money, the husband had to sign the contract!

The Slovak women's movement in the 19th century was rather conservative, so much so that Mária Bellová's graduation was almost ignored, even by *Živena*. Because she had graduated at Budapest university, in the cradle of the oppressor, so to speak, the first female Slovak physician was discriminated against by the new Czechoslovak government. It was only thanks to the efforts of her colleague Jozef Uram, a fellow student from Budapest University who was already head physician in the state hospital in Košice in the 1920s, that Mária was able to find employment in Slovakia.

The First Republic established equality before the law for women and men, which gave the women's movement a boost. Girls could study whatever they liked, and a labour market for women began to develop. The liberty of Masaryk's Republic protected the rights of the religious and ethnic minorities: the German and Magyar minorities could send their delegates to the Czechoslovak parliament, and the Jewish community experienced an era of tolerance and equality with the Gentiles.

The experience of the First Republic's tolerance and the shock created by the pro-active deportation of the Slovak Jews by the clerical-fascist Tiso regime were the main reasons for the Zionist Chaviva Reiková to return to her native Slovakia. The totalitarianism and conservatism of the Tiso regime, with its concomitant anti-feminism, lasted five years. Married women were banned from the workforce, expected to produce children and de-

²⁸³ On the referendum see http://history-switzerland.geschichte-schweiz.ch/chronology-womens-right-vote-switzerland.html; accessed 30 July 2014.

vote themselves to the regime's three Cs: cooking, children and Catholicism. Abortion was a legal offence, and the HSĽS regime made sure that children were brought into line in the Hlinka youth. The Slovak Communist Party operated in the underground, and citizens of all political parties who dared to criticize the regime were imprisoned in Ilava in the early days of the Slovak state, in March 1939. Chaviva could have stayed in Palestine, witnessed the foundation of the state of Israel in 1948, got a university education and had a family of her own; but she returned to her native Slovakia and lost her life in the SNP.

Thanks to the uprising, Slovakia came out of WWII on the side of the victorious allies, but post-war Slovak attempts to establish constitutional equality with the Czechs in the common state failed. In the three short post-war years, the Communist Party positioned itself to assume power; when Czechoslovakia refused to participate in the Marshall Plan in 1947 it was quite obvious that the country was under Stalin's control.

The Cold War started: the Communist Party assumed power on 25 February 1948 and the die was cast. The brutal Sovietization of the country began, with all the associated events such as the eviction of 'bourgeois' middle-class families from the cities in *Akcia B*, the show trial in the 1950s of the 'Slovak bourgeois nationalists' and the building of heavy industry in the countryside that would serve Soviet economic interests.

When Alexander Dubček was elected First Secretary of KSČ in December 1967, the Prague Spring would leave its imprint on the minds of Czechoslovak citizens for many years to come. For a brief period of eight months, Czechoslovak citizens experienced liberty in the very sense of freedom from political oppression and freedom to voice one's opinion. They could travel abroad without a visa, and censorship ceased to exist. Historians in particular were

able to rectify the ideological distortions historical materialism had wrought since 1948.

Anna Štvrtecká, a Party member and historian specializing in the history of KSS, protested against the politics of normalization that started in the night of the invasion of the Warsaw Pact troops on 21 August 1968. In 1969, she published an article about the SNP that was an exoteric text, a concealed critique of the invasion and occupation. In her letter to the chairman of the Slovak Historical Society she implored him to stand up for Czech and Slovak historians who had lost their positions because they had refused to publicly support the official course, to sign the official pamphlet about the counter-revolution. Anna could have lied, signed the pamphlet, kept her position and led the undisturbed life of a member of the prestigious Academy of Sciences, but she refused to cave in to political pressure. Naturally, she lost her position and had to deal with constant economic hardship and interrogation by the ŠtB.

The Velvet Revolution swept away the Communist regime in 1989. Unlike in the Czech part, Slovakia's democratization started slowly, since the Communist regime had industrialized the country, and many citizens fondly remembered the old days, the rise in quality of life under the Communist regime.

Magdaléna Vášáryová, a graduate in sociology from Comenius University and member of a family that was critical of the Communist regime, was well known to Czechoslovak president Václav Havel. Havel had been one of the first three spokesmen of *Charter 77* together with former foreign minister Jiří Hájek (1913–1993) and Professor Jan Patočka (1907–1977), a philosopher and student of the famous German phenomenologist Edmund Husserl (1858–1938). President Havel appointed Mrs Vášáryová, an artist of outstanding merit, the first female Czechoslovak ambassador and she was posted to Austria in 1990. When the prime ministers of Slovakia and the Czech lands decided to separate the country, Mrs

Vášáryová was offered a position as an ambassador of the Czech Republic. She could have moved her family to Prague and kept her position in the Czech Foreign Ministry; employed as an ambassador with all the tangible and intangible benefits of such a responsible position, she could have led the life of a Czech diplomat representing the values of the Czech Republic in various countries. But she decided to return to Slovakia and fight the semi-authoritarian regime of Premier Mečiar, engaging in politics and culture.

Iveta Radičová, a sociologist with a PhD from Comenius University and the SAV alike, entered politics in 1989; she was a spokeswoman for VPN and later joined the centre-right coalition of Mr Dzurinda. Mrs Radičová was the first female prime minister in Slovak history and stepped down when her party lost a vote of confidence in parliament. In the difficult first years of Slovakia's sovereignty after 1993, Mrs Radičová could have moved to the Czech Republic and apply for Czech citizenship, as many Slovaks critical of the Mečiar regime did. She could have stayed in Oxford, applied for British citizenship and started an academic career in England, yet she returned to Slovakia and engaged in politics, fighting, like Mrs Vášáryová, for a democratic Slovakia, Western political values and a Western political orientation.

Adela Banášová is the face of young Slovakia, a small state in Central Europe that has successfully entered European politics and is catching up with the so-called West. She is a celebrity in Slovakia and the Czech Republic alike. Adela is the symbol of modernity, the Western political values such as openness, democracy and education; she is a prime example of a new generation of young Slovak women who benefitted from university education and, owing to their hard work, found good positions. She could have continued as a presenter focusing on a career in the Czech Republic or Germany; yet, her sense of self-assurance and immense popularity have not affected her critical reasoning, nor made her indulge in

arrogance or idleness. She decided to reduce her activities as a presenter; at the moment, Adela is embarking on a change of career. Whatever her next move, I am quite certain that she will be successful.

I hope that my study of seven Slovak women, their courage and commitment to humanism and enlightenment will lead to an increasing interest in the young Republic's history and a better understanding of Slovak politics. Slovakia is still painfully under-represented in European historiography. If my study can help to change this, I shall be more than happy.

Appendix

Chronology

1855, 1 March	Elena Maróthy born in Krupina.
1860	Marína Hodžová founds *Beseda*, a discussion and reading circle for girls.
1861	Memorandum of the Slovak nation, demanding a status of autonomy within the kingdom of Hungary. Franz Joseph I, Austrian Emperor and King of Hungary in personal union ignores the memorandum.
1867	The Austro-Hungarian Compromise (*Ausgleich*) divides the empire into two parts; Vienna has no more say in the domestic affairs of the Hungarian kingdom.
1868	The Hungarian government issues the nationality law, infringing on the language rights of the non-Magyars in the kingdom.
1869	Foundation of *Živena* in Turčiansky sv. Martin; the fourteen-year-old Elena Maróthy joins the women's association.
1874	Last Slovak gymnasium closed down by the authorities.
1875	The cultural institution *Matica Slovenská* closed down by the authorities.
1885–1927	Elena Maróthy-Šoltésová serves as chairwoman of *Živena*.
1885, 10 November	Mária Bellová born in Liptovský sv. Peter.

1905	Mária Bellová enrols in the medical faculty of Budapest University.
1906	Trial of Vavro Šrobár, Andrej Hlinka and associates; they are accused of anti-patriotic activities as they had run for SNS in the elections to the Hungarian assembly.
1907	The Education Act (*Lex Apponyi*) stipulates Hungarian as the language of instruction in all primary schools.
1910	Mária Bellová is the first Slovak woman to graduate with a doctorate in medicine from Budapest University.
1914, 21/22 July	Adele Rosenbergová (later Chaviva Reiková) born in Sajóháza.
28 July	Start of WWI; Mária Bellová serves in a front-line hospital in Transylvania.
1918, 18 October	Declaration of Washington signed by Tomáš Garrigue Masaryk, Milan Rastislav Štefánik and Edvard Beneš. The exile troika represents the provisional Czechoslovak government with Masaryk as President, Štefánik as Minister of Defence and Beneš as Minister of the Interior.
28 October	Czechoslovak Declaration of Independence signed in Prague by Czech politicians and Šrobár as representative of the Slovaks.
30 October	All prominent Slovak politicians and members of the SNR sign the Declaration of Martin, expressing the free will of the Slovaks to live in a common state with the Czechs, thereby announcing Slovak secession from the Hungarian kingdom. They do not know about the Czechoslovak Declaration of Inde-

	pendence of 28 October in Prague because the Hungarian newspapers did not report about it due to war censorship. The Martin declaration represents the legitimate consent of Slovakia to becoming a part of Czechoslovakia.
10 December	The members of the Club of Slovak parliamentarians appoint Šrobár Minister Plenipotentiary for Slovakia, enabling him and his associates to establish Czechoslovak rule in Slovakia.
1919, 18 January	Pressburg/Poszony declared the seat of the Czechoslovak government in Slovakia.
21 March	Béla Kun assumes power in Hungary; occupation of the southern parts of Czechoslovakia by the Hungarian Red Army.
27 March	Pressburg/Poszony renamed Bratislava.
27 June	Foundation of Comenius University in Bratislava.
1920	Foundation of the Šrobár Institute for tuberculosis and respiratory illnesses in children in Dolný Smokovec.
1924, 14 October	Anna Hučková (later Štvrtecká) born in Vaďovce.
1925	Mária Bellová employed at the Šrobár Institute.
1935	Milan Hodža elected Prime Minister of Czechoslovakia. He holds this position until 22 September 1938.
1937, 14 Sept.	President Masaryk dies in Lány.
1938, 30 Sept.	Munich Agreement. Czechoslovakia loses the Sudetenland and Silesia to Germany.

	Beneš, Hodža and the Czechoslovak government go into exile in October.
6 October	Declaration of Slovakia's autonomy. HSĽS and the Hlinka guards in power.
2 November	German-orchestrated Vienna Arbitration (*Viedenská arbitráž*); Czechoslovakia loses territory in the south to Hungary.
1939, 11 February	Elena Maróthy-Šoltésová dies in Martin.
1 March	Anti-Jewish pogrom in the western Slovak spa town Piešťany.
9-10 March	Czechoslovak President Emil Hácha orders the occupation of Slovakia, referred to as the Homola putsch (*Homolov puč*).
14 March	Under German pressure, Jozef Tiso declares Slovakia's sovereignty; the state becomes a satellite of Nazi Germany.
15 March	Hácha signs the Czech capitulation. German troops occupy Bohemia and Moravia, which are subsequently referred to as the protectorate.
18 March	Beginning of the expulsion of Czechs and their families from the Slovak state.
29 March	First deportation of Slovak citizens critical of the Tiso regime to the Ilava prison.
1 September	German attack on Poland; start of WWII. Adele Rosenbergová and some ten Slovak Jews leave for Palestine.
1941, 23 June	Slovakia joins Germany in the attack on the Soviet Union.

9 September	Adoption of the Jewish codex in the Slovak constitution, infringing the Jews' civil and religious rights.
1942, 25 March	First transport of Slovak Jews to concentration camps in Poland and Germany.
15 May	Adoption of the constitutional law that deprives the Jews of their citizenship and legitimates their deportation to the camps. By October 60,000 Jews have been deported.
1943	Anna Hučková joins the illegal KSS; she will participate in the SNP in the autumn of 1944.
1944, 6 June	Allied landing in Normandy.
20 July	Failed attempt on Hitler's life.
29 August	German occupation of Slovakia to fight the partisans, called in by the Tiso government. Start of the Slovak National Uprising (SNP).
17 September	Chaviva Reiková lands in Slovakia. Resistance activities and liason with the British. She flees with partisans to the mountains, where Alice Dubova sees her operating a radio transmitter in a cabin.
27 October	Fall of Banská Bystrica, end of the uprising. The Red Army liberates Eastern Slovakia at the end of 1944.
31 October	Chaviva Reiková and her platoon caught by the Germans. Imprisoned in Banská Bystrica prison and tortured by the Gestapo.
20 November	Chaviva Reiková and her fellow prisoners shot by the Gestapo.
1945, 22–29 March	Signing of the Košice Agreement in Moscow. The negotiating parties, hosted by Stalin, are

	the members of the London exile government, Czech centre-right parties, the SNR and the Communist exiles in Moscow. Beneš and Stalin do not intervene in the negotiations.
5 April	Declaration of the Košice Agreement in Košice.
9 May	Liberation of Prague by the Red Army.
10 May	Czechoslovak government moves to Prague.
2 June	First Agreement of Prague. Slovak demand for constitutional equality blocked.
7-8 July	Foundation of the Democratic Party (DS).
11 April	Second Agreement of Prague. Negotiations unsuccessful for the Slovaks.
26 May	First Czechoslovak post-war parliamentary elections to the Constitutional Assembly. DS wins 62% of the vote in Slovakia, KSS 30% and SSl 3.73%.
27 July	Third Agreement of Prague, as unsuccessful as the previous two.
1948, 25 February	Communist coup d'état. President Beneš dissolves the democratically elected government and appoints a new government according to Klement Gottwald's suggestions. Antonín Zápotocký appointed Prime Minister.
10 March	Mysterious death of Jan Masaryk.
7 June	Beneš resigns; Gottwald Czechoslovak President.
26 August	Magdaléna Vášáryová born in Banská Štiavnica.

1952	Show trial of Rudolf Slánský, Vladimír Clementis and thirteen other Party members, 11 of the 14 accused are Jewish. Slánský, Clementis and nine fellow accused executed in December. Trial against the 'Slovak bourgeois nationalists' in preparation, among them Gustáv Husák and Laco Novomeský.
1953	Stalin dies on 5 March; Gottwald follows on 14 March. Anna Štvrtecká accomplishes her studies of philosophy and history with a doctorate. Employed at the Institute of the History of KSS.
1954	Husák and Novomeský sentenced to life imprisonment.
1956, 25 February	Nikita S. Chruščev's secret speech to the XX Party Congress, initiating de-Stalinization.
7 December	Iveta Karafiatová (later Radičová) born in Bratislava.
1957	Antonín Novotný Czechoslovak Prime Minister.
1963	The Kolder and Barnabite commissions publish their reports about the 1950 show trials.
8 April	Alexander Dubček elected general secretary of KSS.
1967	Magdaléna Vášáryová plays the leading role in *Marketa Lazárova*, an internationally acclaimed film.
1968, 3-5 January	The CC of KSČ vote Novotný out and elect Dubček first secretary. Start of the Prague Spring. Anna Štvrtecká employed at the In-

	stitute of Political Sciences at Comenius University.
21 August	Invasion of the Warsaw Pact troops; beginning of the normalization.
1969	Husák replaces Dubček as first secretary on 17 April. Anna Štvrtecká loses her position at the university and the board of the Society of Slovak historians; she finds employment at the State Archive.
1970, December	The CC publishes *Lessons Learned from the Critical Developments in Party and State Following the XIII Congress of KSČ*, rendering the normalization legitimate. The country is transformed into a federation (ČSSR), though not a real one as KSČ does not federalize. Iveta Karafiatová enrols in the Department of Sociology of Comenius University in Bratislava.
1973, 20 November	Mária Bellová dies in Príbovce.
1975	Gustáv Husák elected president.
1979	Iveta Radičová accomplishes her studies with a PhD. Start of her academic career at the Slovak Academy of Sciences (SAV).
1977, 1 January	Foundation of *Charter 77*, the Czechoslovak dissident group that speaks out for civil rights.
1980, 12 October	Adela Banášová born in Bratislava.
1983 – 1988	Adela Banášová spends a part of her childhood in East Berlin; her father Jozef Banáš is cultural attaché at the Czechoslovak embassy in the German Democratic Republic.

1985, 15 March	Michail S. Gorbačev elected general secretary of the Soviet Communist Party. Begin of Glasnosť and Perestroika.
1988	Magdaléna Vášáryová nominated merited artist of Czechoslovakia.
1989, 17 November	Start of the Velvet Revolution. Foundation of *Civic Forum* (OF) and *Society Against Violence* (VPN). Iveta Radičová co-organizer and speaker of VPN.
1990, 23 April	Constitutional amendment: Democratic Czechoslovakia becomes a federation (ČSFR).
June	First free elections in Czechoslovakia since 1946.
1990 – 1993	Magdaléna Vášáryová is Czechoslovak ambassador to Austria. In 1990, Iveta Radičová is a visiting post-doc fellow at Oxford University for nine months.
1992, summer	Negotiations of Czech Prime Minister Klaus (ODS) and Slovak Premier Mečiar (HZDS) about a common course of economic transformation fail. They decide to dissolve the state, which is a violation of the Czechoslovak constitution.
1993, 1 January	Slovakia becomes a sovereign state.
1993	Magdaléna Vášáryová founds the *Slovak Foreign Policy Association* (SFPA).
1995, 8 January	Anna Štvrtecká dies in Bratislava.
1998	Mikuláš Dzurinda and his centre-right coalition win the parliamentary elections; end of the Mečiar government and its semi-autoritarian regime.

1999	Magdaléna Vášáryová runs in the presidential elections.
2000 – 2005	Magdaléna Vášáryová appointed Slovak ambassador to Poland. In 2005 she joins the centre-right party SDKÚ and is elected member of parliament.
2004	Adela Banášová graduates from Comenius University in Cultural Studies. She wins the first of her eight OTO Awards for the most popular presenter in entertainment.
2005 – 2006	Iveta Radičová Minister of Labour in the government of Mikuláš Dzurinda. On 15 June 2005, President Ivan Gašparovič appoints her Professor of Sociology at Comenius University.
2007, 22 March	Magdaléna Vášáryová founds the NGO *Via Cultura*.
2009	Iveta Radičová runs in the presidential elections.
2010, 8 July	Iveta Radičová elected first female prime minister of Slovakia.
2012, 4 April	Iveta Radičová resigns from the premiership.
2013, 12 December	Magdaléna Vášáryová leaves SDKÚ-DS, but remains a member of parliament.
2014, 18 March	Iveta Radičová announces her retirement from politics.

Bibliography

"Bratislava, 1992, 22 října. Protest iniciativy 'Za spoločný štát' proti dohodě o rozdělení Československa zaslaný generálnímu tajemníkovi OSN Butrusovi Butrusovi Ghálímu". In *Češi a Slováci ve 20. století. Česko-slovenské vztahy 1945–1992*. Bratislava, Praha: AEP, ústav T. G. Masaryka, 1998; referred to as *Češi a Slováci II*.

"Ružomberská Golgotha". *Slovenský Týždenník IV*, no. 26, 29 June 1906, 1-2.

"Sedemdesiate vianoce prvej slovenskej lekárky". *Ľud 8*, 24 December 1955, 5.

"Zákon na ochranu mladistvých osôb pred alkoholem". In *Niekoľko slov k slovenským ženám*. Bratislava: Krajinské ústredie pre Slovensko, Čsl. Abstinentného sväzu, 1932.

Aron, Raymond. *The Opium of the Intellectuals*. New Brunswick, London: Transaction Publishers, 2005.

Arpáš, Róbert. "Metamorfózy vzťahu slovenských komunistov k československému štátu v rokoch 1939–1945". In *Český a slovenský komunismus (1921–2011)*. Praha: Ústav pro studium totalitních režimů, 2012.

Ash, Timothy Garton. "Mitteleuropa?" *Daedalus 119*, no. 1 (1990): 1-21.

Augustinska, Daniela. "Bola prísna, ale láskavá". *Život 44*, no. 10 (1994): 26-27.

Baer, Josette. "Štefan Marko Daxner (1822–1892). Law and education". In *Revolution, Modus Vivendi or Sovereignty? The Political Thought of the Slovak National Movement from 1861 to 1914*. Stuttgart: ibidem, 2010.

Baer, Josette. "Surviving Totalitarian Regimes. An oral history interview with Mimi Jiránková and Nataša Lišková". *New Eastern Europe 4*, no. 1 (2014): 156-160.

Baer, Josette. "Svetozár Hurban Vajanský (1847–1916). Messianism, Panslavism and the superiority of art". In *Revolution, Modus Vivendi or Sovereignty? The Political Thought of the Slovak National Movement from 1861 to 1914*. Stuttgart: ibidem, 2010.

Baer, Josette. "Thomas G. Masaryk and Svetozár Hurban Vajanský. A Czecho-Slovak friendship?" *KOSMAS. Czechoslovak and Central European Journal 26,* no. 2 (2013): 50-62.

Baer, Josette. "Twilight of the Idols in Slovakia - or using Nietzsche's hammer to strenghten the nation". In *Kapitoly z histórie stredoeurópskeho priestoru v 19. a 20. storočí. Pocta k 70-ročnému jubileu Dušana Kováča*. Bratislava: Historický ústav Slovenskej Akademie Vied SAV, 2012.

Baer, Josette. "Živena – die helfende weibliche Hand? Zur Lage der Frauen in der Slowakei vor dem I. Weltkrieg". In *Körper*. Basel: Schwabe, 2012.

Baer, Josette. *A Life Dedicated to the Republic. Vavro Šrobár's Slovak Czechoslovakism.* Stuttgart: ibidem, 2014.

Baer, Josette. *Politik als praktizierte Sittlichkeit. Zum Demokratiebegriff von Thomas G. Masaryk und Václav Havel.* Sinzheim: Pro Universitate, 1998.

Baer, Josette. *Preparing Liberty in Central Europe. Political texts from the Spring of Nations 1848 to the Spring of Prague 1968.* Stuttgart: ibidem, 2006.

Banáš, Jozef. *Zastavte Dubčeka! Príbeh človeka, ktorý prekážal mocným.* Bratislava: Ikar, 2009.

Barnovský, Michal. "Za PhDr. ANNA ŠTVRTECKOU, CSc., (1924–1995)". *Historický časopis 43*, no. 2 (1995): 414-416.

Bartlová, Alena. "Posledné parlamentné voľby v máj 1935". In *V medzivojnovom Československu 1918–1939*. Bratislava: Veda, 2012.

Baverez, Nicolas. *Raymond Aron. Un moraliste au temps des ideologies.* Paris: Perrin, 2006.

Beneš, Edvard. *Paměti II. Od Mnichova k nové válce a k novému vítězství.* Praha: Academia, 2008.

Berlin, Isaiah. "Two Concepts of Liberty". In *Four Essays on Liberty.* Oxford, New York: Oxford University Press, 1969.

Binney, Marcus. *The women who lived for danger. Behind enemy lines during WWII.* New York: Harper Collins, 2003.

Bystrický, Valerián a kol. *Rok 1968 na Slovensku a v Československu.* Bratislava: HÚ SAV, 2008.

Bystrický, Valerián. "Vysťahovanie českých štátnych zamestnancov zo Slovenska v rokoch 1938–1939". In *Od autonómie k vzniku Slovenského štátu.* Bratislava: Prodama, 2008.

Čaplovič, Miloslav. "Československa armáda medzi Mníchovom 1938 a marcom 1939 s dôrazom na Slovensko". In *Rozbitie alebo rozpad? Historické reflexie zániku Česko-Slovenska.* Bratislava: Veda, 2010.

Cartledge, Bryan. *The Will to Survive.* London: C. Hurst & Co., 2011.

Dejiny SNP 1944, 5. Sväzok. Bratislava: Pravda, 1984.

Doskočil, Zdeněk. "Cesta Gustáva Husáka k moci (1963–1969)". In *Český a slovenský komunismus (1921–2011).* Praha: Ústav pro studium totalitních režimů, 2012.

Dubček, Alexander. *Hope dies last. The autobiography of Alexander Dubcek.* London: Harper Collins, 1993.

Dubček, Alexander. *Leben für die Freiheit.* München: Bertelsmann, 1993.

Dubova, Alice. "War experiences with Slovakian partisans". Yad Vashem Archives, Wiener Library Collection, record group 0.2, file no. 668, 14 pages.

Dudéková, Gabriela, a kol. *Medzi provinciou a metropolou. Obraz Bratislavy v 19. a 20. storočí.* Bratislava: HÚ SAV, 2012.

Dudeková, Gabriela. "Konzervatívne feministky?" In *Na ceste k modernej žene. Kapitoly z dejín rodových vzťahov na Slovensku*. Bratislava: Veda, 2011.

Dudeková, Gabriela. "Learning to Crawl before We Can Walk: Gender in Historical Research (Not Only) in Slovakia". In *Historiography in Motion: Slovak Contributions to the 21st International Congress of Historians*. Bratislava: Veda, 2010.

Dudeková, Gabriela. *Na ceste k modernej žene. Kapitoly z dejín rodových vzťahov na Slovensku*. Bratislava: Veda, 2011.

Dzvoník, Michal. "Osud lojálneho občana". *Historická revue VI*, no. 8 (1995): 28-29.

Einhorn, Barbara. "Where Have All the Women Gone? Women and the Women's Movement in East Central Europe". *Feminist Review XXXIX* (1991): 16-36.

Falisová, Anna. "Medzivojnové zmeny v zdravotníctve". In *V medzivojnovóm Československu 1918–1939. Slovensko v 20. storočí. Tretí zväzok*. Bratislava: Veda, 2012.

Gehmacher, Johanna, and Natascha Vittorelli (eds.). *Wie Frauenbewegung geschrieben wird. Historiographie, Dokumentation, Stellungnahmen, Bibliographien*. Wien: Erhart Locker, 2009.

Goněc, Vladimír. "Z exilových diskusi 80. let: pojem střední Evropy". In *Česko-Slovenská historická ročenka 2012. Češi a Slováci 1993–2012*. Bratislava: Veda, 2012.

Gorbačov, Michail, and Zdeněk Mlynář. *Reformátoři nebývají šťastni*. Praha: Victoria Publishing, 1995.

Guillebaud, Jean-Claude. "Autour du livre de ma cousine de Bratislava". In *Une saison à Bratislava. Présenté par Simone Signoret*. Paris: Éditions du Seuil, 1981.

Hain, Radan. *Staatstheorie und Staatsrecht in T. G. Masaryks Ideenwelt*. Zürich: Schulthess, 1999.

Havel, Václav. "Anatomie jedné zdrženlivosti (duben 1985)". In *Do různých stran*. Praha: Lidové Noviny, 1989.

Hoffmann, Roland J. *T. G. Masaryk und die tschechische Frage*. München: Oldenbourg, 1988.

Hollý, Karol. "Mária Bellová – prvá Slovenská lekárka". In *Na ceste k modernej žene. Kapitoly z dejín rodových vzťahov na Slovensku*. Bratislava: Veda, 2011.

Hollý, Karol. *Ženská Emancipácia. Diskurz slovenského národného hnutia na prelome 19. a 20. storočia*. Bratislava: HÚ SAV, 2011.

Holotík, Ľudovít. "Der österreichisch-ungarische Ausgleich und die Slowaken". In *Der österreichisch-ungarische Ausgleich 1867. Materialien (Referate und Diskussion) der internationalen Konferenz in Bratislava 28. 8 – 1.9 1967*. Bratislava: Verlag der Slowakischen Akademie der Wissenschaften, 1971.

Holotíková, Zdenka, and Viliam Plevza. *Vladimír Clementis*. Bratislava: Vydavateľstvo politickej literatúry v edícii Postavy slovenskej politiky, 1968.

Hroch, Miroslav. *Das Europa der Nationen. Die moderne Nationsbildung im europäischen Vergleich*. Göttingen: Vandenhoeck & Ruprecht, 2005.

Hudek, Adam. "Dilemy kommunistického pristupu k vedeckej politike na Slovensku v 50. rokoch 20. storočia". In *Český a slovenský komunismus (1921–2011)*. Praha: Ústav pro studium totalitních režimů, 2012.

Hudek, Adam. "Obdobie 'konsolidácie' a 'normalizácie' 1969–1989". In *Dejiny SAV*. Bratislava: Veda, 2014.

Jablonický, Jozef. *Z illegality do povstania. Kapitoly z občianskeho odboja*. Banská Bystrica: Múzeum SNP, 2009 (2).

Jaksicsová, Vlasta. "'Pokolenie v útoku'. *Kultúrny život* v zrkadle ideologickej (ne)kultúry v rokoch 1948–1953". In *Slovensko v labyrinte Európskych dejín. Pocta historikov Milanovi Zemkovi*. Bratislava: HÚ SAV a Prodama, 2014.

Judt, Tony. *Past Imperfect. French Intellectuals, 1944–1956*. New York, London: New York University Press, 2011.

Junas, Ján. "Zo slovenského asklepiónu Mária Bellová". *Slovenský Lekár 7*, no. 1 (1997): 50.

Kamenec, Ivan. *Tragédia politika, kňaza a človeka. Dr. Jozef Tiso, 1887–1947.* Bratislava: Premedia, 2013.

Kaplan, Karel. *Report on the Murder of the General Secretary.* Columbus: Ohio State University Press, 1990.

Kázmerová, Ľubica, a kol. *Premeny v školstve a vzdelávaní na Slovensku (1918–1945).* Bratislava: HÚ SAV, 2012.

Kershaw, Ian. *Hitler.* London: Penguin, 2008.

Kocák, Michal. "Elena Maróthy-Šoltésová, 6. 1. 1855 – 11. 3. 1939". *Séria: Fotosúbory.* Martin: Matica Slovenská, 1985.

Kodajová, Daniela. "Odborné vzdelávanie ako predpoklad a prostriedok emancipácie". In *Na ceste k modernej žene. Kapitoly z dejín rodových vzťahov na Slovensku.* Bratislava: Veda, 2011.

Kodajová, Daniela. "Živena – spolok slovenských žien". In *Na ceste k modernej žene. Kapitoly z dejín rodových vzťahov na Slovensku.* Bratislava: Veda, 2011.

Konrád, György. "Is the Dream of Central Europe still alive?". *Cross Currents 5* (1986): 109-121.

Korespondence T. G. Masaryk – slovenští veřejní činitelé (do r. 1918). Praha: Masarykův ústav a Archiv AV ČR, 2007.

Kosta, Jiří. "Systemwandel in der Tschechoslowakei. Ökonomische und politische Aspekte". *Osteuropa 41*, no. 9 (1990): 802-818.

Kostlan, Antonín. "KSČ a věda. Hlavní koncepty vědní politiky v Československu 1945–1989". In *Český a slovenský komunismus (1921–2011).* Praha: Ústav pro studium totalitních režimů, 2012.

Kováč, Dušan. *Dejiny Slovenska.* Praha: Lidové Noviny, 2007 (2).

Kováč, Dušan. *Slováci, Česi, Dejiny.* Bratislava: AEP, 1997.

Kováčiková, Terézia. "Ženy v národnooslobodzovacom zápase (1939–1945)". In *Zborník múzea Slovenského Národného povstania 7*. Osveta: Martin, Múzeum SNP v Banskej Bystrici, 1982.

Krajčovičová, Natália. "Veľká dcéra veľkého otca Alice Masaryková". In *Slovensko na ceste k demokracii*. Bratislava: HÚ SAV, 2009.

Kundera, Milan. "The Tragedy of Central Europe". *The New York Review of Books 31*, no. 26 (1984): 33-39.

Kusý, Ivan. *Význam Eleny Maróthy-Šoltésovej v slovenskej literature a v slovenskom ženskom hnutí*. Bratislava: Osvetový ústav, 1968.

Langer, Jo. *Convictions. My life with a good communist*. London: Granta, 2011.

Langerová, Jo. *Môj život s Oscarom L*. Bratislava: Marenčin PT, 2007.

Lexikón Slovenských žien. Martin: Slovenská Národná Knižnica, Národný Biografický Ústav, 2003.

Lipták, Ľubomír. "Elitenwechsel in der bürgerlichen Gesellschaft der Slowakei im ersten Drittel des 20. Jahrhunderts". In *Bürgertum und bürgerliche Gesellschaft in der Slowakei 1900–1989*. Bratislava: AEP, 1997.

Londák, Miroslav, Slavomír Michálek a kol. *20 rokov samostatnej Slovenskej republiky. Jedinečnosť a diskontinuita historického vývoja*. Bratislava: Veda, 2013.

Londák, Miroslav, Stanislav Sykora and Elena Londáková. *Predjarie. Politický, ekonomický a kultúrny ývoj na Slovensku v rokoch 1960–1967*. Bratislava: 2002.

London, Artur. *On trial*. London: Macdonald, 1970.

Lovčí, Radovan. *Alice Garrigue Masaryková. Život ve stínu slavného otca*. Praha: Filozofická fakulta Univerzity Karlovy, 2007.

Macho, Peter. *Milan Rastislav Štefánik v hlavách a srdciach. Fenomén národného hrdinu v historickej pamäti*. Bratislava: HÚ SAV, 2011.

Magocsi, Paul Robert. *Historical Atlas of Central Europe. Revised and expanded version.* Seattle: University of Washington Press, 2002.

Maier, Diemut. *"Non-Germans" under the Third Reich. The Nazi Judicial and Administrative System in Germany and Occupied Eastern Europe, with special regard to Occupied Poland, 1939–1945.* Baltimore, London: Johns Hopkins University Press, 2003.

Mannová, Elena. "Krízy lojality". In *Prvá svetová vojna 1914–1918. Slovensko v 20. storočí. Druhý zväzok.* Bratislava: Veda, 2008.

Mannová, Elena. "Kultúra vo víchrici ukrutenstva'". In *Prvá svetová vojna 1914–1918. Slovensko v 20. storočí. Druhý zväzok.* Bratislava: Veda, 2008.

Mannová, Elena. "Mužské a ženské svety v spolkoch". In *Na ceste k modernej žene. Kapitoly z dejín rodových vzťahov na Slovensku.* Bratislava: Veda, 2011.

Margolius Kovály, Heda. *Under a cruel star. A life in Prague from 1941 to 1968.* London: Granta, 2010.

Marković, Nenad. "Nationalism and Mentality". In *From Postcommunism Toward the Third Millenium. Aspects of Political and Economic Development in Eastern and South-Eastern Europe from 2000–2005.* Bern: Peter Lang, 2011.

Maróthy-Šoltésová, Eléna. "Slovenskej mládeži". *Slovenská otčina. Vlastivedný sborník pre mládež I*, no. 6-7 (1925): 94-95.

Marušiak, Juraj. "Slovenská spoločnosť a normalizácia". In *Česká a slovenská společnost v období normalizace. Slovenská a česká spoločnosť v čase normalizácie. Liberecký seminar 2001.* Bratislava: Veda a Ústav politických vied SAV, 2003.

Masaryk, Tomáš G. *Česká otázka. Naše nynější krize.* Praha: Academia, 1990.

Mastný, Vojtech. "The Czechoslovak Government in Exile During World War II". *Jahrbücher für Geschichte Osteuropas 27*, no. 4 (1979): 548-563.

Michálek, Slavomír, Miroslav Londák a kol. *Gustáv Husák. Moc politiky. Politik moci.* Bratislava: Veda, 2013.

Michálek, Slavomír. *Za hranicou sloboda 1948–1953. Dakoty 'slobody' a vlak do Selbu.* Bratislava: Veda, 2013.

Milosz, Czesław. "Central European Attitudes". *Cross Currents 5* (1986): 101-108.

Mraz, Andrej. "O dlhom živote". In *Živena XXV.* Martin: Živena, 1935.

Nižňanský, Eduard. "Pogrom v Piešťanoch roku 1939". In *Z dejín demokratických a totalitných režimov na Slovensku a v Československu v 20. storočí. Historik Ivan Kamenec 70-ročný.* Bratislava: HÚ SAV, Prodama, 2008.

Pasák, Tomáš. *Emil Hácha (1938–1945).* Praha: Rybka Publishers, 2007 (2).

Pauer, Jan. *Prag 1968. Der Einmarsch des Warschauer Paktes. Hintergründe – Planung – Durchführung.* Bremen: Edition Temmen, 1995.

Pažout, Jaroslav. "Trestněprávní perzekuce odpůrců režimu v období tzv. Normalizace (1969–1989) – faktor stability a indikátor rozkladu kommunistického režimu". In *Český a slovenský komunismus (1921–2011).* Praha: Ústav pro studium totalitních režimů, 2012.

Pekník, Miroslav (ed.). *Slovenské národné povstanie 1944. Súčať europskej antifašistickej rezistencie v rokoch druhej svetovej vojny.* Bratislava: Veda, 2009.

Pekník, Miroslav, and Eleonora Petrovičová (eds.). *Laco Novomeský. Kultúrni politik, politik v kultúre.* Bratislava: Veda, 2006.

Pešek, Jan. "'Očista' veľkých miest". In *Štátna moc a spoločnosť na Slovensku 1945–1948–1989.* Bratislava: HÚ SAV, Prodama, 2013.

Pešek, Jan. "Nepriateľ so stranickou legitimáciou. Proces s tzv. slovenskými buržoáznymi nacionalistami". In *Storočie procesov. Súdy, politika a spoločnosť v moderných dejinách Slovenska.* Bratislava: Veda, 2013.

Plaschka, Richard G., and Karlheinz Mack (eds.). *Wegenetz europäischen Geistes. Wissenschaftszentren und geistige Wechselbeziehungen zwischen Mittel- und Südosteuropa vom Ende des 18. Jahrhunderts bis zum ersten Weltkrieg.* Wien: Verlag für Geschichte und Politik, 1983.

Plaschka, Richard G., and Karlheinz Mack (eds.). *Wegenetz europäischen Geistes II. Universitäten und Studenten. Die Bedeutung studentischer Migrationen in Mittel- und Südosteuropa vom 18. bis zum 20. Jahrhundert.* München: Oldenbourg, 1987.

Pravda XXXVI, no. 333A, 2 December 1955, 1.

Reich, Bernhard, and David H. Goldberg. *Historical dictionary of Israel.* Scarecrow Press: Lanham, Toronto, Plymouth, 2008 (2).

Rok Šedesáty Osmý. V usneseních a dokumentech ÚV KSČ. Praha: Svoboda, 1969.

Rupnik, Jacques. "Central Europe or Mitteleuropa?" *Daedalus 119,* no. 1 (1990): 249-278.

Rychlík, Jan. "Normalizačná podoba česko-slovenské federace". In *Česká a slovenská společnost v období normalizace. Slovenská a česká spoločnosť v čase normalizácie. Liberecký seminár 2001.* Bratislava: Veda a Ústav politických vied SAV, 2003.

Rychlík, Jan. *Češi a Slováci v 20. století. Česko-Slovenské vztahy 1914–1945,* vol. I. Bratislava: Veda, 1997; referred to as *Češi a Slováci I.*

Rychlík, Jan. *Rozdělení Česko-Slovenska, 1989–1992.* Praha: Vyšehrad, 2012.

Saurer, Edith, Margareth Lanzinger, and Elisabeth Frysak (eds.). *Womens movements. Networks and Debates in postcommunist countries in the 19th and 20th centuries.* Köln: Böhlau, 2006.

Sedláčková, Eulália. "MUDr. Mária Bellová – prvá slovenská lekárka". *Lekárnik 9*, no. 7 (2004): 21.

Sedm pražských dnů. 21–27. srpen 1968. Dokumentace. Praha: Academia, 1990.

Siddharth, Kara. *Sex Trafficking: Inside the Business of Modern Slavery.* New York: Columbia University Press, 2010.

Skilling, Gordon H. *Czechoslovakia's Interrupted Revolution.* Princeton University Press: Princeton NJ, 1976.

Šegeš, Dušan, Maroš Hertel and Valerián Bystrický (eds.). *Slovensko a Slovenská otázka v Poľských a Maďarských diplomatických dokumentoch v rokoch 1938–1939.* Bratislava: Spoločnosť Pro Historia, 2012.

Škultéty, Jozef. "Elena Šoltésová". *Živena XV*, no. 1 (1925): 2-5.

Slánská, Josefa. *Report on my husband.* London: Hutchinson, 1969.

Šolc, Jiří. "Na italské a balkanské fronte". In *Bylo málo mužů*. Praha: Merkur, 1990.

Šoltésová, Elena. "Slovenským matkám!" In *Niekoľko slov k slovenským ženam.* Bratislava: Krajinské ústredie pre Slovensko, Čsl. Abstinentného sväzu, 1932.

Šrobár, Vavro, Dr. "Voľby do Maďarského snemu r. 1906". *Slovenská Otčina 2*, no. 4 (1925-1926): 60.

Šrobár, Vavro. "Úlohy sociálneho lekárstva na Slovensku". *Bratislavské lekárské listy XVI*, no. 16 (1936): 1-17.

Šrobár, Vavro. *Z môjho života.* Praha: Fr. Borový, 1946.

Stokes, Gale. "Cognitive Style and Nationalism". *Canadian Review of Studies of Nationalism 9*, no. 1 (1982): 1-14.

Stokes, Gale. *From Stalinism to Pluralism. A documentary history of Eastern Europe since 1945.* New York: Oxford University Press, 1991.

Strauss, Leo. *Persecution and the Art of Writing*. Chicago, London: The University of Chicago Press, 1988.

Štvrtecká, Anna. "Slovenské Národné Povstanie a československá štátna myšlienka". *Život strany 36*, no. 35 (1969): 4, 11.

Švacová, Soňa. *Humanistické tradície v literárnom odkaze Slovenského národného povstania*. Banská Bystrica: ŠVK, 2004.

Schvarc, Michal, Ľudovít Hallon and Peter Mičko. *Podoby nemecko-slovenského 'ochranného priateľstva'. Dokumenty k náboru a nasadeniu slovenských pracovných síl do Nemeckej ríše v rokoch 1939–1945*. Bratislava: HÚ SAV, Fakulta humanitných vied UMB, 2012.

Sykora, František. "Rozhovor s primárkou MUDr. Máriou Bellovou". In *Cesty k dnešnej medicíne*. Martin: Osveta, 1990.

Sykora, Stanislav. "KSS a čiastočná liberalizácia režimu na Slovensku počas predjaria (1963–1967)". In *Český a slovenský komunismus (1921–2011)*. Praha: Ústav pro studium totalitních režimů, 2012.

Sykora, Stanislav. *Po Jari krutá zima. Politický vývoj na Slovensku v rokoch 1968-1971*. Bratislava: HÚ SAV, 2013.

Teich, Mikuláš, Dušan Kováč, and Martin D. Brown (eds.). *Slovakia in History*. Cambridge: Cambridge University Press, 2011.

Tkadlečková-Vantuchová, Jarmila. *Živena – spolok slovenských žien*. Bratislava: Epocha, 1969.

Unterberger, Betty M. "The Arrest of Alice Masaryk". *Slavic Review 33*, no. 1 (1974): 91-106.

Vajanský, Svetozár Hurban. *Nálady a výhlady*. Turčiansky Sv. Martin: Kníhtlačiarsko-účastinarský spolok, 1897.

Vodička, Karel. "Wie der Koalitionsbeschluss zur Auflösung der ČSFR zustande kam". *Osteuropa 45*, no. 2 (1994): 175-186.

Vondrášek, Václav, and Jan Pešek. *Slovenský povállečný exil a jeho aktivity, 1945–1970. Mýty a realita*. Bratislava: Veda, 2011.

Votrubová, Štefana. *Živena. Jej osudy a práca*. Martin: Živena, 1931.

Waylen, Georgina. "Women and Democratization: Conceptualizing Gender Relations in Transition Politics". *World Politics XLVI* (1994): 327-354.

Williams, Kieran. *The Prague Spring and its Aftermath. Czechoslovak Politics 1968–1970*. Cambridge: Cambridge University Press, 1997.

Wöhrer, Veronika. "Som feministka, no a čo? Versuche mit einem Schimpfwort politische Arbeit zu machen?" In *Womens movements. Networks and Debates in postcommunist countries in the 19th and 20th centuries.* Köln: Böhlau, 2006.

Žatkuliak, Jozef a kol. *November '89. Medzník vo vývoji Slovenskej spoločnosti a jeho medzinárodný kontext.* Bratislava: HÚ SAV a Prodama, 2009.

Žatkuliak, Jozef, and Ivan Laluha (eds.). *Alexander Dubček: Od totality k demokracii. Prejavy, články a rozhovory, vyber 1963–1992.* Bratislava: Veda, 2002.

Zavacká, Katarína. "Totalitarian systems in Czechoslovakia as liquidators of the rule of law". In *Slovak Contributions to 19th International Congress of Historical Sciences*. Bratislava: Veda, 2000.

Zavacká, Marína. "Whispered rumor as a kind of independent political news service in Slovakia in 1953: People and state reacting on the death of J. V. Stalin and Klement Gottwald". In *Slovak Contributions to 19th International Congress of Historical Sciences*. Bratislava: Veda, 2000.

Zemko, Milan. "Medzníky slovenských dejín podľa marxistickej historiografie do roku 1989". In *Český a slovenský komunismus (1921–2011)*. Praha: Ústav pro studium totalitních režimů, 2012.

Zudová, Zlatica. "Žena menom Chaviva". *Smer*, 18 May 1990, 12.

Zudová, Slatica. "Žena menom Chaviva". *Smer*, 25 May 1990, 2.

Internet resources

Bomb Girls on http://www.imdb.com/title/tt1955311/.

Chaviva Reik on http://www.wertheimer.info/family/GRAMPS/Haapalah/ppl/c/f/bc99ecd717b332009fc.html.

Department of Sociology at Comenius University on http://www.fphil.uniba.sk/index.php?id=845.

Emil Hácha on http://www.fronta.cz/dokument/emil-hacha-zaznam-o-jednani-v-berline-v-noci-z-14-na-15-brezna-1939.

Givat Haviva on http://web.archive.org/web/20071014043203/http://www.givat-haviva.net/htm/01_aktuelles/download/HRP_Doku.pdf.

Givat Haviva on http://www.givathaviva.org.il/english/.

Golda Meir on http://www.jewishvirtuallibrary.org/jsource/biography/meir.html.

Ilava on http://www.zvjs.sk/?ustav-vykonu-trestu-vykonu-vazby.

Josefa Slánská on http://www.ceskatelevize.cz/ct24/domaci/167408-nelehky-zivot-po-boku-rudolfa-slanskeho/.

Jozef Banáš' website http://www.jozefbanas.sk/index.php/English.

Lebensborn on https://www.jewishvirtuallibrary.org/jsource/Holocaust/Lebensborn.html.

Lenin as a teacher on http://www.brainyquote.com/quotes/quotes/v/vladimirle153238.html.

Magdaléna Vášáryová's website http://www.magdavasaryova.sk/.

Mária Banášová on http://www.artgaleria.sk/sk/ponuka/socha/socha_m_banasova.aspx; http://zena.sme.sk/c/5768927/maria-banasova-clovek-je-ako-oliva.html.

Obchod na korze on http://www.imdb.com/title/tt0059527.

OTO survey on http://anketaoto.cas.sk/archiv/.

Petition A few sentences on http://icv.vlada.cz/en/media-centrum/tema/a-few-sentences-on-a-petition-from-1989-59398/tmplid-676/.

Slovak Foreign Policy Association SFPA on http://www.sfpa.sk/en/.

Sophie's Choice on http://www.imdb.com/title/tt0084707/.

Swiss female vote on http://history-switzerland.geschichte-schweiz.ch/chronology-womens-right-vote-switzerland.html.

The Bletchley Circle on http://www.imdb.com/title/tt2275990/.

The ship Haviva Reik on http://paulsilverstone.com/immigration/Primary/Aliyah/ShowShip2A.php?shipno=115&pic=ShipPix/115.%20Haviva%20Reik%20at%20Haifa%20%20CZA.jpg&shipname=%3Ci%3EHaviva%20Reik%3C/i%3E&rowno=16.

The Šrobár Institute on http://www.srobarovustav.sk/sk/.

Vájo, Juliús, and Marta Jirouškova. "Jozef Uram – prvý riaditeľ Štátnej nemocnici v Košiciach". On http://www.snk.sk/swift_data/source/NbiU/Biograficke%20studie/34/Vajo.pdf.

The Vrba Wetzler report on http://www.holocaustresearchproject.org/othercamps/auschproto.htlm.

Index

A

A Bit Different (*Trochu jinak*), 161
action programme (*akční program*), 99
Akcia B, 5, 166
alcohol, 39, 40, 105
Allies, 63, 69, 72, 73, 76, 77, 107, 166
Aron, Raymond, 3
Austrian television, 136
Austro-Hungarian Compromise, 18
autonomy, 18, 62, 63, 64, 65

B

babky demokratki (democrat grannies), 142
Bacílek, Karol, 90, 91
Banáš, Jozef, 104, 105, 157
Banášová, Adela, 10, 133, 157, 168
Banášová, Mária, 157
Banská Bystrica, 25, 28, 66, 72, 73, 75, 80, 81
Barnabite Commission, 89
Bellová, Mária, 9, 43, 47, 55, 165
Beneš, Edvard, 27, 63, 69, 70, 76, 88
Berlin, Isaiah, 15
Boutros-Ghali, Boutros, 12
Brežnev, Leonid I., 89, 92, 100, 101, 102
British Army, 61
Budapest, 5, 9, 28, 48, 57, 154

C

Catholics, 24, 34, 35
Čatloš, Ferdinand, 68
censorship, 46, 94, 98, 106, 111, 112, 161, 166
Charter 77, 15, 167
Chruščev, Nikita S., 86
Chuťka family, 77
Čierna nad Tisou, 100
cinema, 138
Civic Forum (*Občanské Forum*, OF), 150
Clementis, Vladimír, 6, 86, 89
clerical fascism, 76, 77
Cold War, 3, 86, 100, 166
collectivization, 85
COMECON, 93, 153
Comenius University, 10, 53, 54, 57, 95, 97, 115, 147, 150, 155, 157, 167, 168
creativity, 137
ČSFR, 11, 12, 140
ČSR, 11
ČSSR, 11, 103
Czechoslovak ambassador, 138, 139, 141, 167
Czechoslovak exile army, 3
Czechoslovak Red Cross, 27, 37, 56

D

Dahrendorf, Ralf, 150
Dakota, 3
Daxner, Štefan Marko, 31, 32
de-Austrianization, 23
Dolchstosslegende (legend of the stab in the back), 70
Doubek, Bohumil, 7
Drehscheibe (hub), 140
Dubček, Alexander, 86, 90, 91, 92, 93, 94, 97, 98, 99, 100, 101, 102, 105, 106, 108, 110, 111, 112, 149, 150, 166
Dubova, Alice, 61, 80
Ďurčanský, Ferdinand, 67, 68
dysfunctional pluralism, 154

E

emancipation, 13, 14, 30, 33, 34, 35, 40, 41, 43, 49, 56, 151, 152, 163, 164
Esterházy, János, 65

EU, 13, 140, 163
Europe, 2, 47, 74, 78, 143, 152
exoteric, 106, 110, 167

F

family, 1, 7, 15, 21, 31, 35, 36, 39, 41, 58, 72, 95, 114, 115, 135, 137, 139, 141, 145, 149, 151, 152, 158, 159, 166, 167, 168
federation, 11, 12, 63, 88, 101, 103, 104, 108, 109, 110, 111
Franz Joseph I, 18, 47

G

Garton Ash, Timothy, 155
gender issues, 13
Gleichschaltung, 65, 75
Gomulka, Władysław, 101
Gorbačev, Michail S., 93

H

Hácha, Emil, 66, 67, 68
Hagana (Defence), 73
Hájek, Jiří, 167
Havel, Václav, 15, 113, 138, 139, 141, 151, 153, 167
Henlein, Konrad, 62
Hitler, Adolf, 62, 63, 66, 67, 68, 76, 77, 78, 107
Hlas (the Voice), 24, 43
Hlinka Guards, HG, 65
Hlinka, Andrej, 20, 65
Hlinka's Slovak People's Party. s. HSĽS
Hodža, Milan, 21, 50, 69
Hodžová, Marína, 21
HSĽS, 62, 63, 64, 65, 66, 70, 75, 78, 87, 166
Hungarian Red Cross, 53
Hurban Vajanský, Svetozár, 35
Husák, Gustáv, 86, 89, 91, 95, 102, 105, 109, 111, 112, 115, 136, 150
Husserl, Edmund, 167

I

Ilava, 71, 166
influenza, 47
Israel, 61, 82, 83, 166

J

Jablonický, Jozef, 76, 114
Jewish codex, 71
Judt, Tony, 3

K

Kádár, János, 100, 101
Karmasin, Franz, 65, 66, 67
Klaus, Václav, 11, 149, 151
Kolder Commission, 89
Košice Agreement (*Košický vládny program*), 88
Kovály, Heda Margolius, 4
Kultúrny život (Cultural Life), 91
Kun, Béla, 54
Kundera, Milan, 102, 112

L

Langer, Jo, 4, 6, 8, 94
Langer, Oscar, 5
L'aveu, 7
law of Holitscher, 38
Lebensborn, 78
Lenin, 54, 100, 159
Lex Apponyi, 20
London, Artur, 4, 7
Ľudáci, 65, 68

M

Magna Charta of the Slovak nation, 109
Magyar assimilation, 13, 17, 163
Maróthy-Šoltésová, Elena, 9, 16, 17, 22, 40, 163
Marshall Plan, 85, 86, 166
Marxism-Leninism, 3, 4, 7, 93

Masaryk, Jan, 76
Masaryk, Thomas G., 23, 24, 25, 27, 35, 51, 58, 70, 78, 98, 165
mass graves, 80
Matica Slovenska, 22, 114
Mečiar, Vladimír, 11, 140, 155, 163, 168
Meir, Golda, 83
method, 9, 10, 36, 81, 91, 99, 136, 137, 148
Mlynář, Zdeněk, 93
monarchy, 11, 14, 28, 140
Montand, Yves, 7
Moscow Protocol, 97, 102, 103
Munich Agreement, 62, 67, 69, 107

N

National Front, 87, 88
NATO, 13, 157, 163
neo-Stalinism, 98
Nietzsche, 36
NKVD, 7
nomenklatura, 5, 148, 155
Nové slovo (New Word), 112
Novomeský, Ladislav, 86, 89, 91
nuclear plant, 140

O

Office of Strategic Services. s. OSS
OSS, 74
OTO survey, 157

P

Palestine, 10, 61, 73, 74, 82, 83, 166
Palmah, 10, 73, 83
Pankhurst, Emmeline, 164
partisans, 73, 76, 77, 79, 80, 81
passport, 136, 138
Patočka, Jan, 167
Paulíny-Tóth, Viliam, 30
photomontage, 139
Pietor, Ambro, 29, 30
pogrom, 70, 71

pozývajúci list (letter of invitation), 101
Prague centralism, 63
Prague Spring, 5, 10, 93, 94, 97, 98, 107, 145, 166
Pressburg, 28, 45, 53, 54
prevrat, 44, 53
privatization, 11, 15, 150, 155
protectorate, 9, 63, 68, 70, 87
Protestants, 32, 34
Prúdy (Currents), 51
Public Against Violence (*Verejnosť proti násiliu*, VPN), 150
public healthcare, 43, 44, 57

R

Radičová, Iveta, 10, 132, 145, 168
Radio Free Europe, 146
RAF, 73, 74
Red Army, 76, 77, 79, 88
reforms of the educational system, 28
Rehabilitation Commission, 89, 115
Reiková, Chaviva, 61, 72, 165
resistance, 13, 61, 76, 91, 95, 103, 110
Riznerová-Podjavorinská, Ľudmila, 31
rule-of-law state, 8, 20
Russia, 35, 102

S

SAV, 10, 95, 148, 168
seven political regimes, 11, 163
sexism, 15, 151
Signoret, Simone, 4, 5, 7
Škultéty, Jozef, 25
Slančiková-Timrava, Božena, 31
Slánská, Josefa, 4
Slánský, Rudolf, 4, 6, 86
Slovak Academy of Sciences. s. SAV
Slovak autonomism, 63
Slovak Communist Party KSS, 78, 87
Slovak Foreign Policy Association SFPA, 141

Slovak National Uprising, 75, 106, *s. SNP*
Slovak Republic, 11, 13
Slovak state, 9, 11, 45, 67, 68, 70, 71, 72, 75, 76, 79, 89, 109, 166
Slovakia's Superstar (*Slovensko hľadá superstar*), 160
Slovenské Pohľady, 27, 36
SNP, 10, 74, 75, 76, 77, 80, 85, 91, 95, 96, 106, 110, 111, 163, 166, 167
SNR, 88, 89, 103, 108, 110
Socialism with a human face, 93, 108
sociology, 10, 49, 135, 147, 148, 149, 155, 167
SOE, 62, 73, 74
solidarity, 105, 143, 144
sovietization, 85, 166
Soviet-type industrialization, 153
Special Operations Executive. *s.* SOE
sponsors, 161
Šrobár, Vavro, 19, 38, 39, 43, 47, 53, 54
Stalinist show trials, 4
ŠtB, 5, 92, 136, 167
Štefánik, Milan Rastislav, 27
Strauss, Leo, 106
Štvrtecká, Anna, 10, 85, 95, 167
Sudeten Germans, 62
Svoboda, Ludvík, 79

T

theatre, 135, 137, 138, 146, 161
Tiso, Jozef, 63, 66, 67, 68, 71, 75, 76, 77, 79, 81, 83, 165
Titoism, 6
Trotzkyism, 6
tuberculosis, 9, 40, 43, 48, 54, 55, 56
Tuka, Vojtech, 66, 68

U

Ulbricht, Walter, 101
United Nations, 12

Uram, Jozef, 50, 51, 54, 165
USA, 5, 22, 82

V

Vansová, Terézia, 31
Vášáryová, Magdaléna, 10, 135, 167
Velvet Divorce, 12
Velvet Revolution, 12, 115, 139, 163, 167
Via Cultura, 142
Vienna Arbitration, 62, 64
virilism, 154
Voice of America, 146
Vrba, Rudolf, 71, 72

W

WAAF, 73
Warsaw Pact, 10, 93, 97, 101, 110, 145, 146, 153, 167
Wetzler, Alfred, 71, 72
Women's Auxiliary Air Force. *s.* WAAF

Y

Yugoslavia, 13, 73, 96

Z

Zápotocký, Antonín, 56
Zaťko, Peter, 67
zemitosť (earthiness), 149
Žilina Agreement, 62, 63
Zionism, 6, 72
Živena, 9, 14, 16, 21, 22, 23, 24, 25, 26, 27, 28, 29, 30, 31, 33, 34, 35, 37, 40, 41, 50, 56, 142, 163, 164
Živkov, Todor, 101

ibidem-Verlag

Melchiorstr. 15

D-70439 Stuttgart

info@ibidem-verlag.de

www.ibidem-verlag.de
www.ibidem.eu
www.edition-noema.de
www.autorenbetreuung.de